OUT OF THE CRADLE

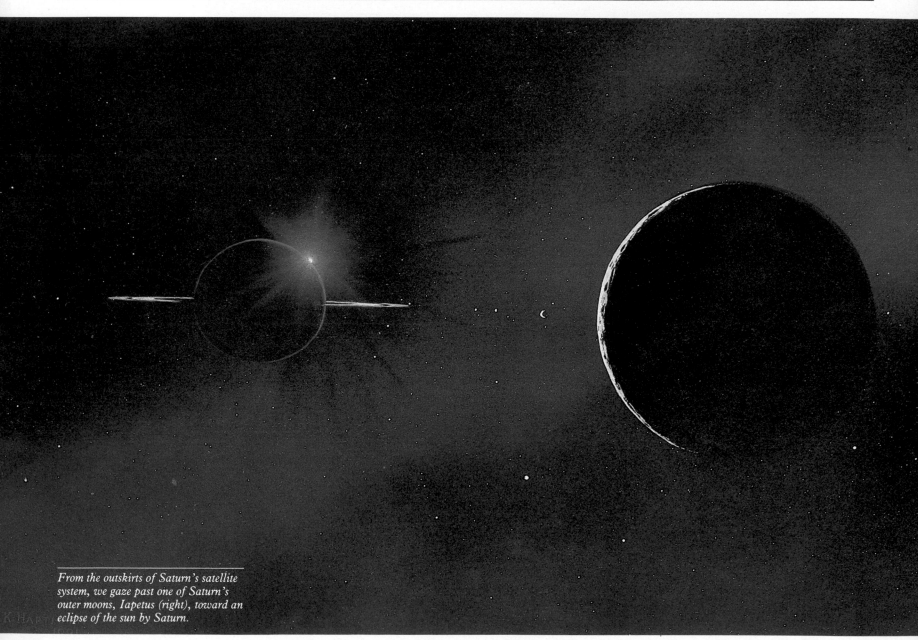

From the outskirts of Saturn's satellite system, we gaze past one of Saturn's outer moons, Iapetus (right), toward an eclipse of the sun by Saturn.

OUT OF THE CRADLE

EXPLORING THE FRONTIERS BEYOND EARTH

by William K. Hartmann, Ron Miller
& Pamela Lee

WORKMAN PUBLISHING, NEW YORK

Paintings copyright © 1984 by
William K. Hartmann, Ron Miller
and Pamela Lee

Text 1984 William K. Hartmann

**Library of Congress Cataloging in
Publication Data**

Hartmann, William K.
 Out of the cradle.

 Includes index.
 1. Outer space—Exploration. 2.
Space stations.
I. Miller, Ron. II. Lee, Pamela. III.
Title.
TL793.H364
1984 629.4 84-40316
ISBN 0-89480-770-6

First printing September 1984

10 9 8 7 6 5 4 3 2 1

Workman Publishing Company, Inc.
1 West 39 Street
New York, New York 10018

Manufactured in Hong Kong

Acknowledgments

Thanks to Peter Workman, Sally Kovalchick, Maureen Kelly, Lynn Strong and the rest of the staff at Workman Publishing Co. for their hospitality and enthusiastic work on our book, and to Tom Miller and Paula Watson-McBride for assistance in production of the manuscript.

Contents

A Word About Our Pictures

I developed an initial list of picture concepts for this book, based on photos and scientific knowledge of planetary environments. Pam, Ron and I expanded our concepts by diverse methods, such as studying NASA photos and maps; making our own photos of "astronauts" (friends in simulated spacesuits) in otherworldly settings, including lava flows, dunes, craters and mountaintop observatory construction sites; reviewing scientific data about colors and textures of other worlds; and painting from life at sites such as Hawaii Volcanoes National Park and Death Valley National Monument, where we transformed landscapes into geologically similar scenes on other planets.

In many captions we specify an angular width worked out in advance for the painting. For example, Jupiter seen from its moon, Io covers an angle of about 20°; if our painting represents a typical camera view of 40° angular width, Jupiter would thus cover about half the width of the painting. In a similar 40° view from the moon, the 2°-wide Earth would cover only 1/20 of the painting's width. Sometimes a wide-angle view better presents a panorama, such as a vista across a crater; such a painting might have an angular width of 90°. Or a "telephoto" view only 20° wide might be a better choice for Saturn as seen from a distant satellite. Our painting designs may mirror the choices of lenses made by future astronauts as they meet photographic challenges on distant worlds.

In addition to our paintings, we present some spacecraft and astronaut photos in early chapters to illustrate what humans have already accomplished. But these photos soon give way to our imaginative views—after all, the future has not been photographed!

W.K.H.

Preface

"Earth is the cradle of humanity, but one cannot live in the cradle forever." —KONSTANTIN TSIOLKOVSKY, 1899

In an earlier book, *The Grand Tour: A Traveler's Guide to the Solar System,* Ron Miller and I described in text and pictures the strange environments and awesome landscapes of worlds throughout our solar system. In this book, Ron Miller, Pamela Lee and I show what we humans will *do* out there. We imagine filling those stunning but empty landscapes with people and their enterprises. We examine not only our opportunities for discovery and adventure, but also how space exploration may benefit Earth both economically and environmentally. We describe past accomplishments, some planned missions, some future milestones: questions we can answer, resources we can seek, places we can go. Our projections, extending perhaps a century into the future, are based as much as possible on firm, scientific knowledge.

But great triumphs of technology and exploration do not begin as full-fledged plans. They begin as dreams. Jules Verne said that what one person can imagine, another can do. Imagination precedes implementation. Martin Luther King, Jr., said, "I have a dream," not "I have a plan." Dreams precede plans. And dreams are images: Hence our pictures. We hope they will conjure an image in the minds of our readers—especially the younger readers, who will move the world into the next millennium. Once they have the image, they can draw up the blueprints.

We hope to create in younger minds an image of cooperative space exploration by all peoples of Earth. It will be up to a new generation to develop the social modes that allow it. The older generation has produced a world where such ventures are occasionally possible, but where the leading nation spends roughly a third of its annual budget on military security and only 2 to 3 percent (including some from the military) on exploring its interplanetary surroundings. Yet this fledgling adventure of the mind may provide the answer to many of the problems that afflict Earth's society today. How can we carry it out without transporting our provincial international conflicts into space? It will be up to students of engineering and technology to learn how to collaborate—to build things—with their foreign colleagues. It will be up to students of business administration and marketing to learn how to make mutually favorable business arrangements with their counterparts in other lands. It will be up to those who go into politics and social studies to figure out how new international projects can be implemented to utilize energy, ores and territories of space for the benefit of people on Earth. It will be up to artists and writers to speak the dream in advance and report its unfolding to the people as it happens.

William K Hartmann

Tucson, Arizona
1983–84

PROLOGUE: THE SOLAR SYSTEM AS OUR BACKYARD

Many people cling to the old grade-school statement that there are nine planets. While there *are* nine important bodies orbiting the sun, there are dozens of moons—some of them bigger than Pluto and Mercury—as well as thousands of additional, smaller bodies known as asteroids and comets. We need a word different from "planet," then, to denote one of the large bodies of the solar system. Let us define "world" to mean one of the bodies larger than 1,000 km (about 600 mi) across. Then we can say that the solar system contains two dozen worlds.

Of the two dozen worlds, one stands out as the strangest. At its surface, water can exist as a solid, liquid or gas. Amidst its icefields, oceans and steam clouds, life evolved. It is the blue and white planet Earth.

Along with other planets, Earth appeared four and a half billion years ago when dust grains, like a trillion brown snowflakes, condensed in the cooling nebular gas surrounding the newborn sun. These grains collided with each other, stuck, and accumulated into worlds and "worldlets." To produce planets in this way took only a few million years, the wink of a cosmic eye. Five billion years ago there was no sun, no Earth, no solar system—only gas clouds and *other* stars.

Like some other planets, this strangest planet contained carbon-based chemicals that reacted and formed giant organic molecules: amino acids and bright-colored slimes. In long gone

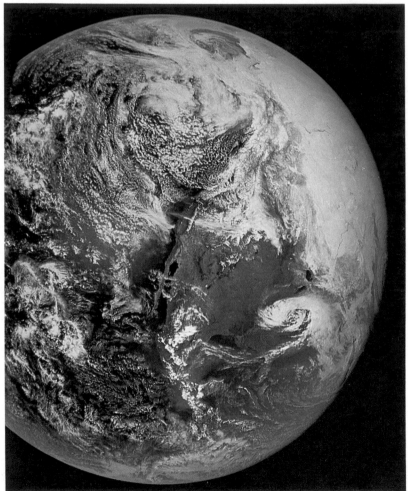

The first views of Earth from space dramatized the fact that we live on a beautiful but finite globe.

NASA photo

ocean bays and tidal ponds, under steamy tropical skies, along barren coastlines, these organic chemicals endowed our world— or our world endowed the chemicals (which was it?)—with life. It happened quickly, geologically speaking, a few hundred million years after the planet formed, within the first 10 or 15 percent of the age of the planet.

For the first half of its history, Earth's landscapes were as barren as landscapes on Mars. The explosion of oceanic lifeforms to species big enough and hard enough to leave abundant fossils came only in the *last* 13 percent of Earth's history: 600 million years ago. Substantial land life—simple plants—spread only the last 10 percent. Dinosaurs came only in the last 3 percent. They were probably wiped out when a 10-km-diameter asteroid, floating in endless orbit around the sun, crashed into Earth 65 million years ago, throwing up an enormous dust cloud that changed the climate.

Just as there was no solar system during the first two-thirds of our galaxy's history, there were no people during the first 99 percent of Earth's history. Winds blew, ocean waves crashed, trees toppled, all with no one to witness. Then, during the last, briefest moment of Earth's history—the last 0.1 percent—clever upright-walking, land-striding animals began to fashion tools out of stone, wood, bone. For 99 percent of humanity's history we made do with these crude tools. But in the last .3 percent of human history, we invented agriculture and cities, and started working in metals. In the last few thousand years we have really gotten going, putting in plumbing, codifying laws, building roads, crossing frontiers and writing histories of it all. Only in our current millennium have we sailed across the world, discovering each other in different lands, living according to different cultural traditions. We swept around Earth's spherical frontier, covering the globe, until suddenly it closed on itself. Now, for the first time, there are no unknown lands on Earth, no more frontiers.

If we imagine Earth's history to be a 24-hour day, we appeared a minute before midnight. What will be here a few

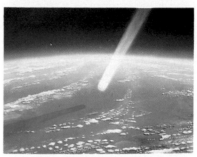

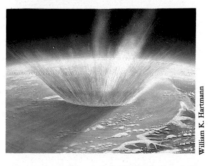

Statistics prove that large asteroids must have hit Earth during past eons, and geochemists have found evidence of one such impact in which a 10-km (6-mi) asteroid hit Earth 65 million years ago. As shown in these three views from 100 km (62 mi) up, the asteroid streaks through the atmosphere and craters the surface, blowing tons of steam and dust into the air. The scene is depicted 10 seconds and 2 seconds before impact, and 60 seconds after. Resulting climate change wiped out dinosaurs and other species of animals and plants.

William K. Hartmann

seconds *after* midnight? A rich, thriving interplanetary civilization? Or a charred Earth in a lifeless solar system?

What an incredible moment we live in! What an important generation is our own! We live during the one moment of transition from stone tools to spaceships. Until our century, the ground in many parts of the world was littered with debris of our ancestors of the recently ended stone age: arrowheads, broken pottery, carvings, ruined temples, mounds that were forgotten

cities. A hundred years from now, most of these will have been picked up, plowed under, plundered or (in a few cases) preserved. We live in the last century to have abundant, untouched records of our ancient past. We live in the last century to see undiscovered tribes of aborigines living in neolithic isolation, unaware of a world bustling with computers, television, hot and cold running water, electric lights at night.

Always pressing on over the next hill, we have spread around the world, eating and burning our way through its frontier. Now we have run out of frontier, and we have begun to run out of resources.

It is no coincidence that we who developed the technological capacity to fly around the world at will and began to exhaust Earth's resources are the same generation that developed the technological capacity to move off Earth, to explore for new knowledge and new resources in the sky.

What will we find out there? What will we do on distant worlds? The rest of this book will answer these questions in some detail, describing future human activities on the moon, on asteroids, on Mars, and so on, in the order that human exploration is likely to occur. But first let's take a whirlwind tour of the solar system to get an overview of the territory.

Closest to the sun is the small world Mercury, only 40 percent bigger than Earth's moon and much like it—rocky, airless, waterless, spotted with lava flows and heavily pocked with craters marking the explosive impacts of meteorites during bygone ages. The 59-day rotation on its axis and the 88-day period to complete its orbit around the sun combine to create a 176-day interval between one sunrise and the next on Mercury. During the months of glaring sunlight, the temperature of the arid soil approaches 425°C (797°F). Then, during the month of darkness after the sun has set, the heat radiates away into the blackness of space, and the soil temperature falls as low as −163°C (−61°F). Mercury illustrates how the complex properties of even a small airless world can produce a unique environment.

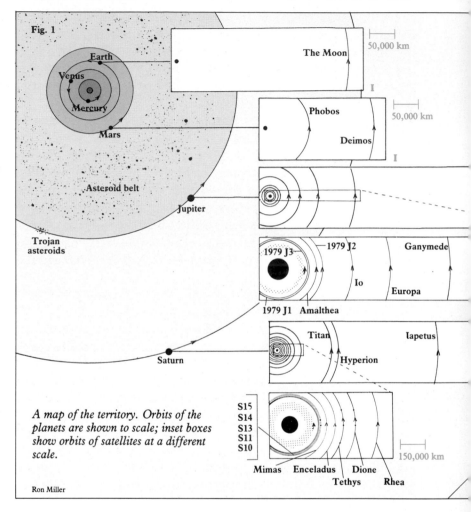

A map of the territory. Orbits of the planets are shown to scale; inset boxes show orbits of satellites at a different scale.

Ron Miller

Next outward from the sun is Venus, almost exactly the size of Earth but with a totally different environment from either Earth or Mercury. It has an extremely dense atmosphere of carbon dioxide gas (CO_2) and is covered by an opaque layer of creamy, yellow-white clouds. The cloudy air allows sunlight to filter hazily to the ground but blocks the cooling nighttime radiation into space, so that Venus' atmosphere has a torrid day-

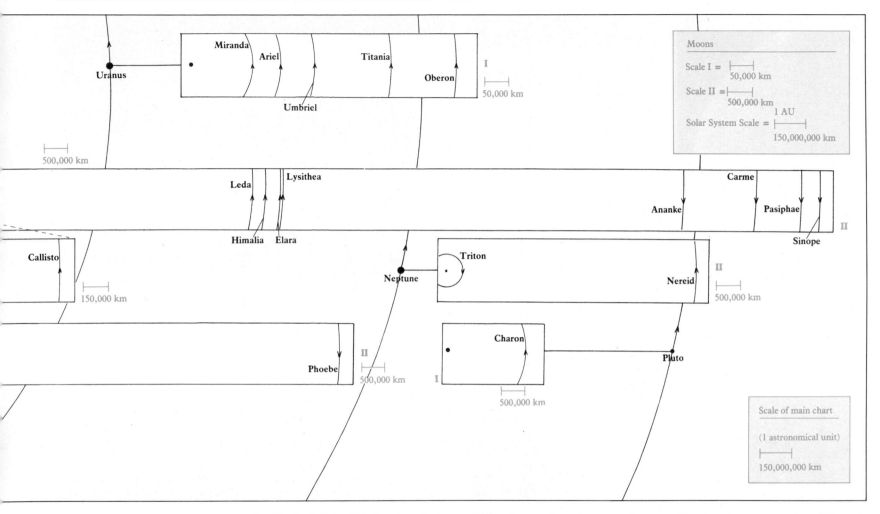

and-night temperature near 450°C (842°F). Lightning bolts flash in the clouds. Russian unmanned landers revealed volcanic rocks and gravel on the surface, and recent evidence suggests active volcanos on the planet.

Passing over familiar Earth and its airless moon, which have *both* been walked by humans, we come to the most intriguing and Earth-like world in the inner solar system: the red planet Mars. Long known as a planet of beckoning mysteries, Mars is about half the size of Earth. Its many Earth-like features are stamped with Martian uniqueness. There is a thin atmosphere of carbon dioxide, clouds of both water and carbon dioxide crystals, canyons, dunes, craters, rock-strewn plains, polar snowfields, cliffs with landslides, and strange, dry riverbeds. Mars has water, but virtually all of it is frozen: thus the riverbeds raise a

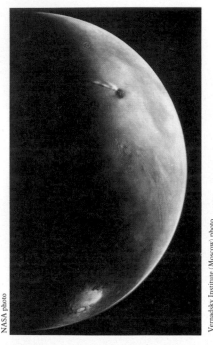

NASA photo

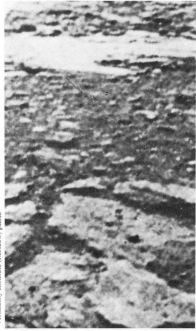

Vernadsky Institute (Moscow) photo

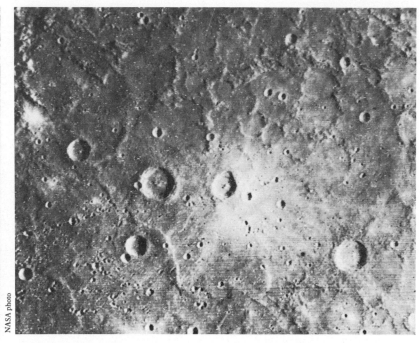

NASA photo

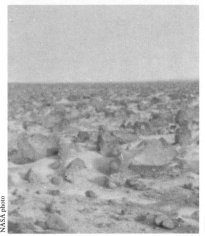

NASA photo

NASA photo

Above left: the dawn side of Mars. Clouds that formed during the night trail to the left of a dark volcanic mountain in the Tharsis desert (upper center of picture). The giant canyon, Valles Marineris, stretches up and down (lower right center). White frost covers circular impact craters at the south (bottom).

Far left: winter in a rocky plain on Mars. The Viking 2 lander photographed a thin frost cover that lasted 100 days at this site in the midnorthern latitudes. Lava boulder fragments litter the plain to the distant horizon.

Above center: the rocky surface of Venus. Scattered rocks and gravel were revealed on Venus as seen in this photo from a Russian unmanned lander.

Near left: Venus, Earth's twin sister in terms of size, hides its surface behind thick clouds of sulfuric acid droplets in a dense atmosphere of carbon dioxide. This ultraviolet photo from a space probe enhances the contrast of the cloud patterns.

Directly above: Mercury's heavily cratered surface, resembling that of the moon. Bright rays of pulverized, glassy debris extend from a recent crater. Photo width: 560 km (350 mi).

mystery. Under what ancient conditions did *liquid* water splash across the surface of Mars? Did life ever evolve when the water was abundant? Future explorers will pursue these questions on Mars itself.

Between Mars and Jupiter is the main swarm of asteroids, called the asteroid belt. Here are thousands of small, rocky and metallic bodies ranging from less than a mile across to almost a third the size of the moon. Astronomers' spectra reveal that asteroids come in a surprisingly wide variety of rock and mineral types, as we'll see in a later chapter.

Beyond the asteroid belt are the four giant planets, ranging from four to ten times the diameter of Earth. Led by mighty Jupiter, the largest planet, they also include Saturn, Uranus and Neptune, in order out from the sun. So huge are these planets that their gravity has retained enormous, dense atmospheres of hydrogen, helium and hydrogen-based compounds—gases so light that in the weak gravities of Earth and other inner planets they long ago floated to the upper atmosphere and leaked off into space. But these gases were held by the giants. The thick atmospheres of the giants are marked by opaque clouds, often colored by organic compounds. On Jupiter and Saturn the clouds form colorful whirls of orange, yellow, red and white. Uranus and Neptune have hazier, bluish aspects, reminiscent of Earth. The clouds hide the surfaces of all four giant planets. These surfaces may not be solid at all (at least in Jupiter's case), but may grade from thick atmospheres to a slushy ocean of liquid hydrogen. Some of the high-pressure gases are poisonous. The surface gravities are strong, making it hard to stand and hard to return by rocket from the surface to the safety of space. Thus the giant planets seem unattractive targets for human surface exploration—at least for the forseeable future.

But the giant planets each have surrounding systems of extreme interest. Jupiter, Saturn and Uranus, for example, have rings. The rings of Saturn are formed by countless bright iceballs; the rings of Jupiter and Uranus are composed of more dusty material of uncertain composition. Neptune apparently has no rings.* Are ring systems formed by debris of broken satellites or by primordial debris left over from planet formation? No one knows.

All four giant planets have systems of moons, greatly multiplying the variety of worlds and worldlets available in the solar system. Jupiter and Saturn each have a dozen or more worldlet-class moons (smaller than 1,000 km across), ranging from hundreds of kilometers down to tens of kilometers across. The small moons of Jupiter tend to be colored by black soil, while those of Saturn are generally bright and icy. The systems of Uranus and Neptune add another half-dozen known worldlets to the list.

In addition to the worldlets, the giant planets have a number of world-sized moons (larger than 1,000 km). Here we begin to sense the extreme strangeness of some solar system environments. Of the four such worlds in the Jupiter system, ranging from the size of our moon up to a size just exceeding that of Mercury, the innermost is one of the strangest. This is red, orange and white Io (pronounced *eye'oh*), covered with sulfur flows and home to dozens of active volcanoes whose plumes of debris erupt 100 km and more into the airless, silent sky. Next outward from Jupiter is Europa, an almost featureless white billiard ball whose icy plains are crisscrossed by faint cracks and grooves like a network of tan veins. Europa's plains of ice form a floating crystal layer believed by many scientists to hide a deep underlying ocean of water. Eruptions of steam, freezing to ice crystals, have been suspected on Europa. Third outward is Ganymede, with an older, more rugged surface pocked with craters and split by bands of brighter ice grooved with parallel fissures. Outermost of the four large moons is Callisto, whose surface of dark soil and ice is dotted by craters.

Most of Saturn's moons are ice-covered and heavily cratered, though systems of cracks and parallel grooves, reminiscent of Ganymede and Callisto, can be found on some of them.

*Neptune passed in front of a distant star in 1983 and eclipsed its light, but no additional blink-outs by rings were seen on either side of the planet.

Saturn's one world-class moon is another example of a unique, mysterious environment. This is the Mercury-size moon, Titan, shrouded in a thick atmosphere of nitrogen and methane, made opaque by reddish smog. The smog is believed to hide a surface where methane may rain or snow out of the clouds. Oceans of liquid organic chemicals (such as methane and ethane) may exist.

The last world-class satellite is a moon of Neptune called Triton. Unlike the worlds described above, Triton has not yet been visited by spacecraft, and until a few years ago it seemed to have little personality of its own. Then Earth-based astronomers detected spectroscopic evidence of methane ice and gas on Triton. In 1983 observers at the University of Hawaii made an extraordinary announcement. According to their spectroscopic work, Triton probably has oceans of liquid nitrogen. These oceans may be dotted among "continents" of methane ice under a sky filled with a thin nitrogen-methane atmosphere. It would be a strange Antarctica-like world, with a dark sky and dim lighting from a remote sun.

At the outskirts of our solar system orbit moon-sized Pluto and its own satellite, Charon, both rich in methane ice. Pluto and Charon do not quite mark the outer limits of the solar system. Thousands of comets orbit here and beyond. They are chunks of ice ranging from a few kilometers across to unknown larger sizes. Perhaps the largest examples are additional Pluto-size worlds as yet undiscovered.

Zones of the Solar System

Here, then, we have a solar system that at first seems bewildering in its variety. The diversity of planets leads us to an important concept that we might call "zonal differentiation," describing the fact that planets in zones at different distances from the sun have different compositions. "Differentiation" is a term used by geologists to refer to processes that concentrate various minerals in different places. On Earth certain processes concentrate iron ore in one place, quartz sand in another, coal in still another, and so on. If there were no differentiation on Earth, all rocks would

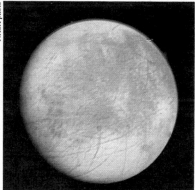

The moons of Jupiter.
Io, in backlit crescent phase, reveals its sulfurous orange colors and bluish plumes from erupting volcanoes.

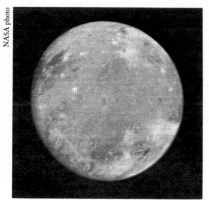

Europa is an icy tan billiard ball, marked only by faint dusky patches and shallow grooves.

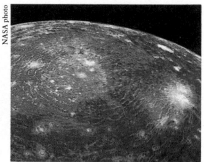

Ganymede has Callisto-like dark regions, and bright swaths where the dark regions have been broken apart by eruptions of fresher, grooved ice.

Callisto shows bright patches where impacts have exposed icy material underlying darker surface soils.

NASA photo

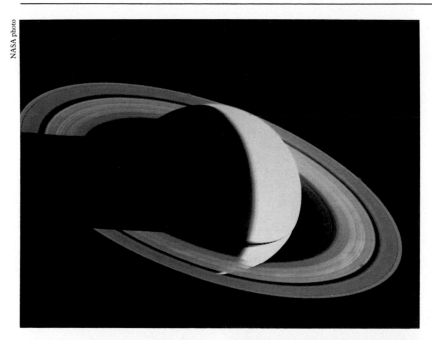

Ringed Saturn was photographed by Voyager 1. This crescent-lit view shows the intricate shadings and divisions in the rings, the shadow of the rings on the globe, the shadow of the globe on the rings (left) and parts of the planet seen through gaps or thin regions in the rings.

NASA photo

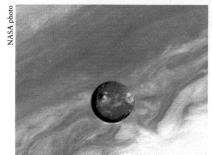

Above, sulfurous-red Io hangs against the backdrop of Jupiter's swirling, colored clouds.

NASA photo

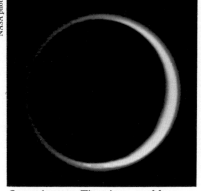

Saturn's moon Titan is covered by orangish smog. This crescent view reveals bluish light scattered through the backlit atmosphere above the haze (left).

NASA photo

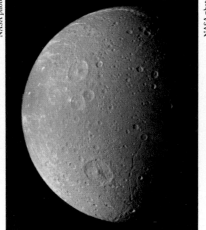

Saturn's moon Dione is one of several heavily cratered Saturnian moons with water-ice composition. Fractures are prominent at bottom center. The largest crater is about 100 km (62 mi) across.

NASA photo

Cratered, icy surfaces on Saturn's moon Enceladus are broken by swaths of fresh, grooved terrain, possibly formed by relatively recent water eruptions that formed ice plains. Fracture lines are prominent.

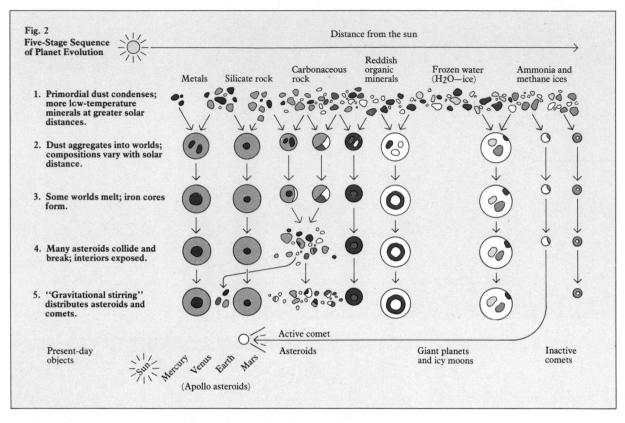

Fig. 2
Five-Stage Sequence
of Planet Evolution

Distance from the sun

Metals Silicate rock Carbonaceous rock Reddish organic minerals Frozen water (H₂O—ice) Ammonia and methane ices

1. Primordial dust condenses; more low-temperature minerals at greater solar distances.

2. Dust aggregates into worlds; compositions vary with solar distance.

3. Some worlds melt; iron cores form.

4. Many asteroids collide and break; interiors exposed.

5. "Gravitational stirring" distributes asteroids and comets.

Active comet

Present-day objects

Sun Mercury Venus Earth Mars

(Apollo asteroids)

Asteroids

Giant planets and icy moons

Inactive comets

be the same, and there would be no commercially valuable concentrations of useful materials, such as iron ore, copper ore, and soil. Similarly, certain cosmic processes during the evolution of the solar system led to differentiation among planetary materials. Metal-bearing rocks tend to be in one zone, ices in another. As we shall see in the rest of this book, understanding of differentiation processes among planetary materials will be an important factor in our coming conquest of the solar system. It will guide us in seeking and utilizing resources throughout the solar system, just as understanding of terrestrial differentiation has led geologists to ore deposits on Earth.

What are the processes that gave rise to zonal differentia-

tion? Planetary evolution was complex, of course, with special events occurring in the history of each planet, but we can describe a simple five-step scheme that explains much of what we need to know about the solar system. This scheme is shown in the diagram on this page.

In step 1, dust condensed four and a half billion years ago in a disk-shaped, cooling gas cloud that surrounded the sun soon after it formed. This cloud is called the solar nebula. Think what happens when a cloud in our own sky cools as it rises in the atmosphere. Water vapor, the condensable gas in the cloud, forms droplets or solid particles such as snowflakes or hailstones. In the same way, condensable substances formed solid grains in

the solar nebula as it cooled. The important point is that the cloud was always hotter near the sun than in its outer regions. The local temperature controlled what could condense. In the hottest regions near the sun, only high-temperature minerals such as metal oxides and rocky silicates could condense. These formed the rocky materials metaphorically refered to as a "trillion brown snowflakes" earlier in this chapter.

Further from the sun, moist carbonaceous materials, rich in black graphite and related minerals, were added to the mixture of metal grains and rocky silicate grains, forming black, charcoal-like rocks that contained chemically bound water inside their minerals. A little beyond this zone, reddish organic material colored the mix. These were not biological in origin, but were rich in complex organic molecules involving carbon atoms.

In the outer solar system, the temperatures were so low that water condensed as ice grains. Farther out, methane and other compounds also formed ices. These ices were so abundant that they swamped the stony material.

Eventually the gas of the nebula blew away, leaving behind the various solid grains.

Step 2, also about four and a half billion years ago, occurred when the grains in each zone aggregated rapidly into larger bodies the sizes of asteroids, moons and planets, just as snowflakes sometimes aggregate as they fall. Studies of meteorite ages suggest this took no more than a few million years. Already we had zonal differentiation—rocky worlds near the sun and icy worlds further away.

In step 3, some worlds melted, allowing metals and other dense minerals to sink to the center. This explains why many planets (including Earth) have dense cores of nickel-iron alloy. At the same time, light minerals floated to the surface like slag in a smelter, forming crusts of light rocks like Earth's granites and the moon's basaltic lavas. Scientists are not sure what melted the planets. Radioactive minerals trapped inside the planets may have been one major heat source, but there are scientists who believe that other heat sources (such as heating by induced electrical currents) acted on some planets. Several lines of evidence, including meteorite samples, show that even many small asteroids were not immune from melting and formed nickel-iron cores or nodules in their interior. This step also occurred during the early history of the solar system, perhaps during the first 100 million years or so.

Step 4 involved high-speed collisions among remaining planetesimals, fragmenting many of them—especially the asteroids that were left as crowded debris in the zone between Mars and Jupiter. Earlier collisions, which had led to the aggregation of particles into planets, had occurred at slower speeds; when a projectile hit a target, it was simply accumulated by the target, leaving a crater on the target's surface. But now the gravity of newly formed massive planets, such as Jupiter, accelerated many of the bodies to high speed. When a relatively large projectile hit a neighboring target at such speed, it blew both of them apart. Once-melted asteroids were broken open, suddenly exposing nickel-iron cores and other hitherto inaccessible minerals formed deep inside them. Asteroid collisions were most common during the first billion years of the solar system's history but have continued at a slower rate ever since.

In step 5, continuing throughout the history of the solar system, the gravitational influence of Jupiter and other planets threw some small bodies, such as asteroids and comets, out of their original zones. For example, this "gravitational stirring" deflected many asteroids from the asteroid belt into the inner solar system, where they approached (and sometimes collided with) Earth and the other inner planets. Comets, which are asteroid-like worldlets of dirty ice from the outer solar system, were also occasionally thrown into the inner solar system. Here they acted differently from asteroids. The warm sunlight caused their ice to sublime, that is, to change from solid ice to gas. (In space, ice does not melt into water because the water is unstable. Water exposed in space spontaneously boils away in a cloud of water vapor gas, which immediately disperses. Thus, ice exposed to strong enough sunlight simply skips the liquid stage and

sublimes directly from solid form to gaseous form.) The gas streaming away from a comet forms the comet's tail. Every time it passes through the inner solar system, the comet loses some of its ice until one of two things happens: the comet loses all its ice, leaving an inert, asteroid-like worldlet of residual dirt perhaps a few kilometers across; or it loses only the ice from its outer layers, leaving a hidden core of dirty ice overlain by a protective layer of loosely bonded soil. In either case, the inactive comet would look like an asteroid from the outside, and astronauts cruising nearby might have to study it carefully to find out if this "asteroid" really began life as a comet and if it had a hidden core of ice. The net effect of this gravitational stirring somewhat confused the well-defined compositional zones that existed earlier, but it brought bodies from remote zones into orbits close to Earth. This gives an intriguing variety of nearby worldlets.

Comparison of the five-step scheme with the real solar system shows that it explains many features of our planetary environment. The list of observations giving evidence for this scheme is too long to recount here, but we can give some examples. For instance, Mercury, in the metal-rich zone closest to the sun, has the largest iron core in proportion to its size, and the highest density, of any planet. The array of compositions shown in step 1 on page 16 matches that predicted from theoretical chemical descriptions of the cooling solar nebula; it also matches the general compositional zones observed among the planets. The asteroids are a chaotic mixture of objects with different compositions. The meteorites that fall onto the Earth from space are fragments of these asteroids and show a similar range of compositions, from carbonaceous rocks to pure nickel-iron alloy. The nickel-iron meteorites in particular have chemical properties proving they formed inside molten asteroid bodies that later solidified and were broken by catastrophic collisions. Frozen water is abundant on the satellites of Jupiter and Saturn; frozen ammonia and methane (with freezing points lower than that of water) are believed to exist, in addition to water ice, among the satellites of such remote bodies as Pluto and Neptune.

In summary, the five steps of dust condensation, aggregation, melting, collision and "gravitational stirring" explain the zonal compositional structure of the solar system and the fact that asteroid fragments and comets have been scattered outside their original zones.

Once upon a time, such discussions were academic. As recently as 1956, only a handful of scientists cared about the composition of bodies in different parts of the solar system. The nature of lunar rocks and soil was unknown. Mars was still "the mysterious red planet." The *very best* views of Jupiter's satellites with giant telescopes showed them only as pinhead disks with vague, dusky patches on them. At scientific meetings a handful of scientists read short papers to each other and, with the excitement of in-group devotees, debated the nature of these worlds. Amateur astronomers and science-fiction readers avidly followed the scientists' latest results and nourished their sense of wonder with backyard telescopes that revealed shadows stretching 100 miles across the floors of lunar craters during sunset on the moon. But the public of that once-upon-a-time Eisenhower world never stopped to ask why lavas once flowed on the moon, whether rivers ever flowed on Mars, what exists beneath the ice of Europa, whether methane snow flurries blow across the organic sludge of Titan, whether waves splash on Triton or whether a Manhattan-size fragment of asteroid rock will fall out of space into the Atlantic next Thursday. In that once-upon-a-time world of abundant energy and materials, shipped to the United States from small and large countries around the world, people paid little attention to the metal and rock and soot and ice floating throught the skies above us. In the next year, 1957, all this changed when the first artificial satellite was launched into orbit around Earth.

Today, astronauts train to fly among these worlds to explore their secret places, to bring back the samples that will tell us their histories. Meanwhile, scientists and engineers are thinking ahead about how to utilize the knowledge and materials to be gained from frontiers beyond Earth.

THE BEGINNING

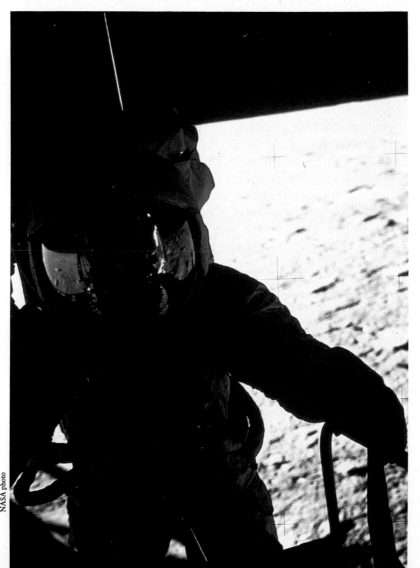

NASA photo

Prelude to exploration. An Apollo astronaut pauses in the spacecraft doorway before descending the ladder to the moon's surface.

In future years, as we spread across the solar system, three dates will live in history: October 4, 1957; April 12, 1961, and July 20, 1969.

On October 4, 1957, the first human-made object was hurled into orbit around Earth. It was Sputnik 1, a 184-pound sphere launched by rocket from the Soviet Union.

On April 12, 1961, the first human being circled Earth in an orbiting spacecraft. Only four years elapsed between the first space object and the first spaceman. The flier was a brave (considering the risks) Soviet cosmonaut, Yuri Gagarin, flying once around Earth in a five-ton capsule called Vostok 1. (Vostok is the Russian word for ''east.'') Gagarin was killed seven years later in a plane crash.

These first two dates mark the beginning not only of the space age, but also of a vigorous competition between the United States and the Soviet Union in space exploration—a competition between East and West. Sputnik 1 surprised the Americans, who had already announced their own plan for a satellite launching in connection with the International Geophysical Year of 1956–57. Suddenly the Americans had to revise their old image of Russians as shirt-sleeved tractor drivers who could build only dreary apartment buildings with cracking facades. Adding injury to insult, Americans failed embarrassingly in their own first at-

tempt to launch a satellite: two months after Sputnik, in front of a live, international television audience, a Vanguard rocket rose a few feet off its Florida launch pad, then fell back and exploded in an orange and black fireball. American schools began an agonized self-appraisal and upgraded their science curricula. Americans matched each of the Russian successes some months later, launching the Explorer 1 satellite four months after Sputnik 1 and sending Alan Shepard on a suborbital flight in a Mercury capsule about a month after Gagarin's single full orbit. John Glenn made the first American full orbital flight in a Mercury

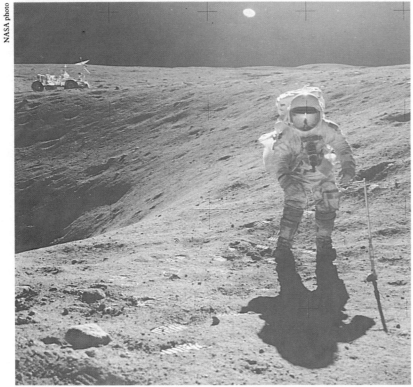

NASA photo

The lunar crater (left) reached by this astronaut has been "sandblasted" by eons of meteorite impacts, softening its once rugged rim.

capsule ten months after Gagarin. As part of this competition, President Kennedy proposed that the United States undertake a bold initiative that would challenge American creativity and technological expertise while surpassing the Russian space effort. He concluded that the challenge of a voyage to the moon would invigorate American science, engineering, education and morale. In a speech to Congress on May 25, 1961, about six weeks after Gagarin's pioneering flight and three weeks after Shepard's suborbital flight, Kennedy said:

> . . . the dramatic achievements in space which occurred in recent weeks should have made clear to us all, as did the Sputnik in 1957, the impact of this adventure on the minds of men everywhere. . . . I believe that this nation should commit itself to achieving the goal, before this decade is out, of landing a man on the Moon and returning him safely to Earth. No single space project in this period will be more exciting, or more impressive to mankind, or more important for the long-range exploration of space; and none will be so difficult or expensive to accomplish. . . . In a very real sense, it will not be one man going to the Moon . . . it will be an entire nation.

When a bitter, frustrated young man shot Mr. Kennedy in the back with a rifle from an office building in Dallas in 1963, the Apollo moon program became something of a memorial to the popular president. Young technical people who were products of post-Sputnik upgraded science programs in American schools worked during the following turbulent decade to achieve the third major event on our list: a date that will be remembered as long as humans retain historical records. On July 20, 1969, a spindly, spidery craft dubbed Eagle descended toward a flat lunar lava field named the Sea of Tranquillity. In a moment of high tension radioed live into the living rooms of Earth, two astronauts reported that their descent engines were kicking up dust. Then, after a pause, we heard: "Tranquillity base here, the Eagle has landed."

Humans had made their first landing on another world. About six and a half hours later, in front of a worldwide television audience watching signals beamed from a camera on the outside of the Eagle, the culmination of the trip occurred: Astronaut Neil Armstrong gracefully climbed down the ladder of the lander, stepped off the footpad onto the powdery lunar soil and said the first words spoken by a human standing on the moon: "One small step for a man, a giant leap forward for mankind."*

At the time, these three dates—1957, 1961 and 1969—were perceived by many people according to a world-view produced by ideological competition between competing quasi-socialist and quasi-capitalist economic systems of the East and West. Were the Russians ahead or the Americans? Scores were kept: Russia 1, American 0; Russia 2, America 3. In years to come, this provincial squabbling with an Earth-locked community will be forgotten. Do we commemorate Ferdinand and Isabella's campaign to throw the Moors out of Granada? These dates will be honored, if we survive, as milestones in an adventure so grand that the participants will somehow hardly notice it happening. It is an adventure of exploration, of probing into a vast and fertile unknown environment. It is the adventure of exploring space. It is the adventure of stepping out of the cradle.

Additional Milestones

Many mini-milestones are occurring along the way. The first human-made objects to reach the surfaces of the moon, Venus

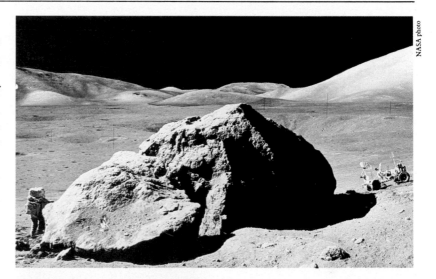

NASA photo

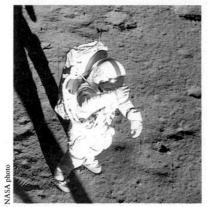

NASA photo

Above: Astronaut Harrison Schmidt, later elected to the U.S. Senate, pauses by a large boulder on the moon. Rock samples collected in this region included rare fragments dating to the moon's early history more than 4 billion years ago.

Left: a walk on the moon as photographed from the lunar landing module during the Apollo program.

and Mars came as early as 1959, 1960 and 1971, respectively. All three were Russian probes with minimal instrumentation that crash-landed and returned no useful information from the surfaces of these bodies.* But they did extend our presence into the

*At this moment, a wonderful humanness entered this technological triumph. Everyone had wondered what Armstrong's historic first words on the moon would be, and Armstrong had planned them in privacy. But when he spoke them, he apparently left out the "a" in the first phrase. (There was some question about this because of noise in the transmission.) Television commentators heralded the enthralling first words from the moon for some time before they began to notice that "one small step for man, a giant leap forward for mankind" made little sense. Armstrong reported that he thought he had said "a man," and we'll give him the benefit of the doubt.

*A good review is given by Nicholas Johnson in *Handbook of Soviet Lunar and Planetary Exploration* (San Diego: American Astronautical Society, 1979). For a more popular account of the Soviet program, see James Oberg's *Red Star in Orbit* (New York: Random House, 1981).

solar system. In 1960 the United States launched the first weather satellite and the first communications satellite, beginning the orbiting systems that today are taken for granted as they provide weather-prediction information and allow instant global communications. Such a system was conceived as long ago as the 1940s by space visionary and science-fiction writer Arthur C. Clarke. It allows intercontinental telephone, radio and television communications to be beamed up to a satellite, relayed around to the other side of the world by line of sight from one satellite to another and beamed back down to the intended receiver.

In 1963 the first woman flew into space. She was the Russian cosmonaut Valentina Tereshkova.

The Russians never acknowledged having a manned lunar program, but there is much evidence that they went partway up that road.★ Their series of Zond unmanned lunar probes, which returned photos from trips around the moon in the 1960s, were apparently unmanned versions of their 25-foot-long Soyuz spaceship first flown in a manned orbital flight in 1967. Reportedly the Zond 5 probe in September 1968 carried a taped human voice to test voice transmissions from the lunar vicinity. During the Zond 6 flight the next month, the Russians actually announced that Zond was capable of carrying humans. Both Zond 5 and 6 successfully returned to land on Earth. But during Christmas of 1968 three Americans flew successfully around the moon, and on live television described the lunar craters and the beautiful, blue Earth-marble. This seemed to take the wind out of the Russian Zond program. Zond 7 in 1969 and Zond 8 in 1970 merely circled the moon, took photos and other measurements, and returned their equipment to Earth. The Zond program then shut

down. But since the Soyuz spaceships have continued Earth-orbital operations into the 1980s, the Zond flights perhaps give a preview of how the inevitable Russian moon expedition may be organized.

Death is a part of life and a part of exploration. The first recorded deaths of astronauts occurred in 1967, when Apollo's Grissom, Chaffee and White died in a launch pad fire within their capsule during a test. Four months later in 1967, Russian cosmonaut Vladimir Komarov died when the parachute lines of the first Soyuz spacecraft tangled during a return to Earth from what had been a successful orbital flight. While the Soviets admitted only the parachute problem, there has been much speculation about a possible altitude control failure in Soyuz 1 that caused it to tumble before reentry.

The next fatalities illustrate the drama and heartbreak of early space flight. In 1971 the Soviet Union launched the first true space laboratory, the Salyut 1 Station, as a "salute" to the anniversary of Gagarin's pioneer flight. Four days later Soyuz 10 rocketed into space with three cosmonauts, presumably to man the spacelab. They made a mechanical linkup but did not enter the lab, returning unexpectedly to Earth after only two days. There was speculation about failure of the hatch and tunnel mechanisms between the two craft. At any rate, after some weeks, Soyuz 11 rocketed aloft with three cosmonauts (G. Dobrovolskiy, V. Volkov and V. Patsayev) who docked and made the first entry into the station a day later. This was a pioneering venture: the first occupation of a space station! Nightly telecasts from the jovial crew were shown on Moscow television, sometimes live.★ After twenty-three days on board

★Luna 2 carried only Russian insignia to a crash-landing on the moon in 1959; Venera 3 crashed into Venus' atmosphere in 1966 without sending back data; Venera 4 sent back atmospheric data during descent in 1967 but failed due to high air temperature and pressure before it struck the ground; Mars 2 crashed on Mars in November 1971; and Mars 3 landed in December of that year but failed within 2 minutes after sending back 20 seconds of featureless television imagery, indicating low light level. It arrived during one of the worst recorded Martian dust storms and may have blown over.

★It is strange to realize that because the drama of space exploration is being pursued in two less-than-friendly countries, citizens in the two lands do not get to share fully in the adventure. We see one-half of it on our TV sets, and the Russian people see the other half. No wonder it does not get the public attention it deserves! The problem is not unavailability of Russian films. A European journalist friend recently in 1984 recounted his many trips to Moscow, where he routinely picks up Russian films of activities in their space stations and other space footage.

Salyut, they closed up shop, returned to their Soyuz ship, withdrew from Salyut docking and on the next day fired their retrorockets for reentry. The reentry and deployment of the parachute system went smoothly, and the capsule landed gently within view of the recovery team. Team members excitedly opened the hatch of the capsule. To their horror, they found the three cosmonauts peacefully strapped in their couches, dead.

According to briefings given to U.S. technicians during the Apollo-Soyuz joint program, this is what happened: the separation of the reentry command module from the orbital vehicle, triggered by explosives, accidentally opened a valve that was supposed to open only in the lower atmosphere to vent the command module and equalize its pressure with the fresh air outside. With the valve open before reentry, air from the command module vented directly into space, reportedly in about a minute. The cosmonauts apparently realized what was happening, but due to poor design the manual closing mechanism was hard to reach and took about two minutes to close. Thus the cosmonauts, unequipped with spacesuits, died from decompression of their cabin and gained the dubious distinction of being the first explorers actually to die in space.

Salyut 1, the first spacelab, was abandoned and fell back into the atmosphere a few months later.* More than a year of redesign followed before new Russian cosmonaut flights were attempted, this time with spacesuits and air-pumping equipment

*The first unmanned satellites, manned spaceships and space stations circled Earth at altitudes just above the atmosphere, about 200 to 300 km (125 to 190 mi). Low altitudes were chosen because the lower the altitude, the larger the payload that can be boosted into orbit with a given rocket launch vehicle. Since they move through the outermost fringes of thin gas extending outward from Earth's atmosphere, these vehicles experience a very slight drag, which eventually causes them to spiral downward into the thicker parts of the atmosphere, where they heat up by friction with the air (like a glowing meteor) and eventually disintegrate in a shower of flaming fragments. Some of the fragments may reach the ground. This was the fate not only of Salyut, but also of other space vehicles, including America's first space station, Skylab. Other ships put into higher orbits, where no drag forces occur, will remain in space almost indefinitely, like planets moving around the sun.

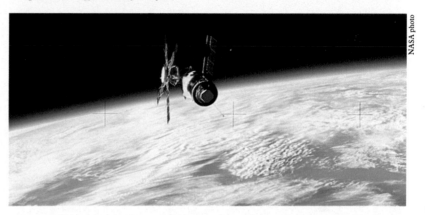

Skylab was America's first space station. Solar panels, facing left, powered the station. Three crews of astronauts occupied it on different shifts before atmospheric drag made it spiral into the atmosphere and disintegrate. This photo was taken during a crew approach in 1973.

NASA photo

that took up the area originally occupied by the third couch. Soyuz was converted into a two-person ship for the next decade.

Apollo-Soyuz: Cooperative Space Exploration

The last Apollo spacecraft was now assigned to a mission very different from a lunar flight. This mission received only modest public attention at the time, but it stands as a major milestone from our point of view. Apollo and a Russian Soyuz vehicle linked together in a joint American-Russian orbital mission in 1975. Three Americans and two Russians met in orbit to shake hands and conduct joint experiments, such as astronomical studies that included discovery of an unusually high-temperature star of interest to astrophysicists. The important feature of the Apollo-Soyuz mission was not the scientific but the human result. It proved that creative technical people in both countries, if given the go-ahead by their political leaders, could establish warm working relationships and succeed in cooperative space missions. The successes involved an initial political agreement between Presidents Nixon and Kosygin in 1972, design of a mating tunnel to link the two dissimilar vehicles, coordination of two launches in two separate countries (about seven and an half

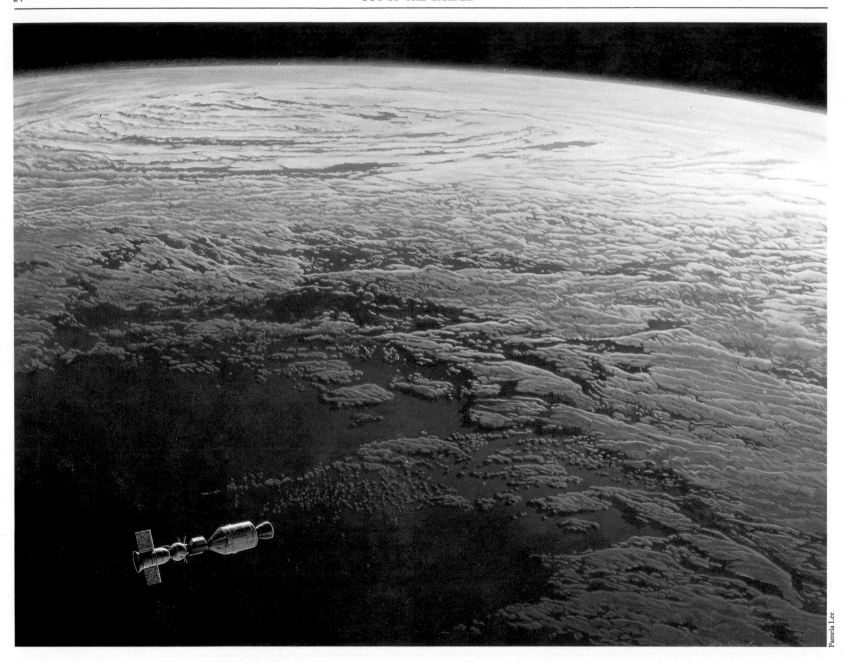

hours apart), training of astronauts in each other's languages, and travel of astronauts and technical teams between the two countries.

At the time, some writers dismissed the Apollo-Soyuz mission as an inconsequential public relations stunt, not really indicative of an underlying change in Soviet-American relations or a substantial decline in world tension. But how could it be? The best we can do is bend twigs; it is unlikely that we can establish a full-flowering tree of international peace and commerce in one planting. Apollo-Soyuz was a twig bent in the right direction and flowering in a brief moment of beauty. In retrospect, in a 1984 year-opening review of four decades, *Time* magazine called it "the high point of deténte." More bent twigs—more international teams whose governments give them goals that require hard work, cooperation and camaraderie— might set precedents to help the world move in the right direction. But unfortunately, for the moment at least, winds blowing from ideologues on both sides of the world have created a climate that will not nurture such efforts.

Expanding Frontiers

As humans pushed out into near-Earth space, unmanned robot probes pushed the planetary frontiers ever outward. In 1970 the Soviet Union parachuted the Venera 7 probe safely onto the surface of Venus, from which it radioed back the first surface measurements. In 1971 the United States' Mariner 9 made the first detailed maps of Mars from orbit, discovering canyons, volcanoes, eroded craters, dunes and dry riverbeds. In 1975 Russian probes Venera 9 and 10 sent back the first photos of the surface of Venus, showing gravel, broken rocks and a bright sky. In 1976 the United States' Viking 1 and 2 landed on Mars, sending back photos of boulders and dunes, and radioing data about the atmosphere and soil. To the dismay of many scientists

The Apollo-Soyuz project linked the last Apollo command module with a Russion Soyuz, proving that technicians from opposing countries could collaborate on space missions. Here, the linked ships are shown drifting in tranquil union at dawn, where the low sun turns the cloud cover to shades of gold and rose.

and romantics, the Vikings found no sign of life on Mars. The soil turned out to be rocks and sterile dust. In 1979 Voyagers 1 and 2 flew by Jupiter and its moons, discovering a ring and three small moons near Jupiter, active volcanoes on Io, cracked ice plains on Europa, grooves and craters on icy Ganymede and cratered, dusty ice on Callisto. By 1980 and 1981 the same two Voyagers had reached Saturn and its moons, discovering intricate structure in Saturn's rings, a host of new moonlets, grooved plains on Enceladus, a biscuit shape for Hyperion, cratered ice fields on other moons and new properties of Titan's atmosphere.

Space Stations

As robot exploration proceeded across the solar system's frontiers, space technicians back on Earth were evolving the next phase of manned space exploration: the space station. During the 1970s, the Soviets launched several of their 20-ton, 36-foot-long Salyut stations, beginning in 1971 with the ill-fated Salyut 1. In 1973 the 70-ton, 83-foot-long Skylab became the first American space station, occupied by astronauts in three successive three-man shifts, the longest of which ran 84 days in 1973–74. Salyut 6, launched in 1977, had docking ports at each end to accommodate two Soyuz resupply ships. Russian-trained cosmonauts from Poland, Czechoslovakia, Vietnam, Cuba, France and other countries have assisted during occupation of the Salyut stations. The Cuban cosmonaut Arnaldo Tamayo-Mendez was the first black man in space. In 1979 two Russian cosmonauts set an endurance record of 175 days in orbit, only to be superseded in 1982 by two other cosmonauts who spent 211 days in the orbiting Salyut 7 before returning. These flights were equivalent in duration and miles traveled to a one-way trip to Venus or Mars. In 1981 the Soviet Union demonstrated the first modular space station by docking a 15-ton Cosmos satellite with a 21-ton Salyut station, and Soviet President Brezhnev commented: "We are now ready to take the next step . . . creation of permanent orbital complexes with changeable crews." There have been many reports that the Russians are designing a space station in the 100

ton class, as well as larger rocket boosters. They have also launched unmanned mockups of shuttle-type vehicles. Subsequently, in his 1984 State of the Union address, President Reagan called for an American manned station.

A different step toward space capability was completed by the United States in 1981 with the first orbital flight of the space shuttle. Here was a new leap in manned space flight: a space ''truck'' that carries commercial payloads into orbit on an economically competitive basis. Corporations, federal agencies, third-world governments and others can arrange launch of their own satellites for communication, weather prediction, remote mapping of mineral deposits, pollution monitoring or tests of weightless manufacturing techniques. As early as the fifth shuttle flight, the space shuttle Columbia, manned by four astronauts, launched two commercial communications satellites. On the seventh flight, in 1983, America's first woman astronaut, Sally Ride, helped launch an Indonesian communications satellite and a German scientific experiment package. These are not empty public relations gestures. In many third-world countries, communications satellites have allowed the first meaningful routine communication between central governmental service agencies and outlying villages. Each international launch forges one more tiny link of commercial and technical relationship between people in different countries. Each link is one more reason not to risk losing the fruits of cooperation by using military action to gain some objective.

We are well on our way to conquering space. If any reader thinks we are too naïvely enthusiastic about our rate of progress, let me repeat a point mentioned by Gerard O'Neill in his well-received book on space colonies: ''Even Tsiolkovsky, once dismissed as a wild-eyed space visionary, was too conservative in predicting the growth of our capability in space; he mentioned 2017 as the date of the first orbital flight!''* Yet in 1984 eleven people flew in space at once: five Americans in a shuttle; five Russians and an Indian in a Salyut.

*Gerard K. O'Neill, *The High Frontier* (New York: Bantam Books, 1978).

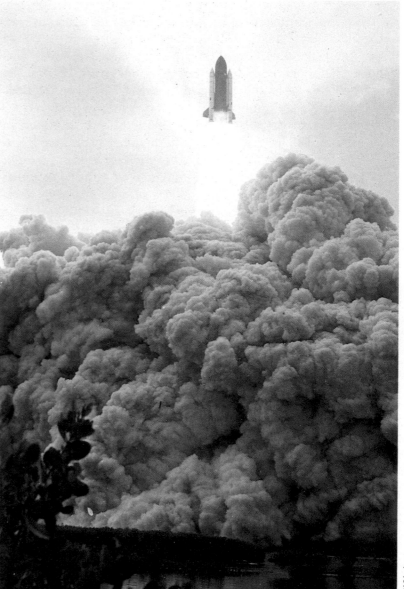

The space shuttle roars aloft.

NASA photo

ALTERNATIVES: A FUTURE WITHOUT SPACE?

The dream of a permanently manned space station is moving toward reality. Will there be a historic date when the last weld is made, the last hatch closed, the power system turned on, hallways flooded with air, and space helmets finally removed as people take up permanent *residence* in space? Or will we just grow into it, adding one module after another to a Salyut descendant, or a Skylab descendant, until one day we realize we have begun permanent residence above Earth? In either case, such habitation seems inevitable.

Or is it? Something *can* stop us. *We* can stop us. Earth's society is poised on a narrow bridge to the future. At the end of the bridge is the possibility of a vigorous interplanetary economy based on space resources and space manufacturing. But the bridge could collapse.

Space and the Crystal Ball

What if we lose the chance to venture into our cosmic environment? Is space exploration important? Is the conquest of the solar system nothing more than mere adventure?

Even if it were "mere adventure," we would argue that space exploration is vitally important. The engineering challenge alone spurs development of new goods and processes. But beyond that, the existence of a frontier gives us psychological as well as physical space. The adventure of exploration is intellectual as well as physical. In the laboratory we have seen what happens to rat communities that breed in closed, frontierless communities: expansion of the population beyond the carrying capacity of the environment, internal struggle, neurotic behavior

and eventual decline of the community. In the world we have seen signs of similar behavior in the human population trapped since 1900 without meaningful frontiers.

So there is an argument that even if space exploration produces no further material or economic results, its cost of 1 or 2 percent of the national budget is a small price to pay for the shared exhilaration of watching our brothers and sisters venture outward to see what's there.

But there is more to the argument than the metaphysical question of the value of exploration. Let us put the question this way: what can we predict about the future course of civilization if

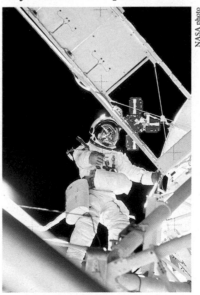

NASA photo

Skylab astronaut working outside the space station in 1973 gave an early demonstration of our capability to work in space.

we do *not* venture boldly into space within the next century? Interestingly enough, many writers have already dealt with this issue, although they phrased it differently. They asked about the future economic trends of global society. They simply assumed, without even stating it, that Earth's society will be closed and finite, restricted to our blue globe.

As a result, when viewed from our perspective, futurist economic literature has a peculiar, closed-minded quality. It divides into two camps, each emphasizing its own selection of facts and each with its own interpretations. Since the writers in each camp tend to be limited by an Earthbound framework, and since many of them come from backgrounds of economic or political theory (not direct scientific observation), the two camps tend to divide along preexisting political lines. It would be handy to have a label for each camp, although fixed labels tend to polarize discussions and prevent us from seeing the intermingling, many-sided points of view. Nonetheless, for simplicity and neutrality, let's call them the technological skeptics and the technological idealists; one sounds just as good, or bad, as the other.

Predictions of the Future

What do these authors actually predict for the future of civilization on Earth in the next century? One of the most important predictions began to take shape when a group of international educators and industrialists met in Rome in 1968 to consider the future of the economy on a planetary scale. They formed a group of about a hundred business and economic leaders that came to be called the Club of Rome, and in the early 1970s, together with M.I.T. technologists, they developed an elaborate computer program to model the world economy.

This was a striking concept. According to the Russian-American Nobel Prize-winner in economics, Wassily Leontief, the very term "world economy" first appeared only in this century, in Germany on the eve of World War I. No one before that time had thought much about the economic system of our planet as a whole. But for decades afterwards, serious theorizing about the world economy was impractical for two reasons. First, its very complexity prevented development of numerical models before the computer age. Each important commodity affects the production and prices of other commodities. The price of oil affects an industrialist's evaluation of whether to build a new coal-fired power plant or invest in development of solar power technology. A global economy involves hundreds of feedback loops of this sort. A second reason for delay in developing world economic models comes from lack of global information. Even today, most economic theories deal only with the economies of individual countries. If we had a *global* computer model ready to run, we would need input data on the price and amount of oil being produced in each country, the rate of wheat production around the world, the amount of iron being mined, and so on. Without good input data, the models could produce no worthwhile output.

By the 1970s both the computer models and a certain amount of basic world data were at hand, much of the latter gathered by United Nations agencies. Thus the Club of Rome was able to push ahead with its model, "Project on the Predicament of Mankind," and in 1972 published a best-selling report called *The Limits of Growth*. The title hints at its final conclusion: Earth civilization is growing so fast that it will use up its raw materials and food-producing capacity in a matter of decades.

As long ago as 1798, the famous English economist and curate Thomas Malthus popularized similar ideas. Noting that population was growing exponentially, that is, doubling every so many years, he concluded that the technological means of food production and other industries supporting basic subsistence could not keep expanding at such a rate. Therefore, he predicted, the population would eventually level off. Nature seems to program us to breed as indiscriminately as possible, and takes care of the result by disaster, such as famine or warfare. Nature likes a surplus of people to deal with horrid contingencies. Having evolved minds, we have an alternative to disaster: we can

use methods of birth control and level the population by peaceful means.

In Malthus' days, as today, warfare over dwindling farmland and resources seemed plausible, and Malthus himself was not optimistic about humanity's long-term prospects. Malthus was the grandfather of the technological skeptics.

Malthus was right in many ways, although the much discussed "Malthusian disaster"—full-fledged global famine induced by a massive population crunch—has not happened, yet. Modern studies indicate that the time required to double world population in the days of Malthus (about 0.9 billion) was about 200 years; by 1970, however, the population had climbed to about 4 billion and the doubling time was down to about 30 years! So, while Malthus was right about exponential doubling of population, he was too conservative: not only is the population growing, but the rate of growth is speeding up!

Neither natural nor economic *closed* systems can keep doubling in this way. Either some new input of support must come from outside (new energy, food sources, goods) or steps must be taken to bring a gradual leveling off; if not, the system may "collapse" in a sudden decline in population or industrial output.

This result appears in several examples of the output for the Club's computerized world model (see page 30). Here are four possible predictions of world history for the next century. The graphs show how conditions have evolved in this century and how they are expected to evolve under various assumptions. The vertical scale on the graph indicates the quantity of each item,

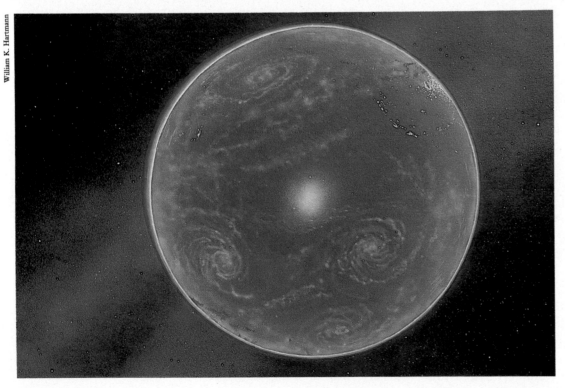

William K. Hartmann

The midnight side of Earth. Space exploration has brought us a keener appreciation of the finiteness of our globe. In this view the sun is behind Earth, backlighting the atmosphere with a sunset-orange glow. We are over Hawaii, with the full moon behind us reflecting the central Pacific. Other light sources include city lights of America, Japan and Honolulu, aurorae near the poles and lightning flashes in storm systems.

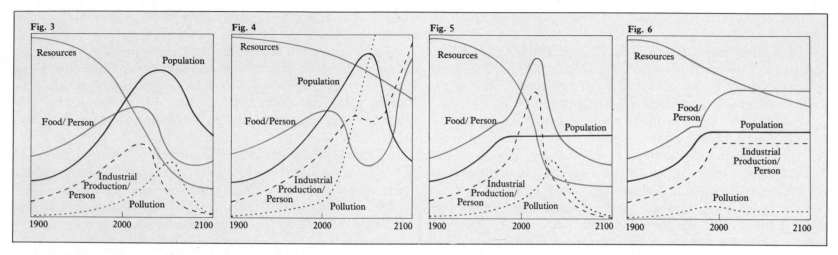

but only schematically. The computer model is probably good enough to predict general trends, not exact quantities. Figure 3 was called a ''standard'' world model because it assumes no major changes in world politics, economics or technology. It is a prediction based on ''business as usual.'' The blue curve shows the rapid decline in resources as they are used to produce energy and consumer goods. The green and black dashed curves show that food per person and industrial production per person keep increasing into the next century, so people's standard of living is predicted to keep increasing. But these people are living in a fool's paradise. The population keeps growing so fast that sometime in the middle of the next century the population outstrips food and production. Food per person begins to decline, famine sets in, the population falls off dramatically and civilization collapses. Industrial production per person declines toward a preindustrial level.

Note a subtle point little stressed by the Club and other futurist writers: if we allow such a collapse to occur, it will *not* be an ordinary ''dark ages'' from which our descendants can once again easily rise by reorganizing government and reacquiring technology. The reason is that the resources will be nearly gone. Our descendants won't be able to start a new industrial age with

easily accessible coal, oil, iron and aluminum, as our ancestors did after the Renaissance. The coal, oil, iron and aluminum won't be there. *We* will have used them up.

The other three graphs show searches for a way out of the problem. Figure 4 investigates what happens if we assume the availability of abundant additional resources.* These include new resources brought into Earth's economy and recovered by intensive recycling. The model predicts that these new materials will simply fuel faster industrial growth, since it will be cheap to build new factories and manufacture more goods. As a result, population, food and goods again rise rapidly in a fool's paradise until *pollution* gets out of hand due to the massive amounts of industrialization. As before, these trends lead only to a disastrous collapse in the middle of the next century.

Because many people who are sensitive to these issues assume that population is the ultimate problem, the Club theorists tried to see what would happen if population growth could be magically stopped within a few years by, for example, educa-

*The actual assumption was that nuclear or other power sources create unlimited cheap power, which in turn enables industry to exploit previously unprofitable deposits of mineral resources.

tion leading to voluntary global birth control. The results are seen in figure 5. Strikingly, this did *not* solve the problem! The model predicts that as population levels off, industry will continue to expand so that more and more food and goods can be produced per person. Thus, even more than before, personal wealth rises. For a few decades, we would congratulate ourselves on our wisdom and prosperity. But the continued growth of industrialization in an attempt to increase personal wealth depletes resources. Once again, in the early to mid-twenty-first century, a collapse occurs due to resource exhaustion.

Figure 6 shows the Club of Rome's ultimate solution: an "equilibrium" world model in which zero population growth combines with political and economic policies to limit industrial growth (generally restricting new capital investment to replacing old, worn-out facilities). The Club also recommends pollution controls, recycling, and soil restoration programs. In this type of model, the equilibrium world population reaches a value only somewhat higher than it is today. The production of food, goods and services per person reaches two or three times the present world average and then levels off. The average income per person, averaged over the world, is predicted to approach half the U.S. average. This is comparable to the European average and about three times the present global average. If such an income gain could be widely distributed, dramatic increases in the standard of living could occur in third-world countries, although the standard of living (or at least consumption rates of food and materials) in the United States would decline somewhat. Some would argue that a modest decline of this sort in the United States has already begun. If this seems disturbing, remember that it is still better for American citizens than a catastrophic collapse of our planetary civilization in, say, A.D. 2035!

Many of the Club's conclusions have been supported by more recent studies, among these a 1980 model of the world economy by Nobel Prize-winning economist Wassily Leontief, mentioned earlier (published in *Scientific American*), and a 1984

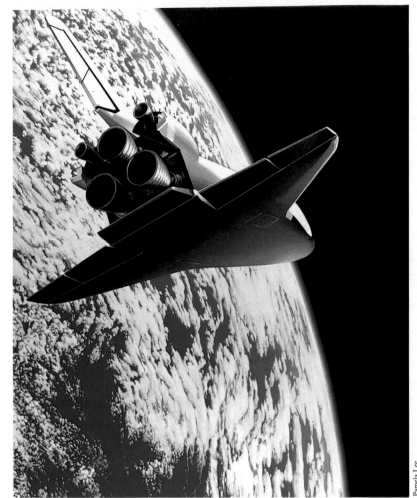

The space shuttle has become our major tool in manned space exploration. Its flights have already demonstrated techniques for space manufacturing and satellite launching and repair.

Pamela Lee

study of world resources by Oak Ridge Laboratory technologists H. E. Goeller and A. Zucker (published in *Science*). In Leontief's "business as usual" model, average personal income rises around the world until at least the year 2000, as in the Club

model, but citizens of rich countries gain faster than citizens of poor countries. The rich get lots richer and the poor get only slightly richer. Such a growing gulf promotes instability, encouraging, for example, political agitators to enlist terrorists to sabotage the rich countries in the name of demands for equality for poor countries.

Leontief's solution is to reduce the growth rate of military spending (already $450 billion per year for the world in the early 1980s) and divert the savings to help economies in third-world countries. In a model where the military growth rate is cut to two-thirds that of the "business as usual" model, the personal income in poor countries grows faster than in rich countries. World prosperity and stability then increase at the same time.

All three studies—Club, Leontief and Goeller-Zucker—emphasize that policy changes must be started *before* 2000 in order to deal with seeds of disaster that will otherwise bloom *after* 2000. The Club's models showed that if the new policies were delayed until 2000, it would be too late. A model introducing these same policies in 2000 led to collapse before 2100! Similarly, Goeller and Zucker find exhaustion of presently recoverable metals and other resources before 2100 and recommend immediate research and development to learn how to mine lower-grade ores and how to substitute other materials.

The most significant impact of such research on government policy came when President Carter appointed a panel of experts to review the matter. This was a historic step because it meant that the most powerful government on Earth was now prepared to look at Earth's future on a planetary scale—and perhaps take appropriate action. The panel's *Global 2000* report, issued shortly before the election in 1980, reaffirmed many of the conclusions we've discussed:

> If present trends continue, the world in 2000 will be more crowded, more polluted, less stable ecologically, and more vulnerable to disruption.... The gap between the richest and the poorest countries will have increased.... There will be fewer resources.... By 2000, nearly half the world's total original petroleum will have been consumed.... Forty percent of the forests still remaining in the less developed countries in 1978 will have been razed.... Prices will be higher....

The *Global 2000* report was the high-water mark of technological skeptics' influence on U.S. policy. As summarized in the prestigious journal *Science*, it "sank out of sight with Carter." But if it sank out of sight, it also left ripples spreading across the pond.

Policy makers in the Reagan administration dealt with these ripples in their own way. Now it was the technological idealists' turn to explain what was wrong with the technological skeptics' views. In *The Resourceful Earth: A Response to Global 2000*, prepared by well-known economists Julian Simon and Herman Kahn, various experts began with the data used in *Global 2000* and either questioned it or drew opposite conclusions. Simon and Kahn, known as extreme technological idealists, deliberately contradicted the *Global 2000* conclusions: "If present trends continue," they said, "the world in 2000 will be less crowded, less polluted, more stable ecologically, and less vulnerable to resource-supply disruption. . . ."

What sense can we make of such profound disagreement among supposed experts? At the very least, it seems to confirm a whimsical paraphrase of Newton's third law: "For every Ph.D., there is an equal and opposite Ph.D."

More seriously, Simon, Kahn and other technological idealists are concerned about every computer modeler's ultimate problem: garbage in, garbage out. That is, if data going into the model are wrong, or if the underlying theoretical model is inaccurate, then the answers spewed out of the computer are worthless. *Science* quotes Kahn: "We are hostile to big models.... Any attempt to have a global model to integrate everything becomes uncontrollable...."

Thus the technological idealists fundamentally distrust the approach of trying to make global economic models or forecasts. They regard common sense and experience as valuable restraints

against being carried away by computer models. Indeed, they deliberately raise their own ideological theory of the world as a response to the detailed data gathering and modeling of the technological skeptics. For example, a 1983 paper drafted for an advisory group of the Cabinet Council on Natural Resources and Environment says:

> . . . if the economies and societies of much of the world remain reasonably free, if technological advance is permitted to continue, and if prices are permitted to bring changes in supply and demand into equilibrium, the world in 2000 will, in general, be a better place for most people than it is today. . . . There will very likely be greater material output for each person. . . .

On the basis of this view, the Reagan administration drastically cut back the work of the Council on Environmental Quality, which was the agency that co-sponsored (with the State Department) the *Global 2000* report. Compared to its peak funding of $3.2 billion a few years earlier, the Council received a budget recommendation of only $.9 billion from the Reagan administration and only $.7 billion voted by Congress in 1983. They essentially gave up trying to take a long-term, coordinated view of the future history of planetary economy.

Which Prediction Is Right?

Let us draw back from the immediate political and philosophic conflicts between technological skeptics and idealists. What can we judge about the future of Earth's economy? Are we headed for trouble? Will space exploration make any difference?

To assess the two sides of the argument, we need to recognize that many of the reports in this field are not scientific in nature. An examination of government or special-interest groups, whether skeptic or idealist, environmentalist or industrialist, is likely to reveal authors trained in traditions of the legal system. Here issues are debated according not to the scientific system, but to the *advocacy system*, in which each side adopts (or

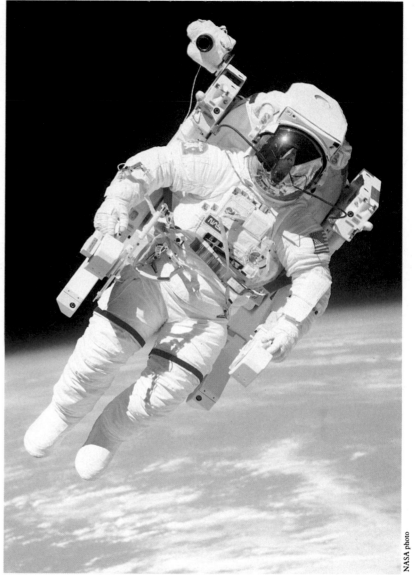

NASA photo

Floating over Earth in the manned maneuvering unit, an astronaut in 1984 symbolizes our rapid adaptation to working in the space environment.

is assigned) a conclusion, then gathers all the evidence it can find to support that conclusion and negate the opposing view. These authors work *for* one side or the other, not as independent truth seekers. This procedure has the advantage of subjecting each argument to strong, even vicious critiques from the opposing side, but it can also lead to suppression of facts: if you find something that agrees with the other side's point of view, you are likely to do your best to keep it from coming to light. In contrast, the scientific tradition is that all the participants strive to get all the evidence they can find, put it out on the table, and then find a point of view (a theory) that fits all the known facts.

In the advocacy game, you get points only for "winning." In the scientific game, you get points for finding new evidence and for concocting theories that work. Economic theories tend to degenerate into advocacy models.

A second point to keep in mind is that if we don't believe the models or predictions of either side in an argument, we must at least understand *why* we don't believe them.

The technological skeptics clearly seem to be on the right track as far as data gathering is concerned. From real measurements made by national and international agencies, they are making a valiant effort to detect trends in the evolution of our society. While we might quibble over the details of some of their data, we can't avoid concluding that they have identified disturbing trends. For instance, it seems that we have burned or dug our way through significant fractions of many of Earth's nonrenewable resources: oil, coal and metals. The Club of Rome, for example, assumes a world supply equaling *five times* the known reserves of different resources; they use the known exponential growth rates for consumption of these resources and thus calculate the number of years required to use remaining reserves under "business as usual." The answers come out ridiculously small in many cases: we would use up five times the known reserves of aluminum in only 55 years, coal in 150 years, natural gas in 49 years, petroleum in 50 years, iron in 173 years, gold in 29 years, and so on. These results are essentially confirmed by Goeller and Zucker's 1984 analysis, which shows known reserves of gold, silver, tungsten, nickel, aluminum, titanium and certain other elements to be *entirely* exhausted *before* 2100. Of course, one answer to this is that the exponential growth rates of the past will start to tail off and we won't use so much so fast. Already, power company analysts have had to scale back their predictions of American power use and international analysts are starting to scale back their projections of material consumption in coming decades. But do we want to go on lowering expectations indefinitely, especially when half the world has yet to raise its standard of living to a small fraction of ours?

Another factor to consider is that the new deposits assumed in the above figures will be less accessible and more expensive than the presently known deposits, so real energy costs of materials will tend to go up. The Goeller-Zucker recommendation is to begin now learning how to refine low-grade ores, so that supplies of materials can be maintained in the next century.

A weakness of the technological skeptics is that they may be too caught up in their own computer models. If you spend a good part of a career building a computer model of a complex system, it's hard to step outside the model and see how the world might turn out differently from the model-fed computer predictions. The technological idealists have a certain historical force in their argument that inventors, impelled by the necessity and the scent of a market, are likely to find solutions that mere trend identifiers do not forsee. To take a famous example, Americans invented a substitute for rubber when World War II shut off supplies of the natural material. Just because we accurately detect a downhill trend does not mean that disaster will occur.

The technological idealists' weakest position is that they violate our second principle: they don't really explain why they

High rendezvous. Joint international flights around the moon would offer dramatic opportunities for cooperation, exploration and mutual safety. Russians demonstrated the capability to send Soyuz-type vehicles (lower right) around the moon in the 1960s Zond program. A post-shuttle American deep-space manned craft is shown at upper right. Earth appears four times as big as the moon in our sky. Angular width of telephoto view: 18°.

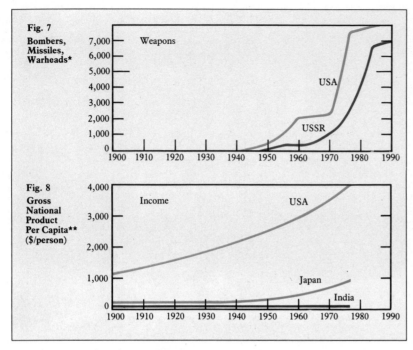

Fig. 7
Bombers,
Missiles,
Warheads*

Fig. 8
Gross
National
Product
Per Capita**
($/person)

Current trends in increasing armaments, and an increasing spread between incomes in the developed and developing countries, suggest growing instabilities in Earth's planetary politics during our generation.

don't believe the computer models. They avoid data analysis and shy away from facing the problems on the always weak grounds of preconceived ideology. Promising a rosy future on the basis of a rosy past does not solve a problem.

It is especially frightening that some technological idealists are satisfied to predict that life in 2000 will not be so bad. As noted above, virtually all studies forecast a ''fool's paradise'' scenario around 2000, with the crash coming a few decades later. Without a good answer to these predictions, it is unconvincing to proclaim salvation on the grounds that things are still fine in the year 2000!

Similarly, in the face of evidence for long-term environmental damage, the technological idealists have an inadequate an-

swer. If we know that CO_2 is increasing in our atmosphere due to burning fossil fuels, and we suspect that this will eventually cause climate changes of unknown consequence, it is simply inadequate to claim that when the CO_2 gets bad enough someone will invent a solution to the problem. That is mere ideology. The CO_2 already in the atmosphere does not easily go away.

To summarize our conclusions from the studies published so far, there is persuasive evidence that Earth's global economy will undergo radical changes within a few decades. Without getting into detailed predictions of dates and quantities, we are forced to the conclusion that we cannot go on expanding population and industry *within Earth's ecosphere* at present rates for more than a few decades.

A Proposed Solution

Herein lies the key to a plausible solution to all the problems we have been discussing. Different from the Club of Rome's (and many environmentalists') solution of creating a steady-state, Earthbound society to eke out a living by stretching Earth's finite resources for a few more centuries, ours allows growth and at the same time achieves pressing environmental goals. Our answer is to stop population and industry from growing on Earth, but to allow them to *grow in space*.

As we will see in subsequent chapters new discoveries about space make this look increasingly attractive as a contribution toward solving some of the problems discussed above. One important discovery is that small asteroids passing near Earth probably contain metals and other accessible mineral resources. Resources on other planets are likely to be less important than asteroid resources for two reasons: they are probably less varied than on Earth or on asteroids, and the higher gravity of planets makes it harder to return materials from them than from asteroids. Abundant, continuous solar energy is also available in

*Adapted from R. Forsberg, *Scientific American*, November 1982.

**Adapted from *The Limits to Growth*, Signet Books, 1972, from data of S. Kuznets.

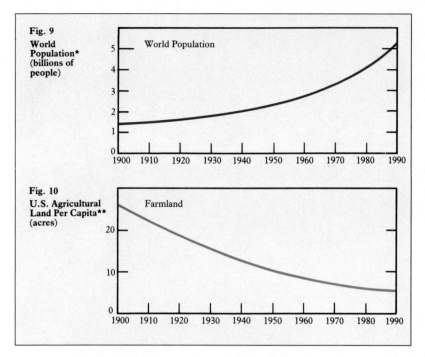

Fig. 9
World Population* (billions of people)

Fig. 10
U.S. Agricultural Land Per Capita** (acres)

As world population continues to climb (top), and as urban sprawl uses up farmland, the amount of productive agricultural land per person declines. Earth's "carrying capacity" and individual life quality are thereby threatened.

the technological skeptics, that could solve the problem discovered by them. Nonetheless, further research on the world economy by the technological skeptics is crucial in developing the solution. Indeed, it is the very existence of the skeptics and their predictions that will encourage the work that solves the problems and makes the skeptics wrong. Without the skeptics, the researchers, the question askers, the hair-tearer-outers and the little old ladies in tennis shoes, the idealists might pursue their business as usual and the then silenced doomsday message might turn out to be right.

The Three Dangers

Three deadly dangers head the list of perils that we must get through in the next few decades if we are to pursue space exploration and build a sustainable civilization.

1) *Nuclear war.* The greatest threat to civilization today is global nuclear warfare. Figure 7 shows the extraordinary rise in total numbers of weapons of mass destruction in our lifetimes and the increasing concentration of wealth in developed countries. To add detail to the second point, consider that individuals in the United States have *ten* to a *hundred* times as much money to spend on comforts than the poorer two-thirds of the world.

There are those who would respond: "Let third-worlders organize their governments as efficiently as we have, work as hard as we have, and they can raise their own living standards." Serious arguments are possible about the fairness of this attitude, since we live in a resource-rich area and many of them live in resource-poor areas. But put aside the issue of fairness. Gross, growing differences in wealth are likely to cause world instability—attacks from poor masses upon the wealthy few. So it is in our own interest—it is in everybody's interest—if we wealthier, technically advanced communities find ways to help the rest improve their position.

space. Gathering and processing materials in space, rather than digging them out of Earth and dumping the polluting processing by-products into Earth's atmosphere, would begin to relieve environmental pressures of expanding industrialization. We cannot claim that it is the ultimate solution, but further exploration is clearly warranted to see if it is a step in the right direction.

The rest of this book will try to develop the idea that coming space exploration will have twofold consequences: it will be an exciting adventure to new places, and it may also allow a dramatic revitalizing of Earth and its economy. There is irony in this conclusion. We have essentially come down on the side of the technological idealists, even while rejecting their reasoning. We are saying that there *can* be a breakthrough, unforeseen by

* After H. Mahler, *Scientific American*, September 1980, and other sources.
**Adapted from data of the Environmental Defense Fund, June 1982.

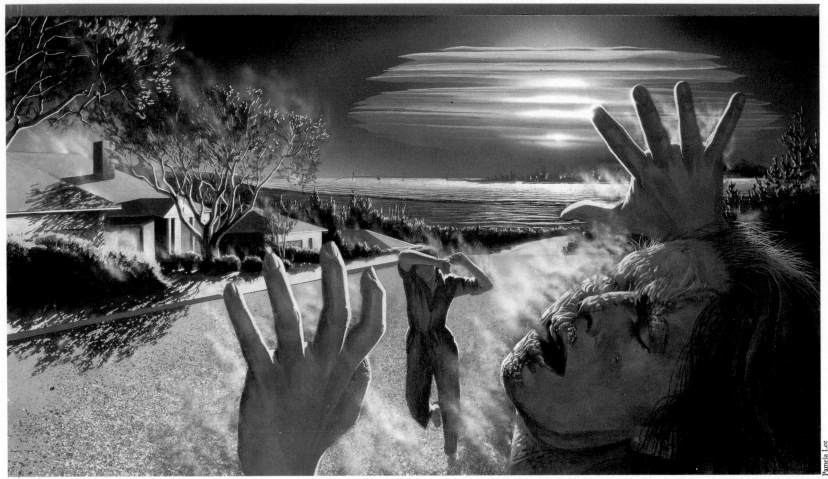

Pamela Lee

The deadly threat of nuclear war is the major threat to our planetary culture. Seconds after a nuclear attack on San Francisco, as viewed from the Berkeley hills, radiation damage has already occurred (shown here based on Hiroshima medical photos) and the blast wave is spreading across San Francisco Bay.

The large fractions of our budgets that we put into weapons are a major factor in preventing us from doing much about the growing income gap. While it is not yet literally true that we could "blow up the world," tabulations of the total Soviet nuclear arsenal suggest that direct physical blast damage effects from their weapons (destruction of buildings, etc.) could cover nearly 18 percent of the area of the United States and fallout damage (radiation death or sickness) could cover nearly half the

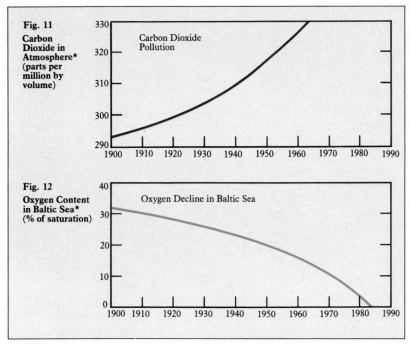

Fig. 11
Carbon Dioxide in Atmosphere* (parts per million by volume)

Carbon Dioxide Pollution

Fig. 12
Oxygen Content in Baltic Sea* (% of saturation)

Oxygen Decline in Baltic Sea

Two examples of subtle modification of Earth's environment by human technology operating within the atmosphere. Carbon dioxide released by fossil fuel burning may cause climate changes; *dumping of wastes into Earth's waters has caused effects such as decline of oxygen content, endangering fish and other marine life.*

death. ***Aside from immediate effects of blast and fallout, scientists reflecting on the climatic consequences of dust thrown into the atmosphere by giant asteroid impacts (as wiped out dinosaurs and other life forms 65 million years ago) have realized that dust and smoke thrown into the atmosphere from blasts in a nuclear war would block sunlight and cause a long period of widespread freezing called "nuclear winter."

We have hired thousands of people with high visibility, the latest equipment, a large fraction of our national budget and enormous political clout to *protect* us from these problems. But where are the equivalent people with high visibility, high technology, lots of dollars and political clout who should be trying to *solve* these problems? Our planetary civilization doesn't need generals and admirals as much as it needs problem analyzers and problem solvers. The astounding fact that the Americans and Russians can't seem to sit down and figure out a way to divert money from warheads into consumer goods for international commerce defies rational analysis. Perhaps as popular pressure builds, political leaders will be forced in such a happy direction.

2) *Malthusian disaster.* If we can avoid nuclear warfare, there will be two other dangers to face before we can establish an interplanetary economy. One of these is the "Malthusian disaster": world collapse due to the population explosion. Figure 9 shows the recent rise in world population, which gives no signs of leveling off even though developed countries have approached zero population growth. As Malthus pointed out, the trouble with such population expansion is providing adequate food. In the developed countries, there has been a trend of movement from the countryside to the cities. Resulting urban sprawl has eaten away much of the best farmland because cities often spread out along fertile land in river flood plains. The result is shown in figure 10: a decline in U.S. farmland. Of course, this trend has been encouraged, even excused, by the fact that modern farming techniques and fertilizers can produce more food per acre than in

area.** Similarly, only 50 H-bombs of megaton size, if they got through the U.S. shield, could wipe out New York, Washington, D.C., Los Angeles, Chicago, Detroit, San Francisco, Newark, Boston, Philadelphia, St. Louis, Pittsburgh, Seattle, and half a dozen other major cities, with deaths of 21 million. Lethal fallout from an all-out exchange could be expected to kill virtually all the population east of a line from Chicago to St. Louis to Atlanta and in Southern California, with additional scattered pockets of

*Adapted from data in *The Limits to Growth*, Signet Books, 1972.

**Data from studies in *Physics Today*, March 1983.

***Data from H. Eierson and F. von Hippel, *Physics Today*, January 1983.

William K. Hartmann

Transfer by the superpowers of military technology into space is underway. The Soviets have experimented with "killer satellites" that explode and throw debris into the path of target satellites. Space weapons of mass destruction are already banned by the 1967 Outer Space Treaty. U.S. and Soviet politicians in 1984 spoke of negotiating to further limit these anti-satellite weapons, but also claimed such a treaty could be un-verifiable.

the past; hence the claim that we don't need so many farm acres. But allowing our available farmland to decline drastically is astonishing in view of predictions of food shortages elsewhere in the world in the next century and the fact that food has been a major American export.

If we are to explore the solar system and exploit materials and energy sources there to build a thriving interplanetary economy, we must avoid the Malthusian population crunch and a possible collapse of the global economy as hungry billions from the third world clamor for more food and living space.

3) *Eco-disaster.* The third deadly danger, more subtle and harder to discuss in terms of predictions, is that we will modify (or have been modifying) our planet's environment in a way that will lead to some unforeseen calamity. One of the two graphs on page 39 shows the increase in atmospheric carbon dioxide. Carbon dioxide (CO_2), produced whenever carbon-based fuels such as coal and wood are burned, is a gas that allows sunlight to pass down to the ground but blocks infrared reradiation from the ground back out to space. Thus, if CO_2 suddenly increased, Earth would be radiating away less heat than it received from the sun and the global atmospheric temperature would tend to rise until incoming and outgoing radiation were equal. This is called "the greenhouse effect," since the CO_2 acts something like the greenhouse glass that lets in the sun but does not let out the heat. In short, increased atmospheric CO_2 should make a hotter planet, just as it has on "Earth's sister," CO_2-rich Venus.

Many theorists expect that the CO_2 buildup (by about 12 percent since 1900!) should cause a gradual warming of the

climate. Other types of pollution complicate this prediction. The important point is that most meteorologists believe climate changes may accumulate as a result of atmospheric pollution, but the total amount and direction (warmer or colder) are controversial. Seemingly small changes in mean annual temperature (a degree or two in either direction) could cause economic havoc, turning currently rich croplands into dust bowls while creating better agricultural conditions in less accessible regions.

The second graph (figure 12) shows how we have made certain environments less nurturing to life. Due to oxidization of dumped organic wastes, the oxygen content in the Baltic Sea has dropped virtually to zero during this century. Similar chemical changes have occurred in the American Great Lakes. The catch of lake trout from Lake Ontario, for example, has declined to less than 1 percent of the average catch in the 1915–30 era, apparently because of pollution.

These are not theories or predictions. These are actual measurements! They are examples of changes we have caused. We and our neighbors on Spaceship Earth are tampering with the thermostat and with water composition, but so far the results have not been catastrophic enough for people to do much about it.

Other kinds of changes might go completely undetected until resulting effects on Earth's ecosystem are too profound to escape, too far along to reverse. In 1974, for example, several scientists working on the chemistry of gases in planetary atmospheres realized that Freon, a gas used in refrigeration systems and as a propellant in aerosol cans, is released into the atmosphere, eventually reaches Earth's high-altitude ozone layer and chemically breaks down the ozone. This is potentially dangerous because ozone is the gas in our atmosphere that blocks most of the sun's ultraviolet radiation, which breaks down organic molecules and is very damaging to life—as can be imagined by anyone who has been sunburned by just an hour's exposure to the small amounts of ultraviolet radiation that does reach the ground! Significant ozone depletion would lead to increased incidence of

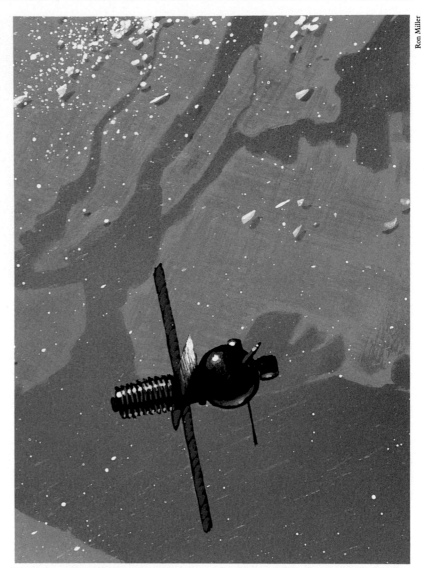

Ron Miller

The more each nation knows about what is going on within other nations, the less chance for major surprise attacks being mounted, as pointed out in the "open skies policy" proposed by President Eisenhower. This reconnaissance satellite over New York City symbolizes the use of satellites to encourage international stability.

Pamela Lee

A second major threat to our planetary culture is overpopulation, with resultant urban sprawl, farmland loss, and inability to maintain adequate food production.

skin cancer for humans. After a 1975 confirmation of the Freon danger by the National Academy of Sciences, U.S. regulatory agencies moved to phase out Freon aerosol propellants by 1979. Here, then, were ordinary consumer gimmicks causing an environmental danger that we barely caught in time. Interestingly, the researchers who caught the Freon problem were planetary scientists who were trying to understand the chemical behavior and measurements of gases in the atmospheres of other planets, especially Venus. Already, planetary exploration has helped save Earth!

To sum up this chapter, Earth's society is headed for drastic changes within some decades. If we try to continue with "business as usual" in an entirely Earthbound economy, we will be stopped by resource exhaustion, turmoil and collapse by the later part of the next century. The three most probable sources of collapse appear to be nuclear war, Malthusian disaster and eco-disaster. These are crazy destinies in which the life-support systems of Spaceship Earth are sabotaged by its inhabitants. Strange it is to realize that if we allow the environment on Earth to be ruined in one of these ways the most likely survivors, if any, are not we who are pleased to call ourselves "advanced" or "civilized." The most likely survivors would be those who have been called primitive: the aborigines and Indians who, in their mountain, desert and jungle remoteness, have kept the lifestyles least dependent on the transportation links, industrial products and other accouterments of technological civilization. Even *their* long-term survival or resurgence would be in doubt in a radioactively contaminated, resource-exhausted or environmentally damaged world. An alternative is to discover additional resources of energy and material outside Earth and to process them there, thus allowing our planet to begin to relax back toward its natural state. These discoveries, these developments, are not a wild daydream. They are already underway.

FROM SHUTTLES TO SPACE CITIES

The schedule of shuttle missions shows the breadth of our emerging space program. No longer will men and women be limited to test flights, brief scientific forays and experimental feasibility demonstrations, as in the 1960s and '70s. We are entering the era when men and women will begin to carve out careers in space. Planned shuttle missions include the following activities:

Flights of manned spacelab. Several spacelabs, small space stations built by the European Space Agency (ESA) and riding within the shuttle cargo bay, will be carried into orbit during shuttle missions. The first one flew successfully in 1983. They will be occupied for scientific studies and will be space station precursors.

Deployment of Space Telescope. Space Telescope is a large orbiting astronomical telescope (mirror diameter, 2.4 m, or 94 in) that will provide much clearer images and measurements of remote planets, stars and galaxies than any current ground-based equipment. The increase in performance comes from its position above the shimmering, obscuring air blanket of Earth, which distorts and blocks certain colors (wavelengths) of light, such as parts of the infrared spectrum; Space Telescope will be able to see clearly at all wavelengths and is expected to revolutionize astronomy. It will be launched in the mid- to late 1980s.

Launch of the Galileo space probe to Jupiter. Galileo will make detailed maps of the active volcanoes and ice structures of Jupiter's moons and will parachute a probe deep into Jupiter's atmosphere to measure the hidden environment below its colorful clouds. Some delays have occurred in the mission, but it is currently planned to arrive at Jupiter in 1988.

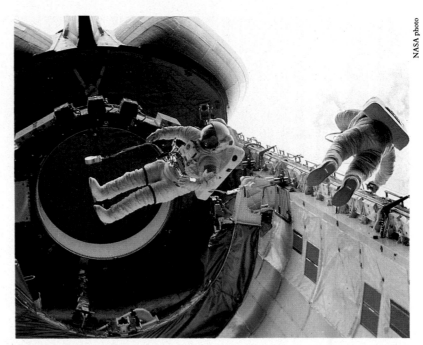

NASA photo

Shuttle astronauts, working with ease in the shuttle cargo bay as well as leaving the bay to rendezvous with orbiting satellites, have paved the way toward large construction projects in space.

Repair of existing satellites. The first example came in 1984 when the eleventh shuttle docked with a disabled sun-monitoring satellite.

Launch of additional commercial and government payloads. Communications satellites, for example, will enhance international

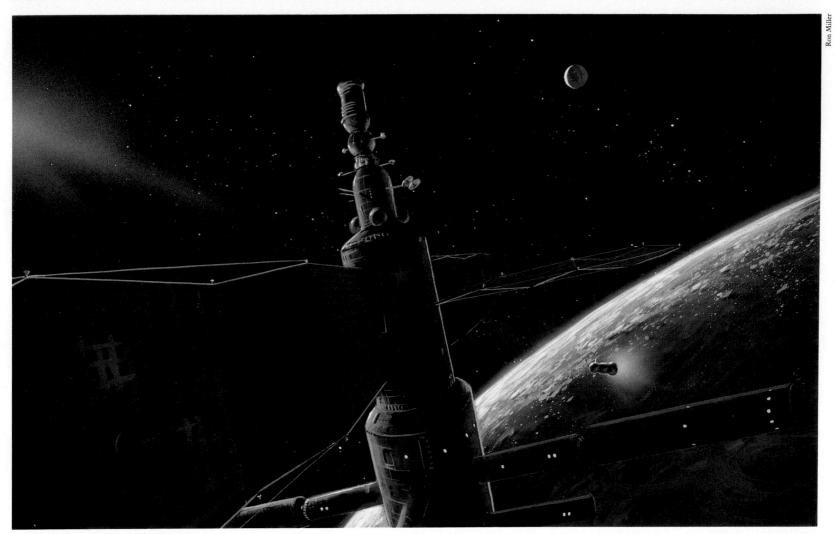

Ron Miller

Soviet technicians have emphasized expansion of their Salyut space station capabilities. This imaginary view shows a future expansion of the Salyut-type station with docked modules. A Soyuz-type ship has docked at top center; another maneuvers in distance.

contact. Geological mappers will record reflectivities of worldwide terrains in different wavelengths, helping to map different mineral properties.

Continued tests of zero-gravity techniques for separating chemicals to produce valuable drugs. In a process called electrophoresis, devel-

oped on Earth for this purpose, a sample containing desired materials flows through a solution between positive and negative electric terminals. Because molecular particles of different composition have different sizes and charges, they collect at the different terminals at different rates and can thus be concentrated. But here on Earth gravity limits the amount of material that can be processed because too dense a sample "collapses" into a blob instead of separating through the solution. McDonnell Douglas Astronautics Co. and Ortho Pharmaceutical Corp. sponsored tests of this process in zero gravity. From complex biological samples, their system separates a drug that will be useful for treatment of a protein-deficiency disease. Tests on early shuttle flights indicated the zero-gravity system generated at least 463 times as much separated material as an equivalent ground-based system. *Production* of samples for tests on humans is scheduled for a 1985 shuttle flight. Many observers expect this drug to become the first product commercially manufactured in space. In a second example, a shuttle chemical experiment in 1983 demonstrated weightless condensation of perfect crystals (germanium selenide, in this case) to sizes ten times larger than the same process on Earth. This could lead to new processes to make crystal components for electronics, computers, etc.

Meanwhile, the Soviet Union continues its decade-long development of space stations, using the Salyut design and docking multiple Soyuz spaceships to the station at once. The Russians have also continued their tests of a shuttle-like craft, of which reduced-scale, unmanned models have been launched from the U.S.S.R. to water landings in the Indian Ocean. Soviet space engineers are rumored to be working on a larger permanent manned space station design to be serviced by two classes of shuttle-like vehicles.

Future Progress

Clearly we humans have almost developed a capability to operate at will in near-Earth space. This capability has already been bought and paid for out of tax dollars. In the case of the shuttle fleet, some of the expense has been for scientific purposes (dollars from NASA) and some for military purposes (dollars from the Department of Defense). A few dollars have even come back into the till from commercial users who pay to have their satellites launched.

The point is that our fledgling space capability permits us to be much bolder in predicting a future than we could have been a few years ago. If this book had been written in 1956, we could not even be sure that weightless flight in space was humanly possible. Even unmanned satellites were still a dream. Space travel was relegated to the comics in those days. In 1976 we still viewed space operations as experimental, something involving huge expenditures for one-shot rocket boosters. Now, in the 1980s, if we want to speak of using orbiting collectors to capture solar energy, or of building a processing plant for zero-gravity preparation of drugs, the costs no longer have to include development of a launch system from scratch, or proof of the possibility of docking, or tests of extravehicular activity by astronauts. We already have these capabilities on a routine, even commercial basis and can predict further milestones in capability:

Demonstration of the ability to fabricate huge structures from lightweight components. These structures could easily exceed the size of our largest skyscrapers. If we picture a construction facility floating in space, we can imagine bolting beam after beam, end to end, until the structure extends a mile or more out from the actual construction site. In the weightlessness of space, there are no gravity stresses on such objects. Beams could be bolted together into huge lattice structures to serve as solar collector surfaces or antennas. Similarly, some structures might be held together simply with wire cables. They could be spun at a slow rate to produce the artificial gravity of centrifugal force that would hold them in outward-directed tension and keep them relatively rigid.

Construction of a large permanent manned facility in orbit. This facility will be built from modules launched from Earth and

joined in space. As mentioned earlier, the Soviets have already tested this technique by docking a 15-ton module with their 21-ton Salyut station. NASA is pursuing a permanent manned station by the early 1990s, following President Reagan's mandate.

Demonstration of energy sources in space. All human activity requires energy, whether it be heat to keep warm at night, fire to cook food, or chemical energy to power our electrical generators. The sun is an obvious energy source in space—it shines undiluted by atmosphere or cloud, twenty-four hours a day. An exception occurs at facilities orbiting close to planets where the orbital path takes us through their shadow for part of each orbital cycle. But for objects orbiting higher than a few thousand kilometers above Earth or other planets, only a small fraction of the time is spent in shadow. Even low orbits over polar regions could, in principle, be kept in sunlight all the time. Solar collectors will, therefore, be big business in space. Nuclear reactors offer a second energy source in space as a backup to the solar collectors. They are long-lived; moreover, once above the atmosphere, any radioactive waste gases could be vented and blown out of the solar system by the solar wind, the ceaseless stream of thin gas blowing out from the sun. Solid wastes could be cheaply and safely fired into the sun for disposal. Furthermore, reactors could be easily shielded with massive amounts of soil from the moon, asteroids or other sources. When pollution is taken into account, nuclear energy makes more sense in space than on Earth, where we don't want radioactive by-products to accumulate in our closed ecosystem.

An International Space Station?

A large, permanent space station will be costly and massive. Since the European Space Agency is already cooperating with NASA on the spacelab project, further international cooperation seems plausible during development of the permanent space station. ESA has voiced interest. With various nations contributing dollars to the project, a large station might be built sooner

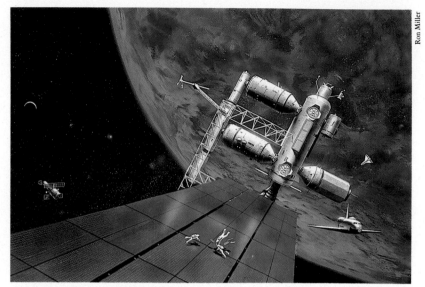

An early permanent American space station could be assembled from modules delivered by shuttles and powered by so-lar panels. The night side of Earth looms in the background.

than would otherwise be possible, with staff from the various countries sharing and maintaining sections of the final habitat. Perhaps such a station would serve as a celestial beacon, pointing the way toward more harmonious international relations on Earth.

However, in an echo of the problems discussed in the last chapter, such cooperation seems endangered by the nationalistic tendency to clamp security lids on new technical concepts, rather than simply *use* them for human good. According to the respected journal *Science,*★ NASA has promoted the idea of international studies of a space station with collaboration of the United States, Canada (where the shuttle manipulator arm was built), Japan and Europe, but "that hope foundered in the fall of 1982 when the U.S. State Department refused to grant the export agreements that would enable American firms working on

★15 July 1983.

the space station studies to exchange technology with the foreign firms.'' As a result, ESA proceeded with its own studies. In March 1983 the ESA space station team was not allowed, as a result of the State Department ruling, to attend a NASA-sponsored conference on space station technology.

Some might argue that it would be more efficient for the United States to develop its own space station as soon as possible, and then with good will invite others aboard on a cost-sharing basis. Nonetheless, it seems incredible that ideologues in the State Department (of all places) should become the roadblock in preventing us from cooperating on a major space project with our own allies! This is a demonstration, if any is needed, that the biggest problems in exploring space for the benefit of Earth are not engineering or scientific in nature; rather, they are the political problems of learning how to agree on policy goals and work together to implement them.

Space Cities: The Motivation

Once permanent habitat occupancy, construction techniques and energy independence have been demonstrated, the road to space exploration will be wide open. If we can build a space-floating solar collector X meters on a side, then we can generate 100 times as much energy by building one 10X meters on a side. There would seem to be scarely any limit to the electrical power that can be generated for spacefaring stations—or cities.

Space cities will no doubt grow from space stations. Some people have difficulty accepting this. They say, "I can imagine a few scientists staying up there for a while, but why would anyone want to *live* there?" One answer is jobs. Why did workers flock to Alaska during the pipeline construction? Why did frontiersmen press on into the dark forests, across the Appalachians, when they could have stayed in the comfortable colonial cities of Virginia? Frontiers always get converted into habitats if there is an economic or political motivation to keep them open. Already we can sense pressures in this direction. Various nations are anxious to have communication and other types of satellites not

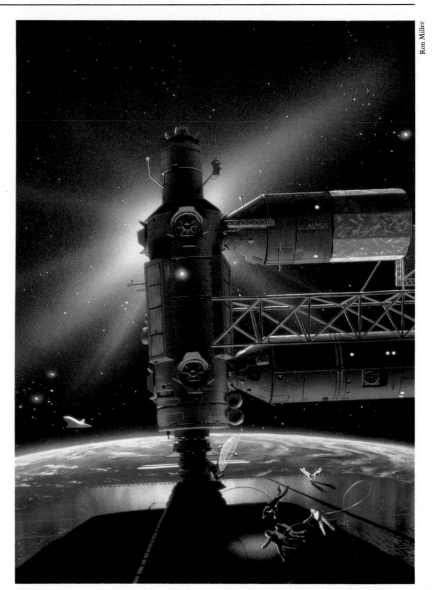

Ron Miller

The permanent manned space station in its early stages of operation. The upper module of the station eclipses the sun, whose pearly coronal atmosphere is visible. Zodiacal light, reflected off dust in the plane of the solar system, stretches to upper right and lower left.

only launched but serviced in orbit. Military planners speak of establishing a presence in the "high ground" of space. Meteorologists, geologists and astronomers already rely on unmanned satellites to make observations such as global images of water vapor concentrations in the atmosphere, maps of mineral deposits, and images of remote galaxies unblurred by the atmosphere. But once manned habitats are aloft, the next generation of scientists and graduate students will want to be up there with their instruments, ready to make quick fixes and observe unexpected targets of opportunity. Even among space artists, enthusiastic debates have already occurred about who will be first to paint a sunrise from Earth orbit, on-the-spot views of the glittering facets of a space city under construction or the brooding hills of the moon. What Ansel Adams or Elliot Porter will carry a large-format camera to watch for the decisive moment as shadows lengthen among lava boulders near the first lunar base?

If technicians, construction workers, soldiers, scientists and poets will slowly gather during extended visits at orbiting stations, how long will it be before someone *stays* to the end of his or her natural life? How long until the managers or commanders of early stations radio back home, "We need more room"? How long until men and women enjoy sexual playfulness while floating together in zero gravity? How long until the first child is born on such a station (at normal gravity or in a low-gravity or zero-gravity ward)? How long until the first spouse with time on his or her hands opens up a little shop? On what unnoticed day will the first space station turn into the first space city?

Antarctica, another human frontier, has been permanently occupied since 1943. McMurdo Station, an American base, is the largest community. With some hundred buildings sprawling over a few acres, with its summer population of about 800, with its New Zealand neighbor Scott Base only about a mile away, is McMurdo Station really a station? Or is it a town?

Most writers have used the term "space colony" to describe what we are discussing. But "city" seems to convey more the correct sense. While a space station may evolve into a space colony temporarily, the colony will evolve into a space city—a dynamic, bustling, creative community with its own sense of identity, independence and purpose.

The process of expanding little space stations into large space cities may be easier than we think. Ways of doing this have been studied at a widely respected California-based space think tank, called the Californial Space Institute and known as Calspace by the community of space planners. (The Institute was established at the University of California at San Diego to promote the space-related industries of California during the administration of Governor Jerry Brown, who was later ridiculed by the press as "Governor Moonbeam" for adopting a presidential campaign slogan advocating serving the people, saving the Earth and exploring space.)

The Calspace group has promoted two dramatic ideas that could pave the way to space cities. First, they note that the space shuttle's external tank (the giant "middle tank" ridden by the shuttle during launch) reaches about 99 percent of the speed required to stay in orbit but is allowed to fall back into the atmosphere, where it breaks apart and burns. Remnant pieces usually fall into the Indian Ocean. In shuttle-planning days, semi-controlled reentry was judged safer than allowing the tank to go into low orbit. If the tank were left unattended in orbit, the gentle drag of the upper atmosphere would make it eventually spiral into the atmosphere in an uncontrolled reentry that could drop pieces on populated areas. Calspace planners believe we should start putting the external tank (known affectionately as E.T.) into orbit. It would arrive ready to use. It is about 48 m (150 ft) long and about 8 m (26 ft) wide inside, and capable of sustaining an inside air pressure at least twice that at sea level. Each tank has a volume several times that of an ample suburban house. A small engine could boost such a tank to a higher, safer orbit where it would not encounter the atmosphere. With minor modifications, it could be filled with air and serve as an emergency habitat or as a module for construction of a first generation of larger stations. It would arrive composed of about 34 tons of

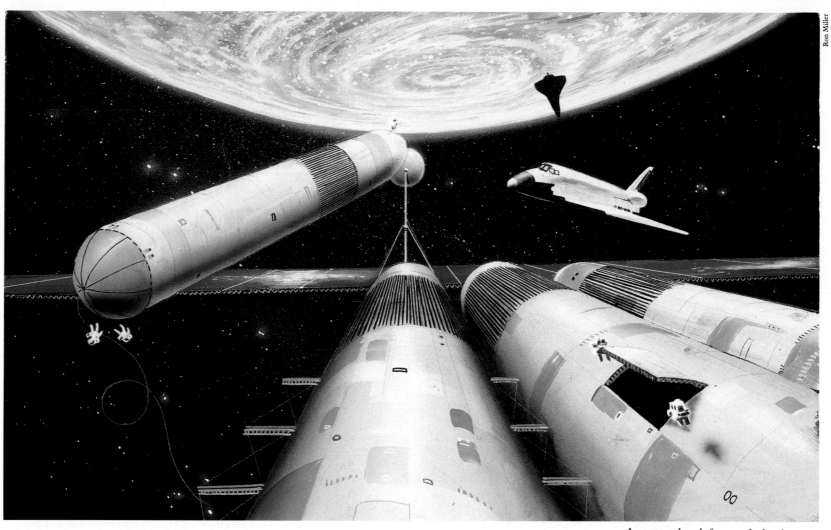

Ron Miller

An external tank from each shuttle launch has been kept in orbit and linked to previous tanks, creating a large platform with abundant resources of fuel, materials and habitable volumes. Here a new tank is being maneuvered into the assembly.

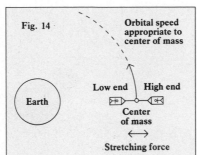

An elongated object (natural or artificial) orbiting around a planet tends to orient itself with its long axis pointing toward the planet.

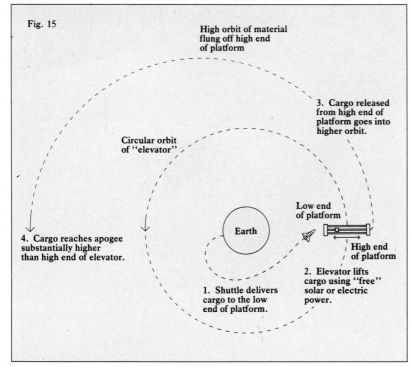

Platforms linked by miles-long tethers could assist in delivering cargo to orbit.

useful metal, insulation and hardware. Even if it weren't used as a ready-made module, it would serve as a repository of raw materials. It also arrives with excess fuel on board—averaging about seven tons per trip! This could be pumped out and stored in orbit for future space missions. These tanks are too valuable to waste in fireballs over the Indian Ocean!

The second scheme advocated by Calspace and other scientists is known as "the tether." This concept takes some explaining. If a spacecraft (or a natural moon) in a circular orbit has an elongated shape, tidal gravitational forces from the planet will tend to point the long axis toward the planet (see figure 13). The gravitational attraction from the planet, stronger on the close end than on the far end, "grabs onto" the close end and holds the elongated body in one position. This is why the moon keeps one face toward Earth: the Earthward lunar axis is very slightly longer than the other axes. Thus any large, elongated spaceship, if left alone in a circular orbit, would eventually come to a position with one long end pointing toward Earth and the other end away. If the ship's position were disturbed either before or after it came into equilibrium, it would go through a long series of pendulum-like swings, called librations, before settling down in the Earth-aligned position.

Now, suppose we built a large dumbbell-shaped orbiter with a cabin at either end, connected by a rigid rod, and let it align with Earth (see figure 14). It would have some strange and interesting properties. Suppose it is in a circular orbit. It would be orbiting with a speed that depends on distance from Earth. As German astronomer Kepler discovered around 1610, orbital speed is faster close to Earth where Earth's gravitational force is strongest, and slower farther away from Earth. Thus the low end and the high end are not quite orbiting at their proper speeds and there is a stronger force pulling the low end toward Earth than the force pulling on the high end. As a result, a very slight stretching force acts on the axis of the station, and people in the low end feel a very slight gravity-like force toward Earth while those in the high end feel a light force away from Earth. For the

same reason, the structure that connects the two capsules would not have to be a rigid rod. It could be a set of strong wire cables, like those of a suspension bridge. Such a structure has come to be called the tether.

Of what use could these facts be? Researchers such as Smithsonian scientist Giuseppe Columbo and the Calspace planners propose reeling out long cables to separate two platforms made out of space shuttle tanks, separated by 20 km (12 mi) or even more. As shown on page 50, this could be used to perform a clever maneuver. A space shuttle could bring up cargo and rendezvous with the low end. It would need enough fuel only to get this far. The cargo is now transferred to an elevator that runs up the cable (against the very weak downward force) to the zero-gravity center of gravity, where it then coasts (with the outward-directed force in the upper part of the station) to the high end. "Free" solar power could be used to power the elevator. Now recall that the high end is actually moving too fast for its orbital position. Thus, if the cargo were now released (step 3 in figure 15), it would fly off into a higher orbit, just as if it had been accelerated from circular orbit by a rocket. Even bigger boosts into orbit could be gained by taking advantage of the slinglike librational motions. Notice that in these schemes no rocket fuel is wasted to boost the cargo into the higher orbit. A rocket might be fired at the orbit's apogee, or high point, to put the cargo into a circular orbit at that height. Conceivably, tethers could be built hundreds of kilometers long and play a major role in delivering goods to orbit.

As mentioned previously, solar power from large collectors might be used to power the elevator and the rest of the station. But Calspace planners have suggested a more bizarre option. They point out that this elongated structure would be moving through Earth's magnetic field. When a metal structure moves through a magnetic field, electric currents are caused in the metal, as discovered by English physicist Michael Faraday in 1841. Thus tethers might be able to generate some of their own electricity rather than relying entirely on solar collectors.

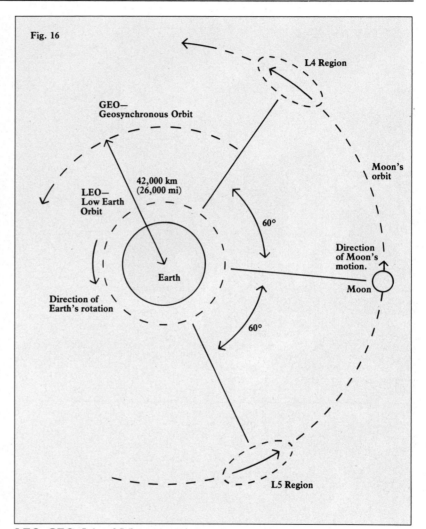

Fig. 16

LEO, GEO, L4 and L5 are attractive regions for space station activities in the Earth-moon system.

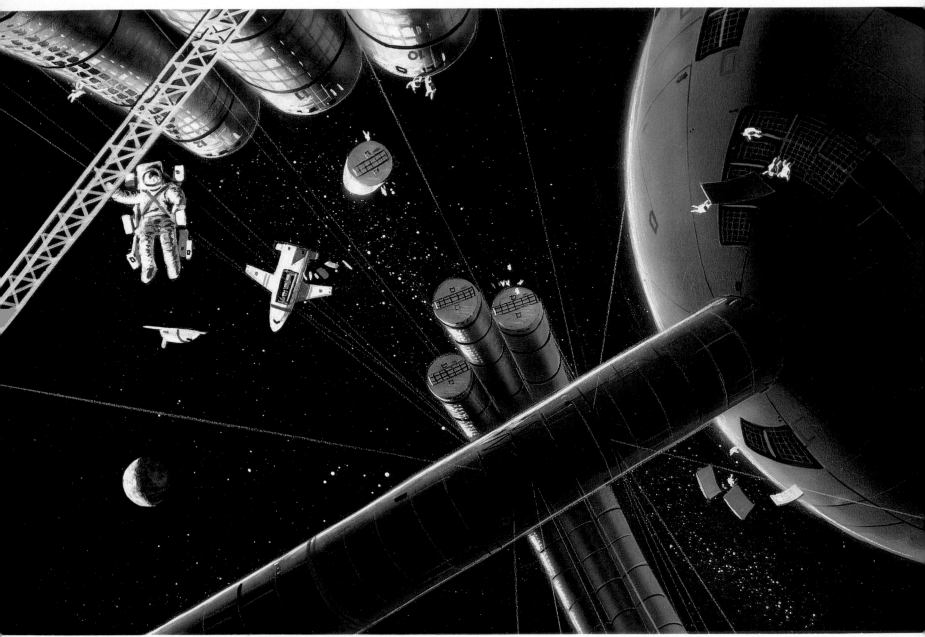

Ron Miller

Experiments with tether concepts are planned for shuttle missions. These will involve reeling out long cables. Tether concepts offer opportunities to transfer life-support equipment outward from low Earth orbit, using minimum energy. But perhaps their greatest importance is that they illustrate dramatically how we are learning to use the special properties of our space environment. Several space planners have predicted that the most important techniques and industries in space will be unforeseen adaptations to the unique space environment—ideas we haven't even thought of yet!

Locations for Space Cities

Shuttles, cargo ferries, space stations or space cities can orbit Earth anywhere in the Earth-moon system, from a point close to the top of the atmosphere (below which atmospheric drag prevents orbits) to a point well beyond the moon (where Earth's force grows so weak that the sun's gravitational attraction dominates and the vehicle eventually escapes into an interplanetary orbit around the sun). This region is called cislunar space. Several locations of special interest have been named.

LEO, or *low earth orbit,* refers to an orbit near the top of the atmosphere, such as the shuttle's path. This region is important because it is the easiest to reach from the ground. Indeed, it has become so populated with satellites and fragments of exploded satellites (accidental explosions and intentional Russian tests of killer satellites) that consecutive 1983 flights of Soyuz and the shuttle had their windows hit by objects big enough to leave a visible chip in the outer glass pane. The time to go around Earth near LEO is typically one and a half hours. Aside from atmospheric drag and concentrated debris, LEO is in, or just below, Earth's radiation belts, where high-energy atomic particles zap

The space station grows into a space city as orbital operations expand and astronauts link modular sections.

orbiting objects and present a health hazard. For these reasons, LEOs are not good candidate orbits for permanent space stations but will be used as a short-term parking orbit for cargos shuttled up from Earth.

GEO, or *geosynchronous earth orbit,* refers to an orbit with a mean radius of about 42,000 km (26,000 mi). At this unique distance, the time to go around Earth is 24 hours. A satellite at this distance is thus said to be revolving synchronously with Earth. Consider the special case of a satellite in a circular orbit over the equator. Both the satellite and Earth are turning once in 24 hours, and so the satellite stays exactly over the same spot on the equator. As seen from this satellite, points on Earth appear fixed. If the satellite is over South America, for example, Los Angeles always appears in the "upper left" corner of Earth. Conversely, as seen from Los Angeles, the satellite remains at a certain point in the southeastern sky day and night. Such a satellite in a circular GEO over the equator is said to be geostationary. (GEO is sometimes used to refer to the special geostationary case, rather than the general geosynchronous case.) Because such a satellite occupies a stationary point in the sky as seen from any point in the hemisphere below it, GEO satellites are perfect for communications. A remote village in Indonesia points its antenna at the sky position of the satellite and picks up communications beamed to the satellite from the Indonesian capital or from other parts of the world. Similarly, a manned station in a geostationary orbit could have constant communication with its parent country on the ground. Thus geostationary orbits are promising candidates for space cities.

L4 and *L5* are two small regions in the moon's orbit. L4 is 60° ahead of the moon, and L5 is 60° behind the moon (see figure 16 on page 51). As discovered by French astronomer Joseph Lagrange, material delivered to these points would tend to stay in about the same position relative to the moon and Earth. Together with the moon, such material would travel around Earth in a month, oscillating somewhat around the L4 or L5 point as it goes. (Lagrange discovered three other similar points,

L1, L2, and L3, but material put at these points ultimately drifts away from them. All five points are called "Lagrangian points.") Material at other points in the moon's orbit away from L4 and L5 would be disturbed by the moon and Earth and eventually crash into the moon. Material at other distances from Earth, of course, would orbit in periods different from one month and thus pull ahead or behind the moon. The L4 and L5 points are attractive as sites for space cities that might be supplied with lunar material. A constant launch angle and speed from a lunar colony would always deliver material to an L4 or L5 point, and communications antennas from L4 or L5 to the moon could be pointed in fixed directions, similar to the link from GEO to Earth. L5 gained additional attention when adopted as the name of the L5 Society, a large organization advocating space colonization.

Artificial Gravity

Space flights to date have been conducted in weightlessness, with a certain modest fraction of astronauts (20 percent?) experiencing some degree of temporary nausea. But weightlessness is not necessary. Artificial gravity can be provided in a space city by spinning it. Centrifugal force then presses all internal objects away from the central axis of spin. For this reason, shuttle external tank modules might be linked and spun (see figure 17) to provide a multilevel station with considerable work area. For the same reason, conceptions of space stations have long favored doughnut-shaped wheels with multifloor living quarters at a substantial distance from a central hub, which could serve as a fixed docking station. The wheel design, developed at least as early as 1950 in now classic studies by rocket pioneer Wernher von Braun, allows a maximum of living space at a fixed distance

The rotating wheel is ideal for providing multilevel stations with multilevel stations with Earth-like gravity in living sections around the rim. Wernher von Braun and other space visionaries proposed this design prior to 1950; it was then made famous in the film 2001.

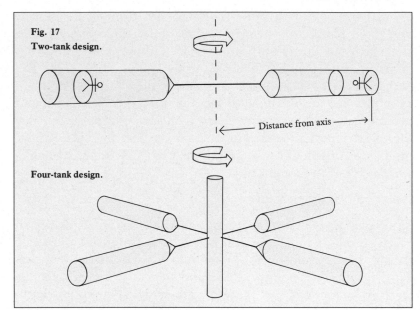

Fig. 17
Two-tank design.

Distance from axis

Four-tank design.

Artificial gravity can easily be attained in spacecraft by spinning them around a central axis. Shown here are two designs using shuttle fuel tanks as modules.

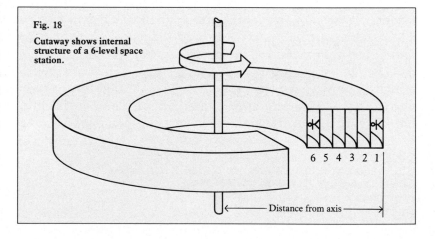

Fig. 18

Cutaway shows internal structure of a 6-level space station.

6 5 4 3 2 1

Distance from axis

from the axis (see figure 18). This design was used in the film *2001: A Space Odyssey.* In the famous "ballet of the spaceships" sequence, in time with the *Blue Danube Waltz*, a shuttle approached the rotating station, aligned parallel to the hub's docking port, spun up to the same rotation rate as the station, and docked.

The amount of artificial gravity depends on the distance from the axis and on the spin rate. It can be adjusted to equal normal Earth gravity (known as 1-G) at the main living level in the wheel by adjusting the spin rate. For wheels with radii of 10, 100 and 1,000 m (roughly 10, 100 and 1,000 yd), the spin rate to give normal Earth gravity would be 6 seconds, 20 seconds and 63 seconds, respectively. A radius of about 100 m (100 yd) might be typical for an early space city; if you were sitting in your room in such a city, looking out the window, you would see the blue Earth swing by once every 20 seconds. If you were sleeping, you might be dimly aware of the cool blue glow bathing your room every 20 seconds, like a slow-motion neon sign outside a hotel window in some old Humphrey Bogart movie. (Whether Earth and the stars actually moved *by* the window or around in an apparent circle would depend on the orientation of the city and whether your window faced parallel or at right angles to the city's rotation axis.)

For a simple early station, a single cylindrical shuttle external tank might be used; however, if we tried to create artificial gravity by spinning this around its long axis (like a pencil rolling across a table), the spin rate would be only 2 to 3 seconds since the radius would be only about 4 m. The fast spin and the steep curvature of the inner "floor" would probably be disorienting, and weightlessness might be preferred. An interesting situation arose in the similarly shaped, cylindrical Skylab station. The station was not spinning, and astronauts inside were weightless. But they found that if they "stood" with head toward the center and feet on the wall, and pushed forward and started running, they could actually run around the circular inner wall of the cylinder with the apparent centrifugal force of their own motion

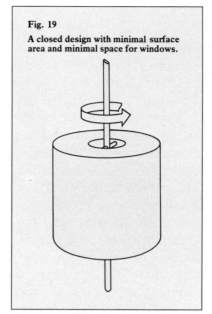

Fig. 19
A closed design with minimal surface area and minimal space for windows.

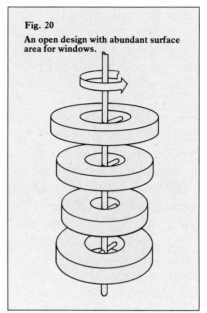

Fig. 20
An open design with abundant surface area for windows.

Designers could minimize costs by adopting sardine-can space station designs (left), but occupants may suffer from minimal opportunities to see outside space. Greater opportunities for exterior views of Earth could be obtained from stacked-wheel designs (right).

providing a strange sort of temporary artificial gravity. As soon as they stopped, they could float back into the station interior.

In a space city of moderate size, several levels could be located near the 1-G level, but levels closer to the center would be proportional to the distance. In a 100-m-radius station, spinning in 20 seconds, an "upper" floor ("upstairs" from the point of view of an occupant) only 90 meters from the center would have a gravity of 0.9 G. A floor only 16 m from the center would have the same gravity as the moon. These floors might provide good low-stress living levels for residents with heart conditions or other health problems, or for visitors returning from the moon.

Space in a Space City

Planning for open spaces within a space city and for the view from space city windows presents an interesting challenge. The human spirit seems to want openness. My grandfather lived in one of those small-town houses with green yard stretching out across a large lot in every direction. I grew up in a house with a frontyard and a backyard. My grandchildren are quite likely to spend time in an apartment complex whose windows look across to another wall of the complex, perhaps 40 feet away and with a landscaped central plaza around the corner. Although we have made progress in many things, and although we should give thanks to our ancestors every time we turn the faucet and hot water bubbles into the bathtub, we do not seem to be making progress in space for living. As builders try to keep housing costs down, they pack more people into less space with less sense of personal room. Now, if there is one thing space has, it has room! Since all early building materials will have to be shipped from Earth at enormous expense, however, there will be enormous pressures to go even further with the sardine-can philosophy of housing during the construction of early stations and cities. If these space stations are built with the prime consideration being to amortize investment over 20 years, to minimize initial taxpayer costs or commercial investments, we are likely to end up with giant sealed stations having minimum exterior surface, with rows of small apartments that may have no windows, and with only a few grudgingly designed park areas among endless metal corridors. A single, giant, closed cylinder might be such a design, as shown in figure 19 on page 55.

Alternatively, would it not be possible to recognize that these are structures destined for long life and future generations of occupants? Would it not be possible to design them as artistic expressions for the glory of present and future humanity? Is it not possible that we might be willing to pay a little extra if people could be caught up in the joy of watching our own pioneers making the first steps out of the cradle? Figure 20 is an example of how the cylinder could be broken up into a series of wheel-shaped structures, allowing more access to windows that would afford a view into space itself. If each wheel were two apartments wide, each living area could have at least one window allowing the occupant to see parts of the rest of the enormous city, the occasional rendezvous of spaceships, parts of the blue Earth and moon, and the distant, steely stars untwinkling in the vacuum of space. There is a question as to whether or not sunlight might enter these windows: sunlight (and its dangerous shortwave radiations) might be blocked by giant solar power panels composing part of the station design.

Many designers have already given thought to the construction of space cities. Among the most interesting concepts are those of Gerard O'Neill and his colleagues at the Princeton Space Studies Institute. Many of these are presented and sketched in the illustrated edition of O'Neill's popular book on orbiting space colonies, *The High Frontier*.

Politics of Space Cities

Many suggestions have been made about how space city governments might work. They might be regulated by agencies of sponsoring Earth governments, like a scientific outpost. They might be military installations (although we can hope not!). Some cities might be built by a private solar power satellite contractor and run as company towns.

In the world today, as in Europe of the 1600s, there is a lack of political space. There is no earthly frontier to move to if you face political or religious repression. Some countries, like the U.S.S.R., don't want to let you out, apparently because of a fear of admitting weaknesses in their system. Countries like the United States, which once welcomed immigrants, now face space and resource limitations of their own.

Two technicians inspect a newly completed solar energy panel as it is placed in its sun-facing position, in Earth orbit. After the initial expense of panel construction, such panels would provide free energy to space cities.

Pamela Lee

*Lovers in viewing rooms in the weight-
less central hub of a space station could
share joyful play while floating against
the backdrop of cloud-dotted Earth.*

Pamela Lee

Space cities offer us an opportunity to implement political systems more creative than military outposts or company towns. If multiple space cities are built, various political advocate groups could prepare experimental constitutions for the governments of different cities, each within a framework of agreement about the product of the given city (so many megawatts of power, so many kilograms per year of pharmaceuticals or of asteroidal platinum, etc.). Some of these constitutions might offer escape valves for certain minorities who feel disenfranchised on Earth. Early space cities obviously could not be numerous enough to offer a haven for every little discontent band. But to a world in which many governments torment and suppress dissidents who have nowhere else to go, space cities offer the opportunity to be creative enough and brave enough to experiment with governments. Why not say to outbound space

pioneers, "All right, if you think political system x is so good, go to space station X and see if you can make it work"? After five or ten years, productivity and standards of living in the otherwise equal stations would offer dramatic experimental evidence about the qualities of different social systems.

The Product of Space Cities

While stations will grow into cities due to scientific, military, engineering and other pressures, they won't be truly viable until they begin to *produce*. One type of production will be the 0.63 kg (1.4 lb) of food per day, 3.6 kg (7.9 lb) of water per day and 0.82 kg (1.8 lb) of oxygen per day needed for life support of an average person, along with the additional 3.6 kg (8 lb) of water per day typically used for washing. Some water and oxygen will be recycled; additional production will be needed for a growing

population. As we will see in later chapters, there is a high probability of finding these materials in low-gravity environments in space, rather than hauling them up at great dollar and energy expense from high-gravity Earth. Interestingly, some analysts believe that people may not be able to live indefinitely in small, closed systems of space-city size because of the buildup of poisonous waste products we don't yet fully understand, which might be left after normal filtration and recycling. Accordingly, various sectors of the city might have to be flushed and "refreshed" every year or so.

But when we speak of being viable, we mean producing something of economic value so that commerce can begin on an equal footing with outside societies. What can a space city produce of economic value? Already space shuttles and other missions have demonstrated the attractiveness of controlled, variable-gravity environments for certain manufacturing processes, such as the drug manufacturing described earlier in this chapter. Similarly, molten droplets of metal, glass and other materials would form perfect spheres in zero gravity due to surface tension. This effect may facilitate manufacture of ball bearings and other similar products in zero-G orbital facilities.

Another form of productivity is the manufacture of materials that will be utilized not on Earth but *in space*. An example, which we will encounter again in later chapters, is the manufacture of liquid oxygen for rocket fuels from the oxygen chemically bound in lunar or asteroidal soils. Thus there will be a "feedback loop" in the growing space economy. Some materials from space will be processed to enhance our space capability. As work and travel in space become easier and cheaper, more materials can ultimately be acquired and traded with Earth. The infusion of space materials into the space economy enriches that economy.

The Solar Power Satellite

One of the most grandiose and exciting projects proposed for orbiting space cities is construction of so-called SPSs, or solar power satellites (the Department of Energy has used SPS to stand for "satellite power system," but the concept is the same). The idea, first discussed by American engineer Peter Glaser in 1968, is simple. Build giant solar collectors in orbit, free from real estate costs and losses due to night, haze or cloud, then beam the collected energy down to receiving antennas, or "rectennas," on Earth by microwave, and instead of a polluting coal-fired or nuclear generating plant we have a relatively clean "rectenna farm" from which transmission lines carry the power into the regional power grid for nearby cities and industries. (The receiving station, a multi-mile-wide array of receiving antennas in a remote area, could literally be used also as farmland.)

In Earth's vicinity every square meter pointed toward the sun receives 1.35 kilowatts of power continuously. This power comes in "free" 24 hours a day. For collectors located in geostationary orbits, the time lost by passing through Earth's shadow can be reduced to as little as 72 minutes per year!

Suppose during a construction period of some years, builders in a space city could assemble a panel of solar cells 2 km wide and 50 km long and could collect energy at 10 percent efficiency. The panel would then constantly be producing 13.5 billion watts, or 13.5 gigawatts (abbeviated Gw) of electricity. This is about 13 times that of the largest nuclear generating stations, nearly 3 percent of the total American utility generating capability and the equivalent of 570,000 barrels of oil per day. One conception of an SPS system being studied by the Department of Energy includes 60 satellites spaced around the equator, each with a collector area of about half that mentioned above. These figures give some idea of the magnitude both of the energy to be gained and of the projects that have been seriously discussed. Hundreds of workers and maintenance people would live in orbit to build and service each station. Development costs of $74 billion over 20 years have been proposed by Glaser for such a system. There is controversy, of course, over the costs, but it must be remembered that by the late 1970s the United States was throwing away roughly $100 billion per year to buy oil from

Arab and other countries. Unlike money spent on an SPS system, the money spent for OPEC oil does not lead to the creation of a long-term or productive facility for anyone on Earth; it merely burns oil.

The great advantages of an SPS system include political independence from other energy producers, long lifetimes of the satellite generators, utilization of "free" energy from the sun, zero pollution of Earth by burned or nuclear fuels and zero destruction of Earth in mining such fuels.

Many objections and questions have been raised about SPS systems. One major objection is that the energy being transmitted down through the atmosphere to Earth could have harmful side effects. Biological damage caused by low-level microwave radiation is not too well understood medically, and different countries have different safety limits. However, engineers have proposed focusing the transmitted energy into a narrow beam some miles wide and placing the receiving rectenna farms in remote areas. The space transmitters and the rectenna farm would be linked by direct radio-control beams in addition to the main power beam, so that if for some reason the power beam strayed from alignment with the farm, the control link would be broken and the system would automatically shut off. Environmental damage of such a system would seem to be considerably less than that of its coal-fired, oil-fired or nuclear competitors!

Another major objection to the SPS is that we should not become dependent on highly centralized, high-technology power plants. Partly, the concern is that these plants are vulnerable to attack or misuse by an enemy, terrorists or madmen. Partly, the concern is philosophic: many writers feel we should move toward localized, dispersed power (such as solar panels on each housetop) instead of a centralized, monopolistic system. Partial answers to these concerns would be that a solar power satellite would be no more vulnerable to attack than a comparable major ground station. A network of satellites would provide some safeguard against catastrophic loss of national or worldwide power by loss of a single giant station. Localized power sources have many advantages, including psychological independence, and so no one would require that all power come from an SPS. Industries may need more concentrated power sources than dispersed ground systems can deliver, and many environmental advantages could come from powering industrial facilities with clean SPS energy instead of ground-based fossil fuel or nuclear polluters. Space systems could reduce political tensions by making nations less dependent on specific geographic fossil fuel deposits such as Persian Gulf oil.

Finally, note that much of the power from SPS systems will ultimately be used by the space cities themselves. We envision that much future industrialization will occur in space, thus saving Earth not only from pollution associated with energy production, but also from the ravages of deep ore mining and from smelter pollution. Furthermore, studies of current societies on Earth show that conventionally defined standards of living in various countries are remarkably correlated with power consumption per capita. Therefore, we could imagine that space cities, by investing a small percent of their effort into construction of new solar panels, could ultimately have "energy to burn," becoming major industrial centers and achieving high standards of living for their inhabitants as well.

The first baby born in the new world of space (Virginia Dare ——?) is introduced by her mother to Earth, the mother of us all. Introduced to weightless environments at an early age, the baby may find them natural and enjoyable but would live under at least partial gravity in other regions of the rotating space city.

ROBOT ASTRONAUTS

Suppose you wake up one morning to discover that you and 200 companions have been cast up on a remote, uninhabited island with no hope of imminent rescue. In a few years, you establish a settlement and children arrive; but you begin to deplete the game supply, as well as the timber supply you use for fuel and housing. At the same time, you build boats and learn to navigate the bays and reefs around your island, occasionally venturing out onto the open sea. For the moment, your community is thriving, but its very prosperity portends future crisis. You can predict, not necessarily a disaster, but a change in lifestyle. The island won't support an ever expanding population. Even with a constant population, you may have to shift to materials that are different from those you have been using—perhaps with more emphasis on those from the sea.

During this period, explorers from your community have climbed the highest mountains and sighted a number of other islands barely visible in the haze around the distant horizon. Some of them may be desert islands; some may be mere rocks with colonies of birds and seals; some may have forests. Even if they are poor in the materials you use now, these islands may have other materials you could adapt to your purposes. You won't know until you go look.

At such a moment in your community's history, you would probably adopt a fourfold plan of action: 1) discourage population growth, 2) emphasize conservation of raw materials, 3) start a program to identify substitute materials, and 4) begin construction of large boats to allow navigation forth and *back* from the other islands.

This story, of course, is a metaphor for where we are now. We have established a thriving community, and our population is getting too big for our island. A few hundred years ago we *did* wake up to discover our isolation on island Earth as well as an amazing fact: certain pinpoints of light in the night sky are other islands. At first we thought they were like ours. With his new telescope, Italian naturalist Galileo Galilei in 1610 recognized Venus and Mars as globes and tracked four moons moving around Jupiter. By 1800 English astronomer and composer William Herschel could see polar snowfields and clouds on Mars; he propounded "the plurality of worlds"—the idea that the sky is full of worlds like our own. Then we discovered that the worlds are not all like Earth. By 1900 American astronomer Percival Lowell correctly concluded that Mars was drier and colder than Earth, but incorrectly claimed evidence of intelligent life there. By 1965 Mariner 4 had shown that there are no civilizations on Mars. Other probes showed the moon and other worlds to be barren and rocky. Still later probes revealed worlds of ice.

Which brings us to unmanned probes. Unlike lost islanders, we do not have to launch manned ships to explore our nearby islands. We have the luxury of sending robot probes to tell us what they are like *before* we go there ourselves.

As shuttles and space cities establish our permanent presence in near-Earth space, robot probes will continue to push the frontiers of exploration to greater distances. The table on page 66 summarizes some of the expected probe missions, based partly on recommendations by a major 1983 NASA program plan. Recalling the origins of interplanetary probes in the mid-1960s, we may well say that the interval 1965 to 2000 will be the golden era of space probes. After that, interplanetary scientific probes may fade in importance as *people* expand the space frontier.

Probing Halley's Comet: An International Adventure

Comets are primordial planetesimals of ice and soil that have been stored in the frigid outer parts of the solar system since the beginning of its history. In the outer solar system, they move very slowly; however, their orbits occasionally take them into the inner solar system, where, following Kepler's laws, they move very rapidly (orbital speeds reach as high as 100 km/sec or more). Therefore, although they may spend thousands of years out of sight beyond the orbit of Pluto, they may pass through the innermost solar system in only a few months. A few comets, during their trip into the inner solar system, happen to pass close enough to Jupiter or some other planet to have their orbits altered by the planet's gravity so that they never return to the outermost regions. On their new orbits they may circle the sun every few years or, in the case of Halley's Comet, every 75 to 76 years. On its last loop through the inner solar system in 1910, Halley's Comet appeared to be spectacular because it passed near Earth. As it heads around the sun in 1986, its appearance will not be so spectacular because Earth will be on the far side of the sun from the comet's location. But this time we will be ready to reach out to Halley's location for an even closer look than we had in 1910. We will send probes there.

Astronomers have known for years that Halley's Comet would return in 1985–86, but they could not be sure of the exact date because of minor changes in the comet's orbit due to planetary attractions on each trip around the sun. Therefore, a race was on in the early 1980s to see who could first locate the comet on the inward leg of its journey so that its precise orbit could be measured. This race was won by Cal Tech astronomers in the fall of 1982, when the comet was picked up beyond Saturn's orbit. Then the comet was tracked, and soon the precise location could be predicted for each day during the 1986 pass through the inner solar system.

Meanwhile, space engineers in various countries planned probes to meet the visitor. American space scientists vigorously promoted a Halley probe, but during those years a congressional

The United States, while not among the several countries sending probes to Halley's Comet, may prepare special payloads of large telescopes to study comets from the space shuttle in Earth orbit.

William K. Hartmann

William K. Hartmann

A space probe penetrating into the heart of a comet is within sight of the 3-mi-diameter nucleus, seen through a haze of dust and gas, but is threatened by out-rushing swarms of dust grains and ice chips. Jets of gas, fed by subliming ice, expand in streamers from the nucleus. Such an environment may greet Europe's Giotto probe as it nears Halley's Comet.

mood of austerity cut dollars out of a NASA budget already pinched by shuttle development costs. So Congress decreed that America would not participate in the close-up study of Halley's Comet.

In Europe the consortium of countries that had formed the European Space Agency (ESA) began building what is probably the most sophisticated Halley probe. Named Giotto, after the Italian painter Giotto de Bondone who witnessed the 1301 passage of Halley's Comet and painted one of the first realistic representations of it in a chapel fresco, this cylindrical spacecraft is nearly 3 m (10 ft) tall and carries a multicolor telephoto camera, dust detectors and devices to measure cometary gases. It will be targeted within 500 km of the nucleus deep inside the comet's head, which is composed of gas and dust.

In Russia engineers began building two spacecraft named VEGA 1 and 2 (from the Russian spelling of the probe name VEnera-GAlley). Each of the two vehicles, after independent launches in December 1984, will carry a Venera lander to Venus and then use the gravity of Venus to swing the Halley probes toward the comet. Each probe, equipped with wide-angle and telephoto cameras and other instruments, may be targeted at different distances, such as 1,000 and 10,000 km from the comet. Even at 10,000 km, the cameras can record features as small as 200 m across.

In Japan space technicians at the Institute of Space and Astronautical Science (ISAS) began building a probe called Planet A. The smallest of the probes, Planet A is only about 1.4 meters (4½ feet) across. Carrying two instruments, an ultraviolet telephoto camera and a solar wind analyzer, it will probably be targeted farthest from the comet to obtain a broad view of the streamers of dust and gas around the comet nucleus while the other probes photograph the nucleus itself.

The nucleus is predicted to be a chunk of dirty ice, or a loose agglomeration of such chunks, about 5 km (3 mi) across. All the probes will encounter the comet between about March 8 and 15, 1986, when it will be closer to the sun than the Earth is. Because of the sun's heat, the ices in the nucleus will be furiously subliming (i.e., turning to gas and blowing off into space). This process forms the head and tail of a comet—the diffuse region of gas and dust around the nucleus, and the streamers pushed away from the comet in the anti-sun direction by sun-generated gases called the solar wind. As the ices wear away from the surface layers, they dislodge particles of dust and grit that are also blown outward from the nucleus. Many of these will be microscopic, but some may be larger. Perhaps house-size chunks of dirty ice will break away as well. Radar studies of a comet that passed near Earth in 1983 showed that its nucleus consisted of not one large object, but a swarm of small objects, possibly pieces that were temporarily separated by gas pressure but would fall back together again as comet activity decreased.

We are not sure what to expect in the mysterious heart of Halley's Comet, except that it will be a dangerous environment for a spacecraft. Giotto is targeted so close that it will possibly be destroyed. It will be exciting to watch and wait as it plunges deeper and deeper into Halley's cloud of dust and gas. Will it show us eruptions of gas and floating icebergs drifting off the nucleus? Will the true nucleus be hidden from the cameras by a veil of dust and hazy gas? Will the mirror that protrudes from the dust shield (to reflect light to the safely hidden camera) become sandblasted by microscopic dust grains so that the image gradually fades away as Giotto approaches? Or will we receive clear images until the whole probe goes dead, hit by some large chunk? Will we know what hit us?

American space explorers, accustomed to a leadership role, have been frustrated as they sit on the sidelines while colleagues in other countries prepare to visit Halley's Comet. To take a cheery world-view, adopting the point of view of the human species, we have a pretty good mix of Halley's Comet probes. All the countries involved will share data, and humanity will learn a lot. A disinterested outsider might argue that it's just as well for the Americans to work on other projects, such as the Galileo Jupiter probe, and continue expansion of the space shuttle

Future Unmanned Probes of Other Planets

PROBES UNDER CURRENT DEVELOPMENT	HIGH-PRIORITY NASA-RECOMMENDED U.S. PROBES	OTHER PROPOSED OR POSSIBLE PROBES
Giotto: European probe to Halley's Comet. Launch, July 1985; targeted no more than 500 km from comet nucleus; high-resolution camera, dust-counting microphones, etc. Arrival, March 1986.	**Mars orbiter:** Will refine geochemical and climatological data about Mars, and map compositions of soils and rocks.	**Lunar geoscience orbiter:** Polar orbiter to complete chemical mapping of moon and search for possible ice in shady crater floors at pole. Curiously, Apollo-era orbiters did not complete these tasks.
Vega 1 and 2: Soviet probes to Halley's Comet. Launch, December 1984. Cameras, spectrometers, etc. Arrival March 1986.	**Asteroid fly-by and comet rendezvous:** Mariner Mark II (low-cost upgrade of old Mariner probes) flies past a main-belt asteroid and goes on to meet a comet; makes close-up photos and measurements of dust and gases. Launch, early 1990s(?).	**Mars penetrometers:** Torpedo-shaped probes to bury themselves in Martian soil, make seismic measures, search for ice, test soil composition. Cheap, can be landed at many sites.
Planet A: Japanese probe to Halley's Comet. Launch, August 1985. Camera, solar wind analyzer. Arrival, March 1986.	**Titan probe:** Drops probe with cameras and chemical analyzers for trip through atmosphere and beneath clouds. Fly-by vehicle or orbiter carries out additional radar mapping of surface topography.	**Asteroid penetrometers:** Same type of penetrator to be sent to asteroids to discover internal structure and composition differences between asteroids of different spectral type. Probable minimum of 4 per asteroid.
Galileo: U.S. probe to parachute into Jupiter's atmosphere: orbiter will map Jupiter moons in detail.		**Io penetrometers:** Similar devices to bury seismometers on Io and measure the crystal structure as well as the degree of stability and seismic vibration in the surface layers.
Venus radar mapper: U.S. probe to orbit Venus and map surface beneath clouds to 1-km resolution and 100-m accuracy in elevation. Under early development.		**Comet and asteroid sample return:** Lander scoops up samples, sends return capsule to Earth. Return of a sample from these low-gravity bodies would be relatively easy.
		Mars rover: Wheeled vehicle with long lifetime could be driven to geologically exciting sites for close-up photos and sampling. Remote-controlled from Earth.
		Saturn orbiter and ring probe: Will complete mapping of icy satellites and send probes into different regions of rings to clarify nature of ring particles and their relative spacings.
		Neptune/Pluto probe: Designed to clarify nature of Neptune's large moon, Triton, and its possible liquid nitrogen oceans; also, other details of the Neptune and Pluto/Charon systems.

The American Galileo mission to Jupiter will parachute the first probe into Jupiter's mighty clouds. It may give us the first good information about the lightning-streaked lower clouds and the regions below them. An orbital module will remain above Jupiter to study the satellites, one of which is seen in the upper right.

Ron Miller

William K. Hartmann

As if cruising along a giant racetrack, a hypothetical future probe sails 300 km (190 mi) above Saturn's rings. The probe will descend into the ring plane and make the first measurements among the particles that compose the denser parts of the rings. Clumpy ringlets, dis- *covered by Voyager probes, run along the middle of an inter-ring gap, through which is seen the distant sun. The mechanism producing the gaps and narrow ringlets is uncertain. Angular width of wide-angle view: 90°.*

capabilities. However, there is a real issue of how many opportunities a country can pass up before it begins to lose its technical cutting edge and its best minds drift off to other projects or more exciting agencies in other countries.

Therefore, not content to sit idly by, American space technicians have invented their own makeshift comet mission without even building a new spacecraft. The third International Sun-Earth Explorer, or ISEE-3, was launched in 1978 with no thought about comets—its purpose was to measure the solar wind. It has fuel for limited maneuvers. Engineers recently maneuvered it into a series of five close flyby encounters with the moon, during which the moon's gravity altered the probe's orbit. On the fifth encounter it passed within 100 km of the moon and zipped out into interplanetary space toward a comet called Giacobini-Zinner. On September 11, 1985, ISEE-3 will pass within a few thousand kilometers of Comet Giacobini-Zinner. Although ISEE-3 carries no cameras, it will be able to measure the gas environment near the nucleus. Thus, though it will provide no photos, it will make the first direct measurements in the head of a comet, beating the more advanced Halley probes by six months.

Future Probes

The table on page 66 lists many other probes in addition to the flotilla of comet probes in the next few years. One of the most exciting missions will be that of Galileo, carrying a probe to be dropped into Jupiter's satellites. Galileo is the last U.S. probe built under the philosophy that each major new probe should mark a major advance in the state of the art of spacecraft building. Under this philosophy, for example, the Surveyor moon lander was a major leap ahead of the earlier Ranger crash-lander; the Viking Mars orbiter and lander advanced over the Mariner Mars orbiter and the Voyager that mapped the Jupiter and Saturn moons was a quantum jump ahead of the earlier Pioneer. Galileo marks a major leap forward from the capabilities of Voyager. In addition to probing Jupiter, it will be able to

Pamela Lee

move among Jupiter's satellites during a period of 20 months for detailed mapping and monitoring of Io's volcanic eruptions.

During recent years of austere NASA budgets, the decision has been made to depart from this philosophy of stepwise advance. Near-future probes will probably be based on low-cost redesign of an earlier generation of probes. Nonetheless, exciting explorations are possible. Radar mapping of Venus is an example. An orbiting probe sends a radar beam through the opaque clouds. The beam bounces off the surface, measuring altitudes and roughness of the topography. Pioneer Venus in 1978 made planetwide radar maps of Venus in this way, showing raised, continent-like plateaus and rolling plains. Mountains higher than

A future probe makes the first soil composition measurements on the surface of Mercury. The crater in the background is cut by a giant fault, or fracture. The sun is mostly hidden behind the spacecraft antenna, revealing the glow of the inner zodiacal light caused by sunlight reflection off dust particles along the plane of the solar system. The bright "evening star" at far left is the distant Earth.

Everest appeared to be volcanoes. Vague depressions appeared to be impact craters. The smallest details resolved were around 100 km, and better resolution was desirable in order to understand the nature and implications of these geologic features.

American engineers designed the Venus Radar Mapper to achieve this by mapping details as small as 1 km. Even as this mission was being prepared for flight in the mid-1980s, the Russians put two radar mappers into orbit around Venus in 1983. Their orbits allowed detailed mapping only in high northern latitudes, but the images approached kilometer-scale resolution. In March 1984, about two weeks *before* the Russians released their new Venus radar images publicly in the Soviet Union, a delegation of three Russian scientists attended the annual international Lunar and Planetary Science Conference in Houston and presented their astonishing pictures to American and European colleagues. Their slides showed intricate geologic structure around a plateau called Ishtar Terra. While the plateau top was relatively level, the zone around it was broken by a maze of knife-edge ridges and valleys, sometimes curving around 300-km-wide volcanic domes resembling those already seen on Mars. Here and there the scene was dotted by 100 + -km impact craters, often showing a double-ring structure. The ridge maze faded into rolling plains farther from the plateau. From the number of impact craters, the Russian analysts estimated the plains to be about a billion years old, perhaps implying less geologic activity—less youthfulness in the terrain—than is found on Earth.

This wealth of new information slightly tarnished the glow of the planned American orbiter, which would now have to aim for more complete global coverage and perhaps slightly higher resolution. Nonetheless, American researchers and probe planners, thrilled to see the lay of the land on our mysterious sister

Facing page: Future probes may explore the outskirts of the solar system. Here a spacecraft sails past Pluto's moon, Charon. Pluto itself, subtending nearly 9°, is in the upper left. The starlike distant sun, upper right, appears like a nearby streetlight. Angular width of picture: 42°, approximately that of an ordinary snapshot.

Right: Penetrators offer an inexpensive way to study surface and interior properties of asteroids and other bodies. As demonstrated already on Earth, these torpedo-shaped probes can penetrate rock, soil or ice and emplace various instruments. Data are transmitted to a mother ship by an antenna in the protruding tail section.

Ron Miller

Ron Miller

Facing page: Because humans may not be able to land on hot, high-pressure Venus for many years to come, space researchers might attempt to rocket soil samples up to orbiting vehicles. American orbiters and Russian landers have discovered lightning among Venus' clouds.

Left: A future probe may investigate the peculiar structure of Uranus' system of narrow individual ringlets. The cause of its difference from the broad, subdivided ring system of Saturn is unknown.

Venus, gave the Russians a long ovation for a job well done.*

The implications of the Russian and anticipated American detailed maps of Venus will take years to determine. We are unlikely to explore Venus during this time, because its deadly

*Following the Russian tradition of giving small gifts to reaffirm friendship, one of our planetary geologists came up with his expired Texas license plate. It spelled CRATER. A group of us who had studied Venus geology autographed the gift and presented it amidst smiles and handshakes to the beaming Russians. There is a poignant joy in sharing friendship with foreign colleagues as you realize silently that your governments are engaged in a life-threatening struggle. A thought occurred as we shook hands. Resolving problems—and resolving detail on Venus—is perhaps more important than "winning" confrontations.

840°F temperatures and its crushing air pressure 90 times that on Earth. But Venus probes will allow us to address a variety of questions that reflect back on Earth's mysteries. Does Venus really have continents? If so, is there any sign of continental drift, as on Earth? Are the low plains like our seafloors? Are the high mountains really volcanoes, as suggested by Pioneer scientists who mapped clusters of lightning flashes around them? Subsequently, other scientists found that Venus' atmosphere has dramatic, rapid changes in sulfur dioxide, a gas produced by volcanoes; this supported the idea of active volcanoes on Venus. To explain the sulfur dioxide behavior, scientists postulated a

huge volcanic eruption on Venus in the mid-1970's. Will we one day witness titanic outbursts under the lightning-laced clouds at Venus?

Each planet and satellite yields its own similar set of questions. In most cases, we will want to send probes before astronauts venture too close. For instance, a lander on Mercury could give the first direct data on that planet's composition. And what lies beneath the murky smog of Titan? Chemical theorists in 1983 suggested that Titan may be covered mostly by an ocean of liquid methane and ethane. We would like to know more of this strange world before we commit a manned lander to descend below the clouds! Similarly, unmanned vehicles should be the first to touch down among the active volcanoes of Io. We need to know whether its surface is relatively still or is constantly shaken and broken by seismic tremors from the mighty volcanic blasts.

To take a fourth example, Saturn's rings offer a vast field of curious, drifting ice particles. What are their shapes? Do they collide? Do they erode each other, aggregate and re-form? How are the micro-gaps in the rings maintained? The rings would be an extraordinary environment, dangerous because of the close crowding of the ring debris. Future probes may literally blaze the trail into the rings, perhaps bumping and chipping their way among the ring particles.

An interesting device called a penetrometer has been developed to drop instruments by airplane into remote regions on Earth. A strong, torpedo-shaped probe with a finned, detachable rear section, the penetrometer enters the ground vertically or at an angle and can reach a depth of several feet in many materials. It can even penetrate solid rock and has been demonstrated to work in lava flows. The rear fins catch at the surface and hold the aft section there, while a cable reels out to maintain electrical contact with the descending front end; a thin antenna protrudes above the surface from the rear portion, allowing signals to be transmitted from instruments in the buried penetrometer to an overhead spacecraft receiver. Such devices have been used not only to monitor ice motions and structure in arctic icefields, but also with sensitive microphones to monitor troop movements during the Vietnam war. They are ideal for planetary exploration. They are well suited for seismic studies, heat-flow measurements and compositional sampling because they are actually in contact with the ground rather than up on rickety legs like the instruments in the Viking lander. A basic design can be built and used throughout the solar system. Three or four penetrometers carrying seismometers could land on a planet and establish a seismic array. The location of any natural earthquakes (planet-quakes?) could be triangulated with this array. An explosive missile could produce a controlled seismic signal that would allow measurement of subsurface properties. Thus penetrometers could measure the internal structures of asteroids, detect seismic tremors from earthquakes or volcanoes on Mars, Venus or Io, or search for ice buried in Martian permafrost layers.

All the probe missions described in this chapter will help us understand the environments that we will be entering as we leave the cradle. They will tell us about the materials that are available, the radiation hazards, the stability of surfaces and other properties. They will help us prepare at least sketchy guidebooks for the first astronauts who go to see these places for themselves.

RETURN TO THE MOON

Four and a half billion years ago, as the planets were forming, primordial Earth somehow acquired a large companion. Before Apollo, some scientists thought the moon aggregated from the same planetesimals that made Earth, in a region nearby. But that didn't explain the contrast between Earth's large iron core and the moon's virtual lack of iron. So other scientists argued that the moon formed in some other part of the solar system, where compositions were different, only to be captured later into an orbit around Earth. But proponents of this theory never gave a convincing argument that such a capture was likely. Other scientists, also before Apollo, thought the moon might have spun off the outer layers of Earth, perhaps because Earth was spinning faster than most planets. This process has been called fission. If Earth's iron had already drained to the center to form the core, then formation of the moon by fission could explain why it has very little iron. But the fission theory was little favored because it could not explain how enough energy was available to throw the material off Earth. Thus no pre-Apollo theory seemed adequate! One scientist quipped that the moon must not exist since no one's theory could explain it.

By bringing back ancient lunar rocks for laboratory studies, the Apollo program was supposed to answer the age-old question of the moon's origin.

What We Learned from Apollo

Apollo provided new information about the moon *and* Earth but did not solve the mystery of the moon's origin. It showed that the moon's material was low not only in iron, but also in so-called volatiles—the materials such as water and gases that can be driven off easily by heating. This suggests that all the moon's material may have been heated by some process in a form where volatile gases could easily escape. Aside from these differences, the moon's material resembles the rocky material forming Earth's outer region, or mantle. Certain minor chemical differences leave questions about whether the moon's material (or part of it) could once have been part of Earth's mantle, as in the fission theory.

To explain the origin of the moon from Apollo data, some scientists (including the author) suggested that a giant impact—

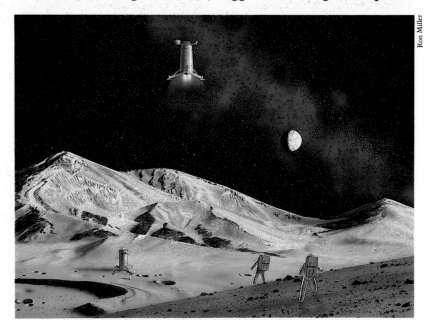

Ron Miller

A future generation of Earth-moon vehicles, derived from upper-stage boosters, deliver astronauts and supplies in the first post-Apollo expedition.

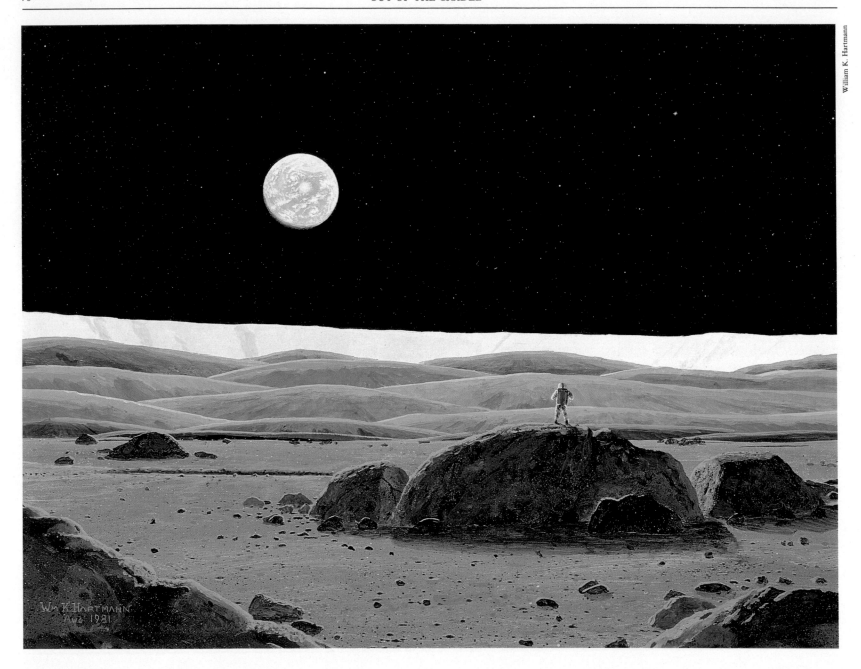

of one of the last, largest building blocks of Earth—might have blown upper-mantle material into a circumterrestrial cloud of fine, hot dust. This dust would have had little iron if Earth's core had already formed, and volatiles such as water would have easily escaped into space. The dust then might have aggregated to form the moon or might have been swept up by a small proto-moon already orbiting Earth. This theory is, at least, not short on spectacle! Imagine a huge, moon-size (or even larger) asteroid crashing into Earth at perhaps 20 km/sec. The explosion would have looked like slow-motion time-lapse photography, with the asteroid requiring minutes to crash into Earth. A vast cloud of debris would have billowed outward during the next hour, expanding and enveloping all Earth in a shroud of dust. Did such a spectacular event ever occur? Perhaps. The random chanciness of such a late collision could explain why Earth has a large moon, while Mercury, Mars and our twin sister Venus do not. To give a final answer, scientists will need better analytical methods and perhaps a wider variety of older, more deep-seated lunar rocks.

While the Apollo expeditions yielded only tantalizing hints about the moon's origin, they did answer many other questions about the subsequent history of the moon . . . and the history of Earth as well. Prior to Apollo, Earth's initial history was little known because continental drift has crushed, buried and melted almost all Earth rocks older than 3 b.y. (three billion years). Thus we had very little record of what happened in the Earth/moon system from 4½ b.y. (birth date) to 3 b.y. (oldest abundant Earth rocks) ago. This was the mysterious adolescence of Earth—its formative years. Apollo samples showed that almost *all* moon rocks are *older* than 3 b.y. and revealed an extraordinary history of intense cratering in the formative years. Using crater counts and dates from the six American and the three

Looking homeward. A lunar astronaut pauses atop rubble in a crater floor to gaze at the full Earth. The sun is rising behind us, illuminating the far crater wall. The crater floor is lit only by blue

Earth-light. Earth subtends 2° in the lunar sky, appearing four times as big as the moon seen in our sky.

Russian probe landing sites, researchers showed that the moon (and nearby Earth) underwent an enormous initial bombardment from 4½ to 4 b.y. ago. This was part of the sweep-up of the last planet-forming debris. The cratering rate before 4 b.y. ago, more than a thousand times the present rate, smashed the primordial rocks so that even on the moon we have only rare, scattered chips of rocks older than 4 b.y. Future lunar explorers will search for better examples of the oldest lunar materials, with clues to the events of genesis.

Combination of data on rock chemistry, rock structure, cratering and geologic landforms fills in many details of the moon's history. About 83 percent of the moon is covered by ancient, heavily cratered uplands. This is the oldest part of the moon—hilly, rolling terrain, composed of crater upon crater. The rocks here are made almost wholly of a mineral, common on Earth, called feldspar. The lightest of the common minerals, feldspars tend to float to the surface as they form in a mass of molten rock, or magma. Heavier minerals, like iron, sink. Thus lunar highland rocks apparently formed when feldspars floated and aggregated in a primeval magma ocean, estimated to be several hundred kilometers deep, about 4.4 b.y. ago. It was a vast, sluggishly churning mass of molten lava. The thin crust of solid, feldspar-rich rock forming on its surface was constantly broken by impacts, splashing glowing spray into a chaotic mixture with older, broken rock.

Gradually the magma ocean cooled and solidified. The crust thickened. From 4.4 to 4.1 b.y. ago, the magma ocean mostly solidified and the cratering rate declined toward its present value. During this era, cratering pulverized the upper few kilometers of rock, creating a layer of dust and chips 1 to 3 km (⅔ to 2 mi) deep. This layer is called the megaregolith (from Greek, meaning deep, rocky layer). Also during this era, asteroid-size planetesimals up to at least 150 km (93 mi) across smashed into the moon and Earth, forming huge crater-like basins as wide as 1,200 km (750 mi). A dozen such basins are still prominent among the more numerous smaller craters. Fractures

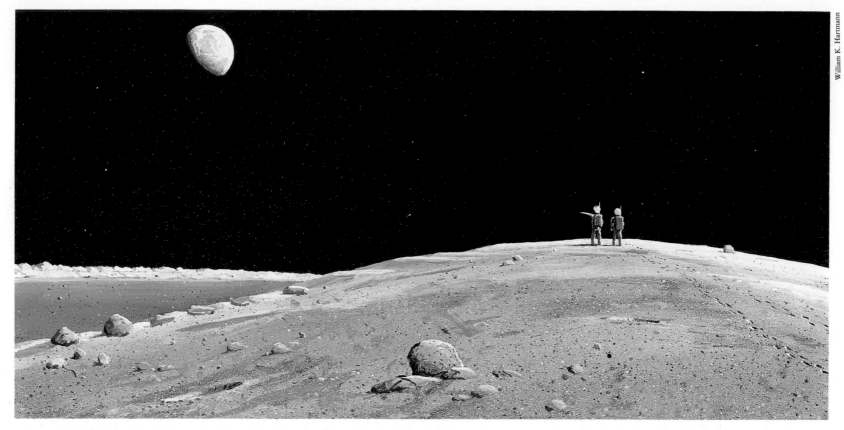

William K. Hartmann

Lunar discovery. On a large crater's rim, astronauts spot orange mineral deposits on the crater's far wall. Apollo astronauts found small patches of orange soil that turned out to be volcanic.

under and around the basins tapped the remaining pockets of buried magma, releasing surging lava flows that inundated many of them. In this way, vast plains of dark, flat lavas formed. Covering the other 17 percent of the moon, they are visible to the naked eye from Earth and form the features of "the man in the moon." These plains are called maria (pronounced *mah'ree-ah*; singular mare, *mah'ray*), from a Latin root for "oceans," because the early lunar observers mistakenly thought they were bodies of water. Thus, for example, the first lunar astronauts landed in the rock-strewn, gray lava plain, Mare Tranquillitatis, or the Sea of Tranquillity. (It should have been the Sea of Excitement, but alas, no such name appears on lunar maps.)

Some of the oldest mare plains were so battered by impacts that they are masked by bright ejecta and pits. Other plains experienced lava flows as recently as 3.2 b.y. ago and are fairly well preserved. Subsequent cratering pulverized the upper layers of these lavas, creating a 10-m (30-ft) layer of dust called the regolith. After 3 b.y. ago there was little activity on the moon, except for sporadic explosions as modest-size asteroids fell and created craters up to about 100 km (62 mi) across.

Future Scientific Goals of Lunar Exploration

This sketchy biography of the moon, begun by Apollo, is an unfinished story. As with any good piece of scientific work, it leads to additional interesting questions about finer levels of detail. Curiosity, then, is one of the motivations for a return to the moon. Our decade of studying Apollo samples tells us the questions we want to investigate next. Where *did* the moon come from? Can we find examples of 4½-b.y.-old rock fragments that clarify the moon's earliest history? Can drilling of ancient highlands reveal deep-seated lunar rocks that could tell us more about the moon's relation to Earth? What was the composition of the impactors that formed the big basins? Where did *they* come from? What was the precise history of the cratering process? Did the cratering rate decline smoothly from the beginning or were there episodes of increased cratering due to breakup of large asteroids and scattering of their fragments toward the inner solar system? Has there been any recent volcanism?

If we could answer these questions about the moon, we would learn about Earth at the same time. The population of meteoroids hitting the moon also hit Earth and may have blasted away crust in some areas, piling it up in others—a process that may have helped define the original seafloor basins and continental masses. Was primordial cratering intense enough to interfere with the beginnings of life on Earth?

While the net effect of cratering creates a dusty regolith, the larger individual impacts of the last billion years have blasted it away. This exposed bare rock surfaces, young, large craters that offer some of the most spectacular scenery and exciting scientific opportunities on the moon. Their rough interiors contrast with the dull but safe landing sites selected for Apollo expeditions. The most remarkable of the fresh, large craters is the 90-km (56-mi)-wide bowl Tycho, whose brilliant interior and long, bright streamers of ejecta create a bright patch that can be seen by the naked eye from Earth. Tycho's age is estimated to be only 100 to 300 million years—young for a major lunar feature. How fresh would it look at close range? In 100 to 300 million years, micrometeorite sandblasting could have produced a regolith only about 0.2 to 0.5 m (8 to 20 in) deep. Orbiter photos confirm that the floor of Tycho is not a dusty plain, like the floors of many craters, but a fascinating mass of contorted hillocks, ragged flows and jagged knobs.

Imagine future geologists attempting the first traverse of Tycho. They descend the crater wall among jagged slabs of rock upended by the impact explosion. Here the slabs jut out in nearly pristine condition; there the slabs are covered by landslides or pools of lava triggered by the heat of the impact. Crossing the floor, the explorers encounter odd fractured hillocks and boulders of fractured, glass-splashed rubble. They cross shadowy cracks and fissures, sometimes dangerously masked by rubble and regolith. Their destination is the complex of central peaks thrust up out of the floor during the last minutes of the explosion as deep-seated rock layers rebounded upward, like the bead of liquid rising from a coffee surface during the splash of a cream drop. These peaks may contain unusual minerals, formed in deep layers that are otherwise unaccessible, as shown by spectroscopic studies by Brown University researcher Carle Pieters.* Her spectra of Tycho's central peak indicate the unusual presence of a coarse-grained rock type called gabbro, formed from magma that cooled at depth. In the similar-size young crater Copernicus she found a still rarer rock type rich in the iron-magnesium silicate mineral olivine, which is generally formed only at considerable depth.

Thus future explorers will visit Tycho and similar craters for three reasons: to seek knowledge of the events that formed so extraordinary a natural feature; to learn what unique, deep-seated lunar materials it may reveal; and to experience the awe of standing in the midst of a well-preserved, twisted landscape produced within a single hour by a silent cosmic explosion long before humans appeared on Earth.

*This work is reported by Pieters in *Science*, 215:59 (1982); and by Pieters and her co-workers in *Bulletin of the American Astronomical Society, 15*: 838 (1983).

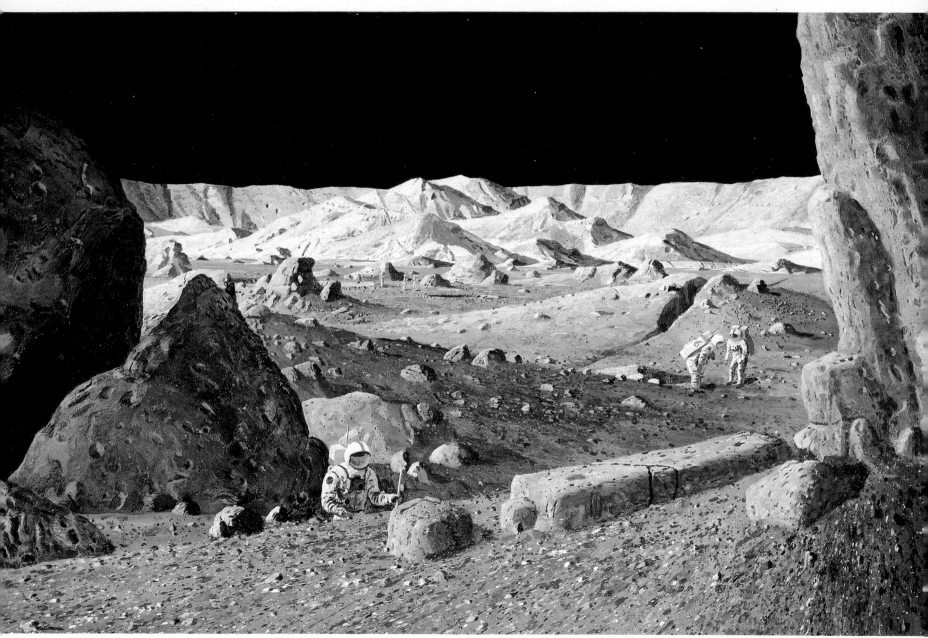

William K. Hartmann

Other Sites to See

There are other unexplored sites on the moon that offer unique scientific and scenic possibilities. A century ago the winding valleys called rilles, usually about a mile wide and many miles long, were considered to be possible riverbeds. But since Apollo proved the absence of lunar water, we know this is incorrect. They are probably lava flow features, although the exact mode of formation remains unknown. Apollo 15 astronauts drove their rover to the edge of one such rille but did not climb down into it or determine its cause. Its floor appeared covered by dust and rubble eroded from the walls, where lava flow strata could be seen in cross-sectional profile. On Earth somewhat similar features have been formed by the collapse of lava tubes, which are long caves formed in lava flows. Future exploration of lunar lavas and rilles might reveal entrances to such caves that perhaps could be sealed and pressurized to serve as ready-made shelters.

Fault scarps are long cliffs created when faults, or fractures, broke the surface. One of the most famous is the Straight Wall, about 100 km (62 mi) long and 250 m (800 ft) high. The Straight Wall breaks the lava plain of Mare Nubium (Sea of Clouds) and is a familiar landmark to generations of backyard telescope observers. Though marked by a few meters of regolith on their slopes, such cliffs may expose interesting cross sections of the lava flows that filled lunar basins 3½ to 4 b.y. ago.

Crater chains are neat rows of craters stretching in lines 100 km (62 mi) long or longer. Their straight-line geometry shows they do not form by impacts, which would be more randomized; rather, they form along underground fracture lines, sometimes by collapse but more often by volcanic eruptions, which build up raised rims on many of them. Related features

Russian cosmonauts visit the impact craterlet made by the Lunik probe, which crashed into the moon in 1959 and thus was the first human-made object to reach another world.

On the floor of Tycho crater, the freshest-looking of the large lunar craters. Orbiter photos have shown a much more rugged, craggy surface than in older lunar areas, which have been sandblasted smooth by micro-meteorites. The contorted features, central peak (mid-distance, 7 mi away) and rim (background, 25 mi away) were formed by the gigantic explosion of an impacting asteroid several miles across. A portion of the Big Dipper can be seen in the northern sky.

are volcanic dark-haloed craters, usually formed along rilles or grooves. Here dark aprons of ejected volcanic debris blanket the surrounding land. Famous examples lie in the 110-km (70-mi) crater Alphonsus, near the center of the moon's disk. Future lunar geologists will want to understand the materials and mechanisms of these ancient eruption sites.

Alphonsus is famous for another mysterious phenomenon. In 1958 Soviet astronomer N. Kozyrev obtained a photographic spectrum indicating a pinkish glow of gas containing carbon molecules near the central peak of Alphonsus. Some researchers interpreted this as evidence of a volcanic gas eruption, consistent with the dark-haloed volcanic pits in the same area. Others found the evidence questionable, since the photographs were of uncertain quality and volatile gases are rare on the moon. Nonetheless, several American observers at Arizona's Lowell observatory confirmed red glows in a different crater, Aristarchus, in 1963. This 47-km (29-mi) crater, the brightest on the moon, has long

been known to be peculiar. Orbiter photos show fissures and lava flow-like features on its rim, near some of the red glow sites. Spectral studies reported in 1983 indicated that Aristarchus rock types are unusual for the lunar surface and are possibly deep-seated, olivine-bearing, glassy lavas. Are some lunar regions, such as Alphonsus and Aristarchus, still the sites of occasional volcanism, even though most lunar volcanism ended 3 b.y. ago? Do they expose rare minerals or release rare gases? The answers await the first lunar explorers who approach the central peak of Alphonsus or ascend the rim of Aristarchus to gaze along its fissured crest and across its brilliant floor.

A historical curiosity suggests another intriguing site to visit. About 230 km (143 mi) over the Apennine Mountains from the Apollo 15 landing site, in the Sea of Serenity lava plain, lies a small, bright craterlet called Linné. During the early days of lunar mapping, in the 1800s, Linné stirred controversy and puzzlement. According to English astronomical historian Patrick Moore, several German observers in the 1830s mapped it as a prominent landmark and described it as a deep crater nearly 10 km (6 mi) across—deep enough to hold prominent shadow even when the sun was 30° above the horizon. In 1866, however, German-Greek observer Julius Schmidt, who had recorded the crater in the 1940s, concluded that it had disappeared! His announcement, equivalent in Moore's charming phrase "to the complete disappearance of a town such as Nottingham from the map of England," caused a sensation. The moon had already been declared geologically dead and unchanging, yet observers confirmed that the feature shown on earlier drawings was gone, replaced by a small, bright crater sometimes seen as lying on a low dome. Modern Apollo photography confirms this craterlet, about 4 km (2½ mi) across, with a sharp, boulder-strewn rim and a bright, hummocky ejecta blanket. It seems to be an unremarkable but relatively fresh impact crater. Surely the old observers were mistaken: we might be able to believe that a historic impact had wiped out an earlier, *smaller* crater, but it's hard to believe that a 4-km crater could have wiped out a 10-km crater! Even though I can't bring myself to believe a major change has occurred in Linné, my curiosity is piqued. I would love to spend a day hiking around its rim, climbing down inside to examine its inner walls and poking among dunes and pits made by the ejected material . . . just to make sure.

At the other end of the size spectrum is a feature that may take years to study: the Orientale Basin, a vast impact structure surrounded by concentric rings of inward-facing cliffs as much as 1,300 km in diameter. Because this basin system is located at the extreme edge of the moon as seen from Earth, it was not discovered until 1962*—even though it is visible from Earth! For the same reason, Earth would always hang low on Orientale's horizon or occasionally dip below it. Global mapping has revealed that Orientale was the last major basin formed on the moon, perhaps about 4 b.y. ago. Its ejecta spreads in radial streaks over hundreds of kilometers. Lava has flooded only its innermost central region and a few arc-shaped strips along the bases of some of the cliffs. The body that hit the moon to form Orientale must have been about 100 or 150 km (60 to 90 mi) across, as big as the larger surviving asteroids. Was it indeed a rocky or metal asteroid resembling the meteoritic material that

*I retain a paternal interest in Orientale Basin; I helped discover it. In 1962, while trying to improve lunar mapping in the early stages of the *Apollo* program, astronomer G. P. Kuiper (my senior professor during my graduate work at the University of Arizona) had set up a 36-in.-diameter globe onto which we projected the sharpest available lunar photos. This allowed us to walk around the brilliantly lit globe in a darkened room and for the first time see the moon as a three-dimensional planet. Craters and lava plains that had hitherto been seen only as foreshortened ellipses and streaks near the moon's edge were now revealed in their true shapes and relationships. I recall a "eureka experience" upon walking around to the edge of the globe when a certain favorable photo was projected and seeing the astonishing bull's-eye system of Orientale, which had never been recognized before. Within a few weeks we were able to see that many more of these multi-ring basins existed, but had not been recognized because they were more degraded than the relatively well-preserved Orientale system. This was an impressive lesson in gestalt-pattern recognition: during centuries of lunar mapping in finer and finer detail, observers had virtually missed the *largest* systematic patterns on the moon—the multiple concentric rings surrounding the largest impact sites!

still falls to Earth today? Or could it have been a giant comet of ice? Or an unfamiliar type of body, perhaps one of the leftover building blocks of Earth or Venus? Geochemical tests of Orientale soils might answer these questions. Geologic observations along the cliffs might reveal how the rings formed. Do they mark horrendous collapses during the impact, similar to the terraces inside the rim of large craters like Tycho? Or did they form thousands of years after the impact, as the surface adjusted to lava eruptions in the basin interior?

Some NASA advisers have proposed locating a permanent lunar base near the edge of the moon's visible disk in order to provide access to the far side. Perhaps Orientale will yield its secrets to occupants of such a base, whose lights will glitter like gold among the blue Earth-lit cliffs during the long lunar night.

Natural Parks and Historical Monuments

Early in the history of lunar colonization, we will want to set aside some of these regions in their natural state or as scientific preserves, free from any mining or other disruptive activity. We can envision a set of "natural parks," something like the American system of national parks. The rugged interior of crater Tycho, the mysterious central peak and dark-haloed craters of crater Alpohonsus, the Straight Wall, the sites of possible recent volcanism or gas emissions in the bright crater Aristarchus, all might be examples preserved in lunar "natural parks."

Similarly, there are already unique historic sites on the moon that might be set aside as "historical monuments," something like the American national monuments. These include the arrival site of the first human-made object on the moon, where the Soviet Lunik II probe crashed near the juncture of the Seas of Tranquillity and Serenity in 1959, and the sites of the first soft-landed probes, the American Surveyors. But of course the most famous and historic site is the unique spot where humans first set foot on the moon: the Apollo 11 landing site. This and the other Apollo sites must be included in the lunar historic monument system.

A Lunar Colony—How Soon?

No nation has a known, official plan for a return to the moon or for a lunar colony. A number of scientists urged President Reagan to announce a lunar base as one of America's space goals in his 1984 State of the Union address, which dealt with the space program; he elected to limit the proposal to a permanent space station. However, a group of space engineers at NASA's Johnson Spaceflight Center in Houston has begun a "Return to the Moon" planning effort and a series of meetings. The first major workshop of this effort was a 1984 meeting of fifty scientists, engineers, businessmen, historians and other scholars. They met in Los Alamos and drafted a manifesto calling for a permanent lunar base as part of a larger expansion of human endeavor into interplanetary space.

Lunar base size and timetable remain uncertain. Many space planners have discussed an early scientific outpost with a rotating crew of around a dozen by the turn of the century. In addition to the lunar science described earlier, it could include research in astronomy and physics, better suited to the lunar vacuum than to Earth's surface. A medical facility would study long-term adaptation to the moon's low gravity, equaling one-sixth of Earth's. This would help in making plans for the base's future. Another issue is the state of the space station project, and the relative merits of putting a given research project in the orbiting station or on the moon.

An extremely important early issue is that of international cooperation in establishing a permanent lunar base. While America could start it unilaterally, such a base would offer a dramatic and highly visible stage to break away from our current concerns with international conflict. It could be a role model to show that technical people from different countries could successfully, indeed joyously, live together to solve larger human problems of exploration and adventure. This could happen only if political leaders have the courage to direct their technical communities toward such a goal.

The lunar base during eclipse. As Earth passes between the sun and moon, its shadow falls on the moon. Earthbound observers see a lunar eclipse; lunar observers see a solar eclipse as Earth blocks the sun. The backlit atmosphere of Earth glows with a brilliant sunset-orange glow, plunging the moon's surface into a mysterious copper-red twilight for more than an hour. This base is a permanent outpost located in the 4-billion-year-old Giant Orientale impact basin, where Earth hangs low over the cliffs that form one of the basin's concentric rings. Most of the base consists of modules buried in shallow trenches and heaped with protective soil. The growing base is powered by three-sided solar panels (left) rendered briefly useless by the sun's disappearance. A monthly supply ship is unloading at right. Angular width of picture: 40°.

The purpose of a colony, however, is not just to have humans living somewhere far away. They must do productive things. Lunar scientists and NASA advisers are beginning to predict lunar-based industry as well as lunar-based science.

The First Lunar Industry: Oxygen Production

While lacking the water or air that we might wish for, the moon does have useful resources. As a result of Apollo, we know what these materials are and can begin planning how to use them to *make* water and air and other substances we want.

We will use such substances not just to support life on the moon or for commerce with Earth. They will become a crucial support for our larger spacefaring ventures. Space activities throughout cislunar space will create needs for oxygen, both for breathing and as a fuel component. As we have seen, if we have the choice of providing space cities and interplanetary rockets with oxygen from the moon or from Earth, lunar oxygen is preferable: only a few percent as much energy is needed to launch material from the moon to Earth orbit as to launch it from Earth's surface to Earth orbit. Some 60 percent of the atoms in lunar soil are oxygen (since most rock-forming minerals on Earth and the moon involve silicon-based oxides). Researchers have already suggested various chemical schemes, such as electrolysis or solar furnace heating, for releasing the tightly bound oxygen from its parent minerals. Because of the tight chemical binding, this industrial process will not be cheap or easy; nonetheless, many analysts believe that when low-cost solar or nuclear energy becomes available on the moon, the cheap-to-haul lunar oxygen will be more attractive as a fuel than expensive-to-haul terrestrial oxygen.

For these reasons, many analysts have concluded that one of the early projects on the moon will be to set up a large-scale pilot plant to produce lunar oxygen. NASA might, for example, give a 10-year price guarantee of $X/ton of liquid oxygen, where X is chosen as, say, two-thirds the cost of oxygen hauled from Earth. Then private industry or international consortiums could bid for rights to invest in, design and build the lunar oxygen plant, once they thought they could produce the oxygen this cheaply.

Nature may have made it chemically difficult to extract lunar oxygen, but she has helped us mechanically. Because meteorite bombardment has pulverized the surface layers, lunar soil particles are microscopic and will not need further crushing prior to processing. Lunar oxygen mining might consist simply of scooping up lunar soil from the 10-m-deep regolith and feeding it by conveyor belts to a chemical treatment plant powered by "free" (no consumable fuel required) solar energy from vast arrays of solar collectors.

Since terrestrial oxygen is available from the air, only modest experimental work has been directed toward oxygen extraction from soils. Further studies of the precise oxygen extraction process thus offer rich opportunities for future inventors.

Other Lunar Industries

Oxygen production may be the main motivation for constructing pilot processing plants on the moon, but in designing such plants we must try to maximize the number of products. A description of oxygen mining gives a clue about many other possible lunar industries. As regolith powders are moved through a chemical production line, a carefully planned *sequence* of processes could recover different valuable materials.

Hydrogen. The highly reactive element hydrogen combines with oxygen to make water; it is also a rocket fuel and it can be used as a chemical agent in processing ores and other materials. The lunar regolith contains roughly 0.01 percent by weight of hydrogen trapped, atom by atom, on mineral grains by impacts of hydrogen atoms from the solar wind. This is a small amount, but it is loosely bound. Mild heating of regolith can drive the hydrogen off into collectors. Thus the conveyor belts mentioned above could feed lunar soil initially into chambers heated by solar reflectors, where H_2 gas would collect and be pumped into hydrogen reservoirs. About a ton of hydrogen would be obtained

for every 10,000 tons of soil processed. Hydrogen recovery would be only the first stage in lunar soil processing; some of the soil would pass on to the oxygen recovery, metal recovery and so on. With solar cells powering the conveyor belts and solar mirrors heating the "hot chambers," the procedure would be self-operating except for the delivery of new soil at the input end.

Water. One way to get water would be to combine the hydrogen (H) with oxygen (O) to get H_2O. Another exciting but questionable possibility exists in a theory championed by lunar geochemist James Arnold of the University of California at San Diego. During impacts of icy comets on the moon, thin clouds of water vapor from the comet's ice must spread around the moon. These clouds would mostly dissipate into space within minutes, since the moon's gravity is too low to hold the water vapor molecules. Nonetheless, in very cold spots, such as shadow-filled crater walls at dawn, a small fraction of the water vapor could condense to form frost deposits. In most such cold traps the sun would eventually rise and burn away the exposed frost, but there are two regions containing special places on the moon where the sun never rises (poor candidates for future outposts of the British Empire!). These are the lunar north and south polar regions, where the sun is never more than a few degrees from the horizon. On deep crater floors or in fractures, shadow would be perpetual. Estimated temperatures are as low as 40K (–387°F), plenty cold enough to trap and hold ice. Ice layers that formed during water-releasing events could be buried and protected by ejecta from nearby, subsequent craters. Eventually, frequent micro-impacts forming new regolith would churn the soil. Other ice might be protected from regolith formation by condensing in cracks or under boulders. Therefore, Arnold and some other scientists believe a search should be made for ice near the lunar poles, using a polar orbiter spacecraft that could map geochemical properties and obtain spectra at many different wavelengths.★ Many scientists urge NASA to fly such a mission soon.

If ice were discovered in patches at the poles, the poles would become the moon's prime real estate. We might have to come to grips with a sudden motivation for nations to try to monopolize the best waterbearing sites in order to control lunar development. This would be especially true if the ice-depositing process lacks the uniformity envisioned by Arnold. For instance, if one major comet impact produced an ice layer that was later fortuitously buried by ejecta at one site but vaporized elsewhere by micro-impacts, then that one surviving ice deposit would become the most valuable spot on the moon. We must avoid conflicts over such unique spots. An agreement to establish an international lunar base, operated by a consortium of nations, might be a way to proceed.

Metals. Many metal ores on Earth are produced by the activity of underground heated water dissolving, oxidizing, transporting or concentrating various minerals. Since the moon lacks water, it is not as rich in metal ore deposits as the great mining districts of Earth. But the economic value of a mineral concentration is determined by the economic environment. Mineral concentrations that would not be ores on Earth could be ores on the moon if it is cheaper to extract their metals and get them to market than to haul them to the same market from Earth. Markets may include lunar colonies, space cities or interplanetary expeditions.

Loose flecks of metallic iron constitute a fraction of a percent of all lunar soils. This metal could easily be removed by magnets (as has been done in labs on Earth) during the conveyor belt processing. The metal could either be utilized at once or shunted aside into stockpiles until large enough masses accumulated to justify further processing.

The lunar highlands, covering 85 percent of the moon, are composed mostly of a feldspar-rich rock called anorthosite, with an aluminum content ranging up to 18 percent by weight—

★Arnold, who is more optimistic about lunar polar ice than most scientists, has spoken of billions of tons of ice in the polar regions—vastly more water than would be transferred from Earth. Perhaps cratering has subsequently vaporized much of this ice; its presence is controversial. But Arnold is a respected scientist whose views are seriously considered; in fact, a recently discovered asteroid was named Jimarnold (a peculiar word) in his honor.

Pamela Lee

higher than that of most Earth rocks. Similar terrestrial anortho-sites have already been used for commercial aluminum production in Norway.

Titanium reaches concentrations exceeding 7 percent by weight in some lunar mare soils. Experiments indicate that electrolysis techniques can be used to produce titanium alloys from such soils.

Other metals may have been concentrated in the deep, cooling pockets of magma that occasionally erupted to form lunar plains. Perhaps in some places, as in deep layers exposed by impact craters or fault scarps, future prospectors may find rich veins that will encourage further mining activities on the

A hypothetical unique lunar resource: a polar ice deposit. Though the moon has no native water, some scientists believe ice deposits may have accumulated in perpetually shaded spots near the poles. If so, those unique spots would become extremely valuable resources. Here we see such a deposit in the shaded bottom of a rille, or ravine, in a crater floor. At the pole, the sun moves around the horizon and shines only on the crater wall.

moon. These will be analogs to the ore deposits that fostered expansion on the American continent from the time of the first Spanish discoveries of gold, silver, and copper ores in Mexico and the southwestern United States.

The hydrogen resources discussed earlier in this chapter might be important in metal production on the moon. NASA

scientist Richard Williams* has discussed the general reaction in which hydrogen (H_2) added to a metal oxide yields free metal plus water (H_2O). He predicts a hydrogen-based lunar economy in which hydrogen would be imported to the moon as well as locally produced. Products such as metal or water could be exported to space colonies.

Glasses and cast basalt. A substantial fraction of lunar soil consists of glass: beads and ragged splashes caused by melting of silicate minerals during impacts. Calspace planner David Criswell and others have spoken of lunar fiberglass industries using glass produced from lunar soil to produce insulating material and other commodities. A more wholesale use of lunar soil would be in cast basalt. Here, basalt lava is melted and cast into desired shapes. As early as 1965 Czech researchers Lubomír Kopecký and Jan Voldan** discussed fabricating objects on the moon by melting and casting lunar basaltic lavas in molds. They pointed out that a cast basalt industry has existed since at least 1852 in Europe, where pipes, tiles and other items are manufactured. The raw materials for these industries are lying all over the lunar surface and would be literally dirt-cheap. A clever wordsmith at the Los Alamos lunar base meeting called this venture a high-tech neolithic industry.

Getting Lunar Products off the Moon: The Mass Driver

An important step in making lunar products available for interplanetary exploration and commerce is to reduce the cost of shipping them off the moon. The moon's very low gravity gives us an option that is much simpler and cheaper than chemically fueled rockets. This option has been called the mass driver by its

*Richard Williams, "Hydrogen Resources for the Moon," in *Lunar Utilization*, abstracts of special session at the 7th Annual Lunar Science Conference, ed. D. R. Criswell (1976).

**L. Kopecky and J. Voldan, "The Cast Basalt Industry," in *Geological Problems in Lunar Research*, Annals of the New York Academy of Sciences, (1965), *123*, 1086.

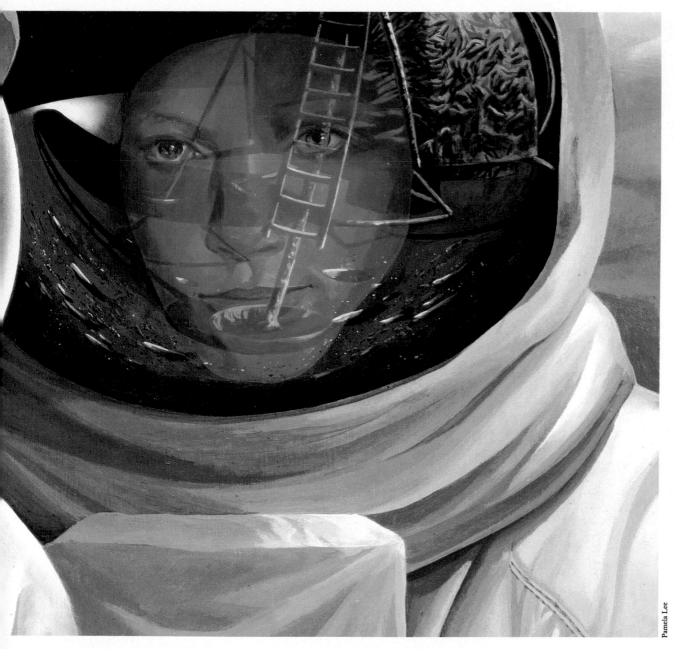

Pamela Lee

Visiting the Tranquillity Monument. The most historic site on the moon is the spot in the lava plains of the Sea of Tranquillity where humans first set foot on another world. The gold-foil-clad bottom stage of the Apollo landing module still sits at each Apollo site. Here a mother from the lunar colony shows her child the monument, which is reflected in their faceplates.

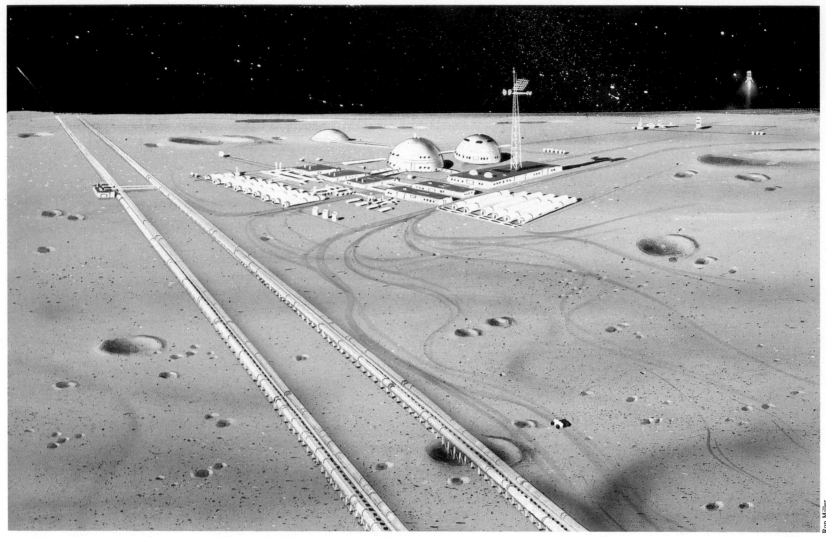

Ron Miller

Lunar processing station and mass driver. Mass driver monorails (left) have been set up at a lunar location where material can be shot off the moon and captured by collectors orbiting within the Earth-moon system. Metal, glass and other lunar resources are processed and launched at this station, establishing the first interplanetary economy.

principal proponent, space colony designer Gerard O'Neill. The mass driver looks like a long monorail, perhaps several miles long. Along its lines are magnetic coils through which metal capsules or "buckets" pass, each containing a payload of lunar metal, ore or other product. The "buckets" are accelerated down the line by a magnetic force created when the current is discharged through the coils. Additional magnetic forces keep the "bucket" suspended, frictionlessly, in a flight path through the coil centers. In this way, fantastic accelerations and velocities can be achieved using only electrical energy supplied by "free" sunlight and solar cells, not expensive chemical fuels hauled to the moon. With a mass driver, lunar materials could be accelerated to lunar escape velocity, 2½ km/sec (1½ mi/sec), and launched off the moon to be captured later near a space city.*

O'Neill and his colleagues at the Space Studies Institute in Princeton have built indoor, tabletop mass drivers that have accelerated objects to 80 mph in one-tenth of a second. The mass driver principle is thus well established and may one day be as fundamental to interplanetary economies as the gasoline engine is to today's Earth.

Growth of a Lunar Colony: The Antarctic Analog

The growth rate of lunar colonies is controversial. O'Neill believes that space cities will be the pillars of interplanetary exploration and commerce, and that the lunar base will remain only an outpost where scientists will visit and raw materials will be mined. O'Neill predicts that space manufacturing facilities will all be concentrated in space cities, where full Earth gravity can be maintained in living quarters (avoiding possible muscle atrophy due to life under the moon's ⅙ G gravity) and that therefore only raw soil, not refined products, will be shipped off the moon.

On the other hand, we can predict that as more scientists puzzle over problems of lunar research, as more administrators arrive to oversee international teams, as orbital space cities grow in size and as more in-space uses are found for lunar materials, one or more lunar bases may expand into permanent colonies. We use the term "colonies" because, unlike space cities, they would consist of a settlement *and* surrounding territory being explored, mined and utilized.

The growth of a lunar colony might bear some resemblance to the growth of operations in Antarctica. In a 1983 speech at a "Return to the Moon" session at NASA's annual Lunar and Planetary Science Conference, Deputy Administrator Hans Mark used Antarctic growth as a model and predicted a permanent population of 1,000 people on the moon by the year 2040.

Many planners believe that the most feasible lunar colony would be international, in order to spread costs and reduce nationalistic competition for individual sites. It is extremely important to apply the golden rule of space exploration from the outset: a lunar colony should be conducted in a way that will reduce, not aggravate, tensions on Earth. The Antarctic analog is again instructive. Following early explorations by British explorers Shackleton and Scott, England was first to claim Antarctic territory in 1908. From 1923 to 1943, additional (sometimes overlapping) claims were made by New Zealand, France, Australia, Norway, Chile and Argentina. As reviewed by science writer Martha Wolfe,* World War II led government planners to

*In his 1977 book *The High Frontier*, O'Neill attributes an early idea for the mass driver and its space applications to a 1950 article by the father of the geostationary communications satellite, science-fiction writer Arthur C. Clarke. However, my co-author Ron Miller has located a curious 1937 book by E. F. Northrup, under the pen name Akkad Pseudoman, that appears to develop a similar concept. Titled *Zero to Eighty*, (Princeton, N.J.: Scientific Publishing Co.) this quasi–science–fiction tale purports to be an autobiography from the year 2000, describing the invention of a "travelling electromagnetic wave cannon" that would be used for space exploration and would launch liquid-fueled rockets. The author apparently built working models and obtained patents, and photos are included. One model was purportedly 30 in. long, 4 in. in diameter, and produced a thrust of 700 lbs.

*Martha Wolfe, "Who Should Rule the Ice?" *Science News* (December 24 and 31, 1983).

begin thinking of possible strategic resources in Antarctica. Indeed, at the time of Byrd's third expedition, President Roosevelt ordered the expedition scientists to turn in their notes and samples to national security analysts. During this period, Antarctic bases of America and Britain became military in administration. This trend toward nationalistic competition was miraculously reversed in 1957–58 during the International Geophysical Year, a coordinated global scientific research program involving twelve nations. So successful was the IGY collaboration that in 1959 the twelve nations signed what Wolfe calls "an unprecedented, verifiable, and equitable treaty of disarmament, environmental protection, and freedom of information" freezing any territorial claims. This is a UN-chartered treaty and is administered by a group of nations that has grown to sixteen members, who meet in private and have negotiated additional agreements to protect various resources from exploitation by individual nations.

Despite these great successes, pressure is now building to develop Antarctic resources. A group of seventy-seven nations, generally representing the third world, has pointed to the UN Law of the Sea Treaty that claims ocean and ocean-floor resources as "the common heritage of all mankind." The group urges similar treatment of Antarctica and more aggressive search for Antarctic resources such as coal, oil and minerals.

The United States, Russia and others with existing bases in Antarctica back the existing treaty, which tends to preserve Antarctic resources. An American NSF official says, "Those governments who have spent great sums of money and many years in the interest of science and conservation feel that you've got to pay your dues to participate [in Antarctic planning]. We want to prevent a switch in emphasis from conservation to exploitation." Yet one can easily see why a resource-poor nation would feel frustrated if wealthy countries just sit on vast polar coal reserves without letting anyone benefit from them. The future resolution of these problems, as Antarctic resources become more known and accessible, is uncertain.

Here we see in a nutshell the kinds of problems that must be considered in lunar base planning. Before military planners or politicians simply assume they must grab off lunar real estate to prevent the other fellow from getting it first, we must convince each other in all nations that any temporary advantage of "firstism" is far outweighed by the benefits of measured cooperation. Firstism is bound to create further problems down the road; besides, as we argue throughout this book, resources throughout space may relieve many of the very pressures that military and political leaders have squabbled over for centuries . . . *if* we approach them correctly.

Thus statesmen as well as scientific and political and military planners should get involved now in planning the administration of a lunar colony. It might be chartered under the United Nations in order to set a positive precedent for optimizing peaceful productivity and minimizing military potential. The table on page 93 shows some goals that might be set as part of the charter of such a colony. The most ambitious goal would be self-sufficiency—the ability to survive indefinitely if cut off from Earth. Such a goal might require decades. But like President Kennedy's clearly stated 1961 goal of a manned landing on the moon within a decade, it could set the tone for the whole program. The research completed on the moon to reach this goal would have wide-ranging implications for proving the concept of an interplanetary economy using planetary materials. Successful demonstration of lunar agriculture, solar power collection, and oxygen and water production from lunar soils would go much of the way toward establishing a self-sufficient, permanent human presence in space.

Such an accomplishment would mark an extraordinary day in human history. It would mean that humanity had a probability of survival even if an unforeseen industrial ecological disaster, or the madness of nuclear war, should render Earth uninhabitable. There are some who fear this goal. They argue that creation of such an "escape hatch" would make destruction of Earth more likely because it would not seem so profoundly evil.★ But

this is like arguing that starting out on a dangerous desert or mountain backpack with no first-aid gear forces you to be more careful. On the contrary, humanity needs as many safety options as it can get.

Humanity should celebrate the day when the lunar colony begins to pay its own way and the later day when the colony becomes self-sustaining. These are days that will help ensure humanity's long-term survival and ability to spread and prosper in the solar system.

Life in the Lunar Colony

Social customs and everyday life in the lunar colony are hard to predict. Several writers have noted that human-powered flight should be possible under the low lunar gravity. We can imagine recreation domes where fliers cavort through the air with strap-on wings that seem to have come from archaic woodcuts of the mythic Greek aeronaut Daedalus. Clever youngsters will vie with professional engineers in annual competitions to see who can design the best wing systems and stay aloft the longest.

In his 1980 lunar mystery novel, *The Patchwork Girl*, science-fiction writer Larry Niven predicted a revival of the ancient art of heraldry. Lunar and space colonists emblazon colorful, personal symbols on their spacesuits so they can be distinguished from spacesuited friends as parties of explorers venture out across the dusty lunar hills and plains.

The lunar glass industry may produce an interesting artistic expression. Under the moon's low gravity, larger shapes could support themselves during the process of glass blowing than is possible on Earth. Artists could create delicate, glittering glass

*When I was invited to write a chapter on space exploration for Friends of the Earth's book *Progress As If Survival Mattered* (a wonderful title with whose spirit I fully agree), I submitted a chapter proposing that utilization of space resources could (if done properly) begin to reduce environmental pressures on Earth. The editor, facing a space problem of his own, cut the chapter from the book, commenting that this idea seemed to promote a "disposable Earth" policy.

Goals for a Lunar Colony

GOAL	RATIONALE
Using solar (and nuclear?) power and lunar (and asteroidal?) material, make the colony indefinitely self-sustaining	Give colony independent economic footing, provide challenging long-term goal; support humanity's long-term survival
Demonstrate human ability to live and work on low-gravity, airless worlds	Establish that we can expand toward ventures on asteroids, others moons, Mercury, Mars
Establish routine production of lunar oxygen	Support for Earth-orbital and interplanetary spaceflight
Settle issue of possible presence of lunar water (near poles?)	Life support on moon and in space cities
Discover and utilize other lunar resources (titanium? aluminum? etc.)	Commerce and economic support of lunar colony
Develop lunar technology (cast basalt, glass, etc.)	Commerce and economic support of lunar colony
Describe formation of lunar crust and magma ocean	Basic science; helps us understand all worlds
Determine moon's deep interior structure	Basic science; helps us understand all worlds
Find sites and dates of oldest and youngest lunar volcanism	Basic science; helps us understand all worlds
Determine sources of basin-forming objects and dates of their impacts	Basic science; bears on origin and early evolution of planets
Determine origin of the moon	Long-term basic scientific mystery; clarifies origin of planets
Protect historic lunar sites (i.e., early landing sites) and unusual landforms; establish monuments and scientific preserves	Set *early* precedents to discover and preserve interesting features for future humanity

W. K. H.

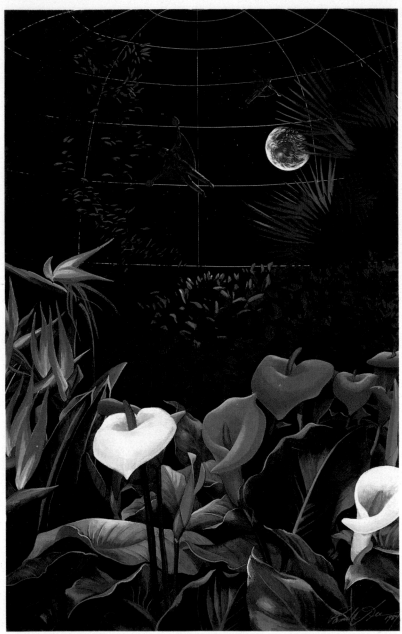

Pamela Lee

sculptures of a size too large ever to be displayed on Earth, where they would collapse under their own weight.

Other issues of social life will need to be solved. Experience in Antarctica shows the importance of a healthy balance of men and women once long-term occupancy begins. Some years ago, single women technologists and scientists began to join the largely male population that "wintered over" during the long months of isolation during the Antarctic winter. Many of these women found themselves under extreme pressure to form some sort of liaison with *one* of the men, sometimes merely social if not overtly sexual. Those who tried to remain entirely independent often found themselves, through no fault of their own, the focus of hostility from the single men seeking companionship. These problems might be avoided on the moon by a substantial population of both men and women. On the other hand, one sociologist studying the lunar-Antarctic analog suggests that the moon may actually be less isolated than Antarctica; resupply ships will visit more frequently here than in Antarctica during winter, and there will be better TV and radio linkup (through direct line of sight) with entertainment and news from Earth.

Just as colonies in the new world developed their own interesting regional characters as they turned into states and nations, a lunar colony will evolve its own social life, products, customs, art forms and jokes as lunar exploration proceeds. Many of its aspects will derive from discoveries we cannot foresee—about lunar materials, environment and geology. Humans have always found new ways of living in the new environments they have occupied. The moon will be no exception.

Foliage and flying. As the lunar colony grows, experimental agricultural facilities may serve also as favorite recreational areas. Here, in a cherished setting of tropical flowers, with Earth overhead, weekend athletes experiment with designs of winged suits that allow gliding in the moon's one-sixth gravity.

ASTEROIDS AND COMETS:OUR FIRST LANDFALLS BEYOND THE MOON

At the outset we described how countless planetesimals, some rocky and some icy, formed in the early solar system four and a half billion years ago. Most of them aggregated into the planets, but some are still left—orbiting endlessly in interplanetary space. They come in a wide range of sizes, averaging 1 to 100 km (½ to 60 mi) across. The rocky ones are called asteroids and are mostly found in the asteroid belt between Mars and Jupiter. The icy ones are called comets and are mostly found in the cold outermost reaches of the solar system beyond Neptune and Pluto; occasionally, objects in both reservoirs are disturbed by the gravity of the large planets in a way that sends them on orbits into the inner solar system. Some cross Earth's orbit and are about as easy to reach as the moon!

At conferences on asteroid science in the early 1970s, researchers often debated whether a mission to an asteroid would be scientifically important. One opinion was that an asteroid sampling mission would be of questionable value: because meteorites are probably fragments of asteroids we might simply end up with a sample of an ordinary meteorite like those already in our museums. What could we learn, some researchers asked, by visiting an asteroid? Today an asteroid mission looks much more exciting. For one thing, our scientific knowledge of asteroids and meteorites has become much richer, allowing us to ask more significant questions about their origins, collisions, thermal histories and surfaces. Through this information, we may learn their relation to the planetesimals that formed Earth. Second, *different compositional types* of asteroids have been discovered by means of telescopic spectral studies, raising the probability that

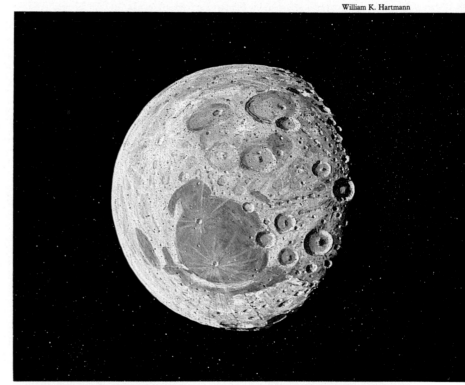

William K. Hartmann

Asteroid 4 Vesta. Fourth to be discovered among the thousands of asteroids in the asteroid belt, 549-km-diameter (343-mi) Vesta is one of the largest. Asteroids larger than a few hundred kilometers are round in shape; smaller ones are mostly irregular fragments of collisions. Spectra show that Vesta is unusual in having a surface of basaltic, lava-like rock. The source of heating or volcanism that could produce such lava is unknown. Although asteroids' surfaces have not been seen at close range, they are believed to be heavily cratered by impacts with other asteroids.

we can recover many *different* asteroidal materials from different asteroid types. These include materials of economic value (such as metals) or support value to supply space cities and lunar colonies (such as water). Researchers have suggested ways of "harvesting" these different materials from asteroids. Asteroid missions would thus have two goals: scientific reconnaissance and feasibility demonstrations of "harvesting" techniques.

Asteroid Compositions: A Range of Materials

As early as 1970, researchers discovered differences in rock types among asteroids, as well as in spectra and general colors (some asteroids being rather gray, others very black or reddish-gray). The combination of spectral bands, colors and reflectivities showed the different compositional types of asteroids in ever increasing detail, and observers soon developed a system of letter designations for the different asteroid types. Meanwhile, laboratory researchers compared the spectra of asteroids to the spectra of meteorite samples and found similarities between certain types of meteorites and certain types of asteroids.

This supported the theory that most meteorites are fragments of asteroids. For example, the C-type asteroids are very black, with low reflectivities of only around 5 percent. In spectra, they resemble black, carbon-rich meteorites called carbonaceous chondrites; these contain organic compounds and chemically bound water in their minerals. Other relationships are less clear. The common S-type asteroid is believed to be stony material, possibly resembling the most common meteorite types, the so-called chondrites. M-type asteroids may resemble stony-iron meteorites, composed of about one-half stone and one-half nickel-iron alloy.

A striking recent discovery is that the asteroid belt shows a strong zonal structure reflecting that of primordial condensations. So-called E-type asteroids (possibly rich in the relatively high-temperature condensate mineral enstatite) are concentrated near the inner edge of the belt, and the S-types and M-types are prominent in the central portion. The C-type asteroids, which resemble carbonaceous chondrite meteorites, are located in the outer belt and in the two clouds of "Trojan" asteroids in Jupiter's orbit, occupying the Lagrangian points 60° ahead of and behind the planet. Also prominent among the Trojans is a so-called D-type asteroid that has very low albedo (probably indicating the presence of the low-temperature carbonaceous materials) but is much redder than the C-type asteroids. The reddish color has been attributed to organic compounds that condense at even lower temperatures than the C-type, carbonaceous materials. Several small outer moons of Jupiter have been identified as also exhibiting the dark, carbonaceous spectral characteristics and may resemble the asteroids of the outer solar system.

As we go further out into the solar system, ices become increasingly important constituents of small bodies. We know that comets come from a swarm of objects that originated somewhere in the outer solar system; the defining cometary properties of gas emission and eruptive instability are, of course, due to their ices. Thus we can view the entire population of asteroids and comets as grading from rocky and metallic-rocky materials in the inner solar system and belt, to rocky objects dominated by black carbonaceous materials and organic compounds, possibly mixed with ices, to comet nuclei in the outer solar system that are dominated by bright ices. University of Arizona astronomer Larry Lebofsky has identified the water chemically bound in the minerals of some C-type asteroids, including Ceres, the largest of all asteroids. This confirms the similarity of these asteroids to water-bearing carbonaceous meteorites and, more importantly, confirms a source of accessible interplanetary water.

Therefore, far from offering only dull rocks in the sky, the asteroid-and-comet swarm offers a range of bodies containing metals, rock, organics and ices. They suggest new resources that could alleviate mining pressures on Mother Earth and, at the same time, fuel an interplanetary economy. They also prompt further scientific study of how they got to be so diverse.

Best Examples of Meteorite Analogs Among Near-Earth Asteroids

METEORITE TYPE (AND % OF OBSERVED FALLS)[1]	ASTEROID	PROBABLE TYPE[2]	POSSIBLE METALLIC Fe CONTENT[3] (WT %)	POSSIBLE H$_2$O CONTENT (WT %)[3]
Carbonaceous chondrite (5%)	887 Alinda	Carbonaceous chondrite	0–5%	<2%
	2100 Ra-Shalom	Carbonaceous chondrite	0–5%	1–10%
	1981 QA	Carbonaceous chondrite or Enstatite chondrite	0–19%	0–10%
Ordinary chondrite (81%)	(1981 QA?)	(See above)		
	1862 Apollo	Chondrite	0.3–3%	~0%
	1980 AA	Impact-shocked chrondite, dark	4–25%	0%
Achondrite (9%)	1915 Quetzlcoatl	Diogenite achondrite	1%	0%
Stony iron (1%)	None identified[4]			
Iron (4%)	None identified[4]			

1. Hartmann, W. K. (1983). *Moons and Planets*, 2nd ed. Based on tabulations by Scott (1978) and Dodd (1981). Note: Percent of crumbly carbonaceous chondrites may be much higher in space, and percent of other types correspondingly lower in space.
2. McFadden, Lucy-Ann (1983). Spectral Reflectance of Near-Earth Asteroids: Implications for Composition, Origin, and Evolution, Ph.D. Thesis, University of Hawaii.
3. Estimated from data on these meteorite classes, listed by Wasson, J. (1974). *Meteorites*, (New York: Springer-Verlag.).
4. Since iron spectrum is relatively featureless, these are hard to confirm.

The Near-Earth Sample of Asteroids

The asteroid belt and the comets and asteroids of the outer solar system are reservoirs from which our samples of near-Earth bodies are drawn, partly at random. The "drawing" is done by processes that we don't fully understand; these may include:

1) gravitational disturbances by Jupiter that throw asteroids out of the mid-belt into the inner solar system;

2) gravitational disturbances by Mars that throw asteroids out of the extreme inner edge of the belt into the inner solar system;

3) gravitational disturbances by the nearest stars that throw comets from sun-orbiting paths far beyond Pluto onto paths directed into the solar system;

4) close encounters between comets and giant planets that send the comets into the inner solar system.

Thus the objects that cross Earth's orbit are a heterogeneous mixture of different types of objects from different source regions. This is confusing for astronomers, but good for astronauts who will want to visit a variety of close-by objects.

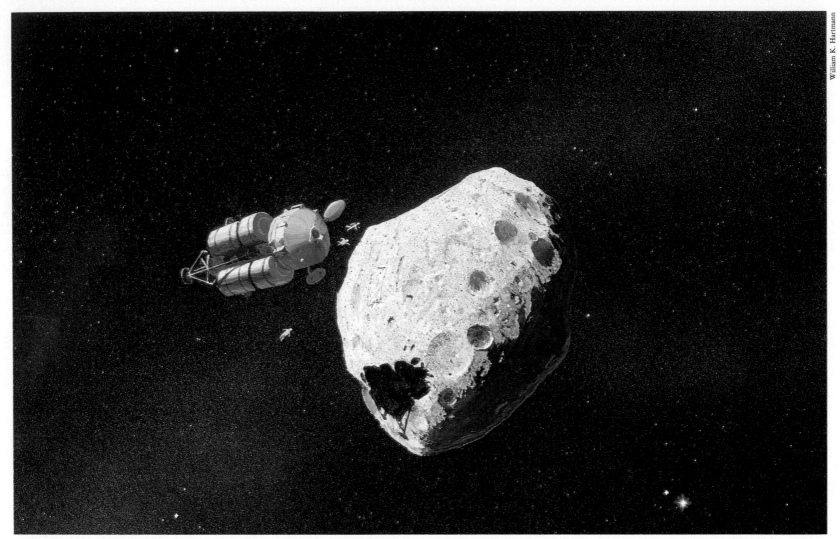

William K. Hartmann

Reconnaissance of an Apollo asteroid. A post-shuttle-era exploration vessel "parks" beside a small Earth-approaching asteroid, and astronauts float across to conduct close-up studies. During this first contact with a world *beyond the moon, the distorted shadow of the ship makes a ghostly after-image of the Apollo landing module that first brought humans to the moon. In the far distance, lower right, Earth and moon make a bright double star.*

The objects that cross Earth's orbit are called "Apollo" asteroids. The perturbation processes that throw asteroids and comets onto Apollo-like orbits have created some Apollo asteroids that approach Earth at relatively low velocity; hence a relatively low energy is required to travel from the Earth/moon

system to an orbit alongside these bodies. This explains why they are such attractive targets for manned or unmanned exploration, and why some are as easy to reach as the moon, easier to reach than Mars or Venus!

Active comets from the outermost solar system also cross Earth's orbit, though generally on much higher-velocity orbits than Apollo asteroids. Because of their high velocity, most active comets would be unattractive mission targets for manned missions, though unmanned probes can easily fly past them.

Anticipated Asteroid Discoveries: Improved Mission Opportunities

An important principle derives from the above facts. A 1983 near-Earth asteroid inventory included 27 Apollo asteroids that cross inside Earth's orbit 1 astronomical unit from the sun and 39 objects that come inside 1.1 astronomical units. Many are larger than 1 km radius. The current discovery rate is several objects per year, thanks primarily to the survey programs of Cal Tech researchers Eleanor Helin and Eugene Shoemaker. Thus we can confidently expect an ever larger sample of kilometer-scale potential target asteroids at any future date when a mission could be launched.

A more subtle point, less widely appreciated, is that the size distribution virtually guarantees thousands of smaller objects that have not been detected but that would make interesting mission targets. For example, based on the distribution of asteroid sizes, for every 30 1-km Apollo asteroids, we can anticipate about 3000 100-m objects. This increased sample would undoubtedly include some targets of even easier accessibility than those now known. Not only would the energy to reach these objects from Earth orbit be significantly below that in the presently known sample, but the energy to land on the asteroid or launch samples off it would be negligible because of the asteroids' low gravity. Therefore, asteroid searches with bigger ground-based telescopes or perhaps infrared telescopes in orbit could be extremely fruitful in terms of space resources.

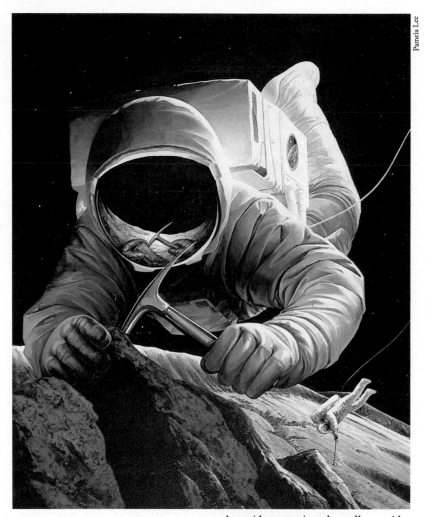

Pamela Lee

Asteroid prospecting. A small asteroid has almost zero gravity. Here astronauts, still tethered to their mother ship, float across the surface looking for unusual geologic structures and mineral samples. The asteroid was broken out of a much larger parent body during a titanic interasteroid collision 4½ billion years ago.

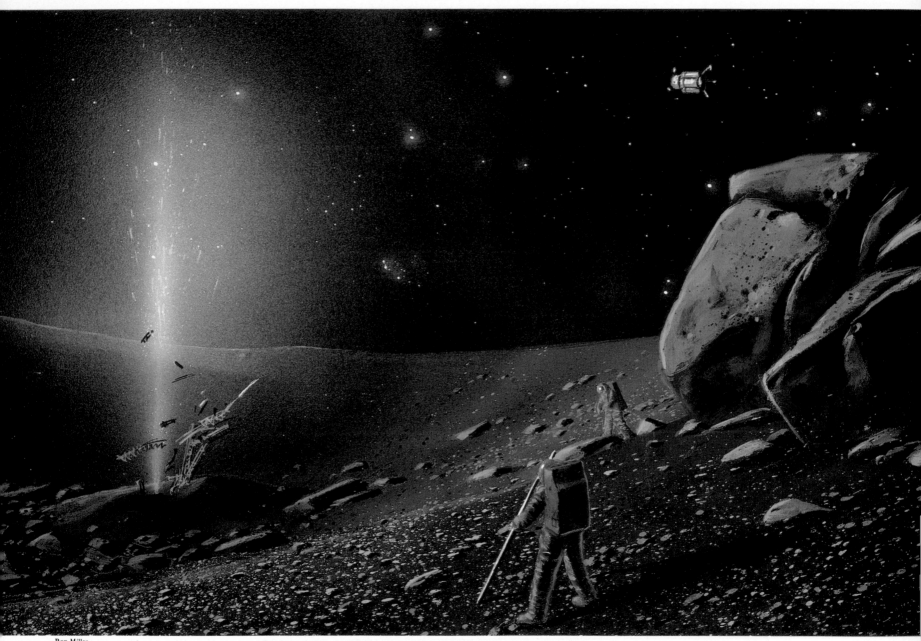

Ron Miller

Composition of Earth-Approaching Objects

If we plan to explore asteroids, we should consider their composition in more detail. From the meteorites that happen to collide with Earth, we know something about the compositions of interplanetary objects near Earth. Of these meteorites, 81 percent are the type called chondrites—rock fragments that have been little altered since they formed four and a half billion years ago. Some 9 percent are the type called achondrites—lava-like rocks that formed after the primitive parent rocks melted and then resolidified. These meteorites must come from interiors of asteroids that got hot enough to melt (due to radioactivity, such as that which heats Earth's interior?). About 5 percent are the type called carbonaceous chondrites—black, crumbly, organic- and water-rich meteorites that probably match the C-type asteroids formed in the outer solar system. The final two types include 4 percent that are pure metal, called irons, and 1 percent that are a mixture of metal and rock, called stony-irons.

These statistics may give a true sampling of the types of asteroids near Earth's orbit, except that the carbonaceous chondrites are so weak and crumbly that many of them may not survive the fall through the atmosphere. If so, space would contain a much larger fraction of them than we get on the ground. Consistent with this are two observations: meteor cameras show that many meteors are weak and burn up in the atmosphere, and the lunar soil contains a meteoritic component that is mostly carbonaceous. Some astronomers thus believe that the rocky material in comets is carbonaceous and that many of the carbonacous meteorites are debris from comets.

The most thorough inventory of near-Earth asteroid compositions is that of astronomer Lucy McFadden (1983). From a list of 17 asteroids with good spectral data, she was able to make only

The asteroid gusher. Astronauts drilling to probe the interior structure of a small asteroid have chanced upon the nucleus of a "burnt-out" comet. The drill has hit a pocket of ices and vapor buried beneath a surface mantle of ice-exhausted soil. The penetration allows sudden venting of gas, ice particles and soil into space.

six close identifications with meteorite types, as shown on page 97. Of these, two were identified as carbonaceous chondritic, another as either carbonaceous or ordinary chondritic. The others included two chondrites and one achondrite. These data again suggest that a larger proportion of the water-bearing carbonaceous materials may be encountered in space than is represented in their 5 percent meteorite fall rate. This finding would be exciting: it would imply that water may be more common in space than otherwise assumed! If carbonaceous asteroids could be found, their water could easily be driven out of their minerals, and collected, by mild heating in solar-powered furnaces.

If 60 percent of the Earth-approaching asteroidal material is carbonaceous chondrite, consistent with the carbonaceous fraction in the lunar soil, then future space explorers would encounter the following percentages among Earth-approaching asteroids:

Carbonaceous chondrite asteroids (including some burnt-out comets?)	60%
Ordinary chondrite asteroids	34
Achondrite asteroids	4
Stony-iron asteroids	½
Iron asteroids	1½
	100%

Some of the near-Earth asteroids may be burnt-out comet nuclei. If so, water may be still more abundant. Asteroids that look rocky on the outside may well contain the last bits of the "burnt-out" comet's residual ice sealed in their interiors.

Anticipated Principal Resources and Extraction Processes

Using the above discussion as our basis, we can tabulate the following resources of economic and life-support interest that may be encountered in asteroids.

Water ranges about 1 to 22 percent by weight in carbonaceous chondrites, and scientists believe similar percentages would apply in carbonaceous C-type asteroids. If these asteroids could be located and "mined," water could be driven off by mild heating and easily shipped off these low-gravity objects to space cities. Ice deposits in deep interiors of some carbonaceous objects of cometary origin may be plausible. Salts derived during ice melting at the time of comet activity might eventually seal pore spaces in the outer volume and allow ice in the core to be preserved if the burnt-out comet, or "asteroid," does not spend too much time near the sun.

Nickel-iron alloy approaches 100 percent in "iron" meteorites and roughly 50 percent in "stony-iron" meteorites. Asteroids of these types would be extremely valuable but hard to identify spectroscopically. Due to the lower strength of the stony component, a thin regolith of pulverized stone might mask the metal phase, possibly requiring *in situ* studies to reveal the metal content. Ordinary chondrite asteroids could also have large amounts of metallic iron, ranging around 0.3 to 25 percent by weight in chondrites. Carbonaceous chondrites have 0 to 8 percent metallic iron. In chondrites this iron appears in flecks and might be scattered through regolith material. Magnetic rakes could "harvest" these metal flecks.

Platinum-group metals are dissolved among metallic phase grains, especially in ordinary chondrites. Unlike other resources, these have commercial values of thousands of dollars/kg. As pointed out by planetary geochemist John Lewis and space advocate Carolyn Meinel,* the United States is highly dependent on other countries (the Soviet Union and in some cases neutral nations) for these materials. These metals are especially attractive to American planners, therefore, as candidates for refining and returning to Earth. Lewis and Meinel emphasize that "all common classes of meteorites contain higher concentration of platinum-group metals than the richest ore bodies in Earth's crust." Lewis has suggested that these materials will "make or break" space mining because of their economic and strategic values. He advocates a chemical process called carbonyl extraction for refining these materials from asteroids. CO gas is passed through the material at certain pressures and temperatures. Under such conditions, iron, nickel and several other metals react to form gaseous carbonyl compounds. The gases may then be condensed and the metals deposited. Under selected conditions, iron and nickel can remain gaseous, while cobalt and platinum metals are left as a magnetic dust. Lewis notes that this process has been used commercially on Earth and is readily adaptable to space.

Hydrogen implanted from the solar wind into regolith grains can be easily driven off by mild heating of regoliths. As noted in the last chapter, it will have a variety of uses in space.

Oxygen and sulfur-bearing minerals are abundant. If abundant ices are found in near-Earth space, electrolysis can easily produce oxygen. Alternatively, but with more difficulty, oxygen can be produced from the rock minerals by the same method we discussed in the case of the moon.

Dirt provides material not only for casting objects, as discussed in the case of lunar basalt, but also to shield space structures from meteorite impacts. This dirt can include leftover material after water, metals and other valuables have been removed. There may be strong military interest in shielding materials, especially electrically conducting materials that could screen electromagnetic pulses. Without these, space systems' electronics can be knocked out by bursts of particle radiation.

Note that in discussing all these resources, questions of asteroid regolith and bulk strength are important. Regoliths offer prepulverized materials. Some carbonaceous and ordinary chondrites (especially shocked ones) may be virtually rubble piles, easy to disassemble. But iron asteroids may be less pulverized because of their strength. If so, the iron asteroids may be frustrating objects—rich in metals but very difficult to break down into fragments or powders that can be easily processed.

*See John Lewis and Carolyn Meinel, "Asteroid Mining and Space Bunkers," in *Defense Science 2000 +* (in press).

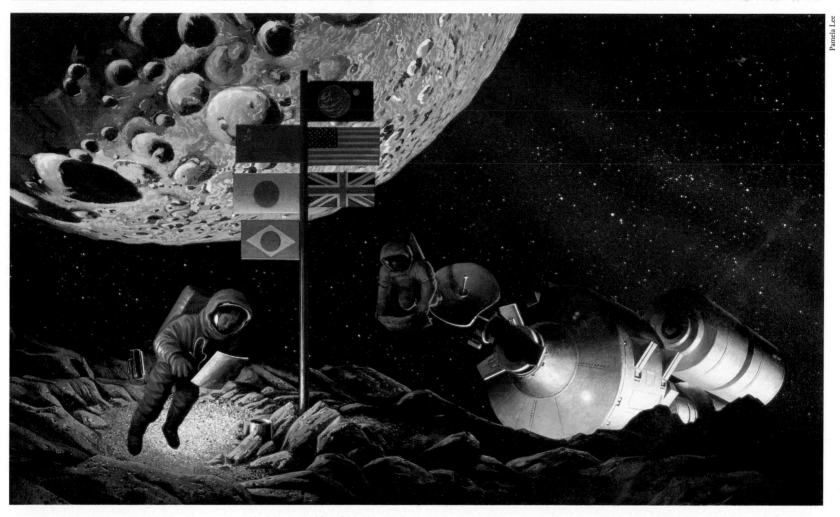

Pamela Lee

Following human landfalls on several dozen asteroids, a tradition has arisen to leave signatures and national emblems on each as a historic record of visits, much like registers maintained on mountain summits by hikers. By tradition, the location is the asteroid's north pole of rotation, a well-defined, fixed point. This is a rare example of a binary asteroid—two asteroids orbiting around each other—hypothesized by some scientists on the basis of controversial astronomical observations in the 1970s and '80s. The companion asteroid (upper left) looms large in the sky.

Further research will be needed to understand the best ways to disassemble coherent asteroid materials (a problem also faced by Earth's miners) in the absence of thick regoliths.

The Total Resource Supply

Nearly 3,000 asteroids are already catalogued in the asteroid belt, most of them between 10 and 100 km (6 to 60 mi) in diameter.

William K. Hartmann

Seismic tests on a Trojan asteroid. A reconnaissance ship has ventured beyond the asteroid belt to study one of the Trojan asteroids in Jupiter's orbit. The small, fresh, bright white crater suggests ice hidden under the dark surface soil. Parking at a distance, the explorers have fired seismometer-carrying penetrators into the asteroid and have now set off an explosion (top) that sends a seismic wave through the object, allowing study of the interior structure. In the dimmer sunlight of the outer solar system, the Milky Way stands out in the direction of the galaxy's center; the constellation of Scorpius, with the red star Antares, is left of the ship.

The total mass of known asteroidal material is equivalent to a layer covering all the land area of Earth to a depth of about 8 km (5 mi). In other words, it far exceeds the volume of material in which mining operations have been carried out on Earth to fuel civilization's material needs so far.

In terms of resources, perhaps the most important asteroids will be those no bigger than a few kilometers across. These

asteroids are fragments from the interiors of the bigger objects and hence are most likely to be differentiated, containing metals or other materials concentrated during melting of the interiors of parent bodies. They are also small enough to be moved into new orbits artificially. Some might be brought into new orbits around Earth, as we will see in a moment. Earlier in this chapter, we observed that there must be thousands of Apollo asteroids in the 100-m size range. In the main belt, the numbers are even greater, and we can anticipate hundreds of thousands of kilometer-scale belt asteroids.

Numbers and accessibility of *comet* nuclei are harder to judge. Most comets are in the outermost solar system. Their velocities when they pass through the inner solar system are high, necessitating greater energies to match orbits with and hence explore them. Those in the inner solar system may be more dangerous to approach than asteroids because they are apparently blowing off sizable chunks of material during their active phase. Radar observations of a close-approaching comet in 1983 revealed, not a radar echo from a single kilometer-scale nucleus, but an unexpected, smeared-out echo interpreted as indicating a billion inch-scale chunks in the central region of the comet; evidently the nucleus partially disassociated into fragments as the ices sublimed into gas, and the gas lifted the fragments into a cloud that surrounded and hid any central, larger body. Other comets have been observed to break apart into several individual subcomets as they passed through the inner solar system. Thus, though most comets are believed to have central, solid, icy bodies a few kilometers across, these bodies may be difficult to investigate at first hand.

Bringing Asteroids Home

A mass driver erected on a small-size asteroid could fling off asteroid soil (after it had been mined of the more valuable metals and other components). This would essentially convert the asteroid into a low-thrust rocket. The asteroid's own waste soil, thrown off at high speed, would be the fuel. Over a period of months or years, the thrust of this rocket system could alter the orbit of a small asteroid, redirecting it wherever we wanted it to go. NASA studies have already been conducted to see how this idea could be used to bring asteroids closer to Earth, or into orbit around Earth, where the materials could be refined and utilized.

Fortunately the mass driver, struggling mightily against the asteroid's inertia, would not have to do the whole job of bringing it into Earth orbit. Recall that Voyager 1 and 2 were deflected toward Saturn by making a carefully planned flight by Jupiter, swinging around the giant planet to get a "free gravity assist" from its massive gravitational force. Similarly, some Apollo asteroids could be maneuvered to a close pass by Venus and redirected toward Earth, saving much work that would otherwise fall to the mass driver. As the mass driver brought an asteroid toward Earth, a sequence of carefully planned passes by the moon and Earth itself could lead to capture of the asteroid into Earth orbit. The main energy for the capture maneuver would come from the moon's and Earth's gravity. Only the "fine tuning" of the orbit, not the major capture operation, would have to be done by the mass driver itself.

The ability to move asteroids into new orbits has another ramification. Consider the following. On April 10, 1972, a house-sized asteroid fragment, heading north, crashed into the atmosphere over Idaho. The glowing fireball was widely photographed. Due to its aerodynamics and shallow entry angle, it skipped back out of the atmosphere into space, avoiding what would have been a Hiroshima-class explosion, probably somewhere in Alberta, Canada.* On June 30, 1908, Earth was not so lucky. A comet fragment or weak asteroid exploded in the atmosphere over Siberia in a burst similar to a 10- to 15-megaton bomb. The region was sparsely populated and no one was killed, but "deafening bangs" were heard 500 km (310 mi) away, an eyewitness was knocked off his porch 110 km (68 mi) away, and trees were seared and blown over a few miles from the ground

*For a fuller account, see L. Jacchia, "A Meteorite That Missed the Earth" in *Sky and Telescope*, 48 (1974), p. 4.

Ron Miller

The first landing on a comet. Descending to the surface, an armored manned lander braves the outflow of slow-moving debris blowing off a comet nucleus. Ice pinnacles have been left where the surface was protected from sunlight by clumps of soil (left foreground). A halo is formed around the sun by myriads of ice crystals near the comet's surface.

zero point, directly under the atmospheric blast. The geological record shows much evidence of even larger asteroid collisions dotted throughout the past, including the suspected 10-km (6-mi) asteroid impact that ended the cretaceous period and wiped out many species, including dinosaurs, 65 million years ago. Probably one or more objects capable of causing serious

damage collide with Earth every century, though most fall undetected into the oceans or in remote areas. With modern hair-trigger surveillance for nuclear missile attacks, these objects present some danger of misidentification as missiles, not to mention the direct danger of explosion damage in populated areas, perhaps once every century or so.

If the human race gains a space capability to detect approaching objects and alter their orbits, we will be able to identify such objects with at least months of warning time. Months in advance of impact, only tiny deflections would be needed to make the object miss Earth altogether. In short, our growing capability to interact with asteroids may lead ultimately to a safer environment for life on Earth, independent of any resource utilization.

Thus, although most science fiction predicted exploration of Mars as the next stop after moon exploration, the new view in the 1980s is that asteroids may become the most important landfalls after the moon. They will play a role in the development of an interplanetary civilization in the solar system. Many of them allow easier round trips from Earth than do Mars or Venus; they offer scientific clues about planetary evolution; and they can provide a variety of materials that could fuel a new interplanetary economy.

In the face of growing nuclear armaments on Earth and squabbling over our last reserves of dwindling resources, the asteroid option offers a hopeful scenario for the future. If scientists and politicians can begin to work out the problems now, we can envision a slow transition from dependence on terrestrial ores of ever decreasing quality and ever increasing cost, to utilization of interplanetary ores. We envision a slow transition from processing ores on Earth and dumping the resultant pollution into its atmosphere and waters to processing of asteroidal materials in space, where waste gases and particles are ultimately swept out of the solar system by the solar wind. This dream requires new social institutions that allow the material and nonmaterial benefits of space production to spread

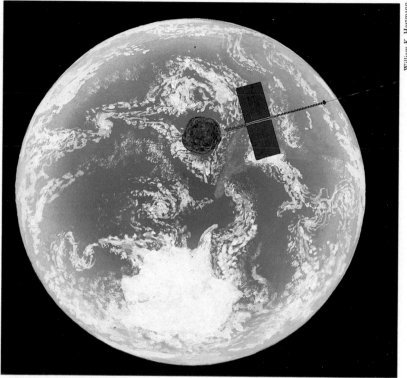

William K. Hartmann

Bringing an asteroid back home. A mass driver powered by solar panels has been erected on a 100-m stony-iron asteroid. During a period of many months the asteroid was maneuvered until it entered the Earth-moon system, where it is being brought into orbit around Earth. (Antarctica and South America are seen below.) It will become a new moon, and its metals and other raw materials will be mined for the benefit of Earth's people and global economy, assuming a political mechanism can be found to accommodate this endeavor.

throughout third-world economies, promoting world stability, while still returning enough advantage to the wealthier sponsors to provide motivation for the enterprise. If these conditions can be met, our skies may acquire new, tiny moons—asteroids towed from the depths of interplanetary space—while Earth itself becomes cleaner and safer.

MARTIANS— IN MYTH AND REALITY

For more than a century, the red planet Mars has been *the* planet of mystery. It was the first and only planet on which early telescopes revealed features that could be identified as Earth-like. Indeed, early astronomers went overboard in assuming it *was* Earth-like. From the theories of the 1800s, an elaborate hypothetical model of Mars grew; we'll call it the mythic Mars. It was a Mars of rippling canals and cool breezes blowing past ruined towers of dying cities.

So extraordinary was the mythic Mars that until the 1970s it colored our perceptions of other worlds. So rich were its possibilities that it fostered the whole genre of space adventure stories that grew into today's tales of star wars and close encounters. Mythic Mars is part of our space heritage; it teaches us something about our own dreams and our ability to interpret unvisited worlds.

Mythic Mars

Mythic Mars got its start at about the same time as the United States. In the late 1700s English composer-turned-astronomer William Herschel and other astronomers had the first telescopes good enough to begin charting the markings that had been glimpsed on the ruddy Martian disk. Herschel identified polar ice fields like those in our Arctic, moving clouds and a more stable pattern of dusky surface markings that revealed the planet's rotation. The rotation period turned out to be a bit over 24 hours—about the same as ours. Herschel concluded that Mars must be quite similar to Earth. He supported the doctrine of "the plurality of worlds," the idea that all celestial bodies are Earth-like worlds, washed with rains, blessed with gardens of vegetation and inhabited by civilizations. Each world, in this view, was created as a garden for a specific set of God's creatures.

Observers incorrectly thought the dark areas on Mars were oceans, heightening the impression that Mars resembles Earth. In contrast, the light orange regions came to be called deserts—correctly, as it turned out.

By the later 1800s, the idea that Mars could be an inhabited world was supported by Darwin's theory of biological evolution. Even if alien worlds were different from Earth (somewhat colder due to greater distance from the sun, for example), species could evolve and adapt to these conditions. Each world was merely a cosmic environmental niche.

Toward the end of the 1800s, superb telescopes were revealing Martian features in ever more complex and strange detail. In 1869 Father Pietro Angelo Secchi in Rome used the Italian term *canali* to refer to certain streaky markings that had been mapped by several observers. These were diffuse, wispy streaks, running among the larger dark patches. Continued mapping revealed that the patches themselves changed shape and contrast somewhat from year to year.

The first human landing on Mars. Moderately streamlined for ascent through the thin Martian air, a manned lander kicks up thick clouds of ubiquitous Martian dust. The sky is perpetually colored pink by windblown particles of this dust. Avoiding common large boulders involves last minute maneuvering.

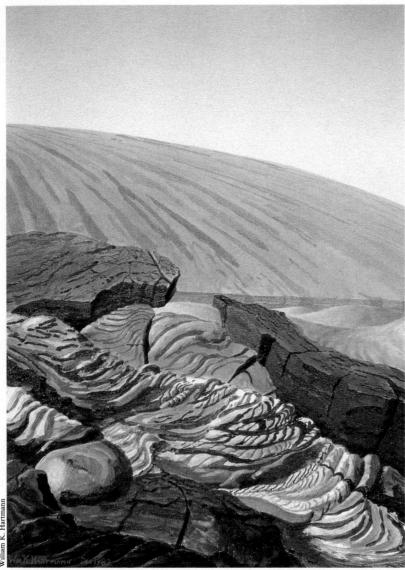

William K. Hartmann

A fresh lava flow near a volcanic dome on Mars. Lava crags contrast with un-dulating background dunes of wind- *blown dust. Flows of lava streak the flank of the background volcano.*

In the summer of 1877 an unusually close approach of Mars produced a new wave of detailed observations. Italian observer Giovanni Schiaparelli, a respected astronomer known for his discovery that meteor showers come from comets, focused more attention on the *canali*—or canals, as they came to be called. Schiaparelli further claimed that they were not diffuse, but narrow, straight lines like spider webs lacing the Martian disk, and his observations in 1879 convinced him that some of them were double: pairs of close, parallel lines. But controversy soon raged over the canals; some astronomers saw lines, some saw diffuse streaks, some saw nothing.

In 1894 the flamboyant American astronomer and world traveler Percival Lowell built a new observatory under the clear skies of Arizona and dedicated it to the study of Martian mysteries. By the turn of the century he reported seeing the canals with unprecedented clarity: they were sharp, straight lines. Lowell came forth with an astounding Grand Unified Theory that explained all the observations. Mars, he said, was inhabited by a dying civilization. The canals *really were* irrigation canals, or rather the strips of vegetation along their borders! They were built by the Martians to carry water from the polar icecaps to the drier, warmer equatorial deserts.

Lowell tied this overly optimistic biological theory to a more realistic planetological theory. He pointed out that if planets formed with a certain amount of heat and atmosphere, the small planets would lose their heat and atmosphere faster than the big ones. The heat of a small body would radiate into space. The atoms of gas, only weakly held by low gravity, would escape, one by one, into space. So Mars would cool and lose its atmosphere faster than Earth. For these reasons (still more or less scientifically valid today), Lowell speculated that any Martian species of life would face a tougher environmental history than terrestrial life. Intelligent Martians would have had to undertake planet-wide engineering, such as the canal system, to survive the cold and drought.

Lowell was the prime architect of the mythic Mars, which

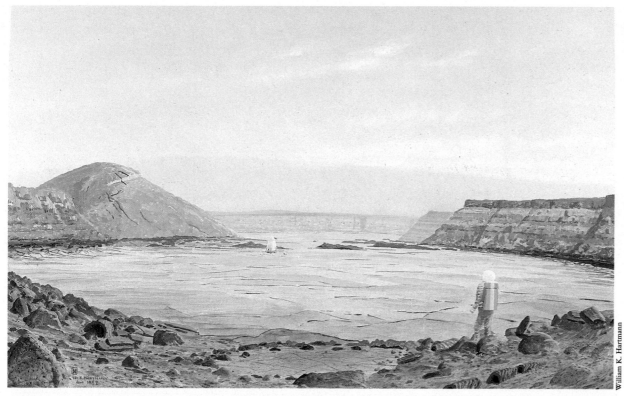

Exploring a volcanic caldera. An early objective will be to determine whether any Martian volcanoes are still active. Here explorers have landed in a caldera, or volcanic crater, to measure ages of youngest volcanic samples.

William K. Hartmann

had a profound effect on Victorian intellectuals. Tennyson wrote a poem about seeing Earth from Martian skies. H. G. Wells wrote in *The War of the Worlds* of an invasion of Martians who could not be defeated by terrestrial technology but were eventually demolished by terrestrial bacteria, to which they were not immune. By the 1920s Edgar Rice Burroughs was writing (in addition to Tarzan stories) Martian novels complete with desert cities, six-legged beasts and heroines in distress. Decade by decade, scientific observations were rendering Mars less and less habitable, and science-fiction writers reluctantly had to follow suit. By 1950 Ray Bradbury's *Martian Chronicles* featured American colonists settling among dusty, ruined cities where the last Martians lurked along languid canals.

The Scientists' Mars: Lowered Expectations

In answer to the furor over Lowell's theory, astronomers redoubled their efforts to discover the true Martian surface climate. A convenient unit for discussing the climate of Mars is the atmospheric pressure at the surface. On Earth this value is 1,000 millibars (abbreviated mb) at sea level and roughly 250 mb at the top of Mt. Everest, where climbers begin to need oxygen masks. At much lower pressures, humans could not operate without spacesuits. The history of astronomical observations of Mars from Lowell's time onward is history of lowered air pressure estimates.

Calculations as early as 1909 showed that even if Mars had as

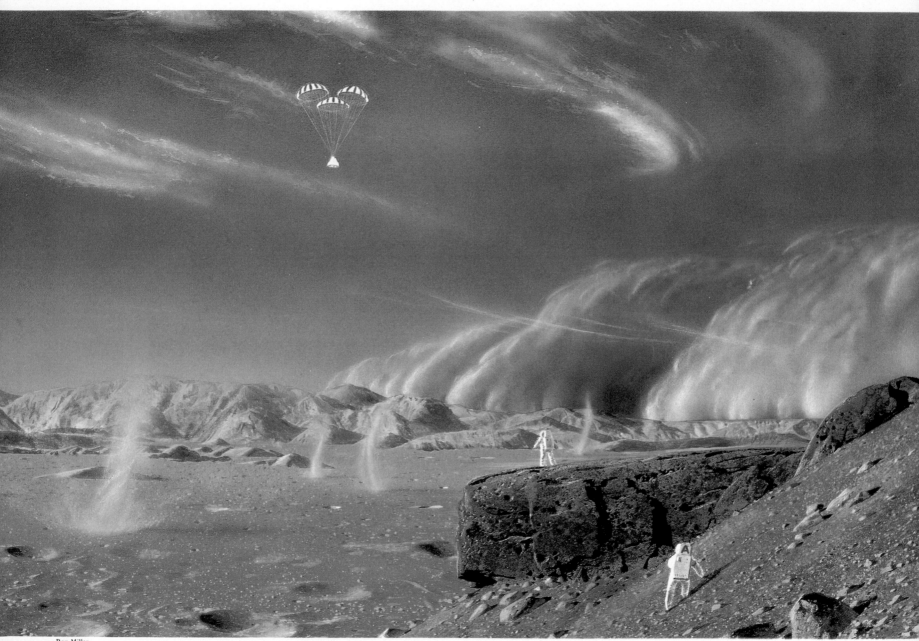

Ron Miller

Facing page: resupply in the nick of time. A growing dust storm threatens to interfere with an attempt to parachute supplies from an orbiting mother ship to surface explorers. Despite the thin Martian air, engineers were able to parachute the Viking landers from orbit much of the way to the surface in 1976. Rocket engines cushion only the final touchdown.

Right: a Martian dust storm and volcanic rift. Seasonal winds, especially during summer in the southern hemisphere, initiate large-scale dust storms, some of which have been observed from Earth to begin in localized regions, spreading to cover virtually the entire planet.

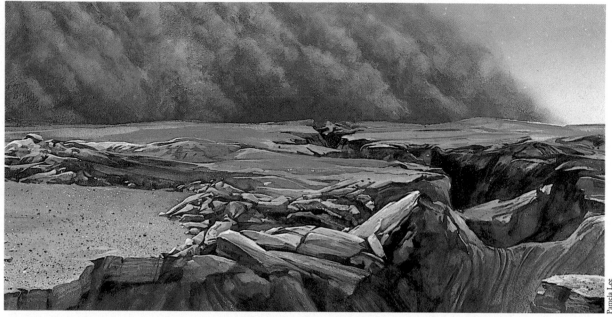

much air as Earth, the lower gravity would reduce surface pressure to 400 mb, and if the Martian atmosphere were scaled in proportion to the planet's mass, its surface pressure would be only 140 mb. An astronomer of that period compared a day on Mars to a day on a 20,000-ft mountain on Spitzbergen Island in the Arctic Ocean! By the 1950s spectroscopes had identified carbon dioxide as a major atmospheric gas and had shown that oxygen and water vapor were very rare in the Martian air. A plan for a Martian expedition published by rocket pioneer Wernher von Braun in the 1950s assumed a Martian air pressure of 85 mb, based on then current data. Researchers reluctantly realized that humans could not breathe on Mars. But the story was not yet over. In the mid-1960s spectroscopes and space vehicles gave the final answer. The Martian surface pressure is in the range of 5 to 10 mb, higher in the deep canyons and lower on mountain summits. Telescopic and subsequent Viking lander measurements showed soil temperatures ranging from about –170°F at night to as high as 45°F on a summer day; the corresponding air temperatures range from about –117°F to –27°F.

Still, many scientists believed that primitive Martian vegetation could have evolved to match these ultra-arctic conditions. They thought the seasonally changing dark patches were best explained by fields of simple mosses or lichens.

The first close-up photos—from Mariner 4 in 1965—made scientists more pessimistic about Martian life. Covering only a tiny fraction of Mars, these photos showed only barren craters. But later photos, including global mapping from orbit by Mariner 9 in 1972, began to make Mars look interesting once again. In addition to ancient cratered terrain, the new pictures showed more youthful geologic features that included lava flows, giant volcanoes (could they be sporadically active in modern time?), giant canyons, vast dune fields and stratified sediment layers around the poles. Here and there were clusters of ragged hills and valleys, usually depressed below surrounding areas that came to be called chaotic terrain. The variable dark patches were found to be dust deposits, blown around by seasonal winds.

William K. Hartmann

Most surprising, Mariner 9 showed dry riverbeds lacing many parts of the arid planet. This was a shock for a whole generation of astronomers. A planet that had seemed to be a bone-dry desert with its scarce water frozen in polar ice was now revealed to have had liquid water flowing across its surface at some time in the past! The riverbed-like features came to be called channels—not to be confused with Lowell's canals.

As for the canals themselves, they were nonexistent. Lowell had been deluded. We now know that different people's eyes have different tendencies to connect splotchy markings, and in this trait Lowell had been extreme. Some of his canals turned out to be streaky, windblown dust deposits; others he had simply imagined.

Even though the main dark patches once thought to be vegetation were now attributed to windblown dust, excitement grew over the possibility of Martian life. If liquid water had once made rivers on Mars, the ancient climate must have been more suitable for life—at least during short periods. Could scattered plants exist on Mars, even today? Surface photos were needed to answer this question.

On July 20, 1976, seven years to the day after the first manned landing on the moon, Viking 1 touched down on a rocky Martian plain. This was the first successful Mars lander (following several Russian probes that crash-landed). Its cameras showed scattered boulders, picturesque dust dunes, an unexpected light pink sky, but no plants. The sky color is caused by windblown reddish Martian dust, stained by rust-red iron oxide minerals. Viking 2 landed on a similar rock-strewn plain some weeks later. Viking cameras returned pictures for three Martian years (5½ Earth years) but showed no trees, no animals, no mosses, no lichens, no fossils . . . no life.

First into the Martian dunes. Mars boasts the largest dune fields in the solar system. This astronaut scouts a route for a party of explorers who will measure structure, stability and ages of the dunes. The upturned rim of an impact crater is seen in the right distance at the horizon.

Finally the mythic Mars and the scientists' Mars had converged into a single reality, forbidding, beautiful, and scientifically challenging. Why did water once flow on Mars? Could life have existed in the past and then died out?

Mysteries of the Real Mars

Instead of accommodating Martians into our world-views, we now have to understand why there are *no* Martians—why there is no detectable life—on the planet where we thought biochemical evolution was possible. Does it mean that humans are products of a special creation that happened only on Earth? Probably not. Researchers have discovered complex extraterrestrial organic compounds in certain meteorites, proving that the building blocks of life were fabricated in other planetary environments in the solar system, beyond Earth. Why not on Mars?

Other mysteries are more geological. Why are sediment deposits at the Martian poles stratified? Were they deposited during dust storms that occurred during climatic cycles, creating individual layers? If there were major cyclic climate changes, what caused them?

But a much larger climatic mystery lurks on Mars. How did the channels form? If floods of water were released, when did it happen? Where did the liquid come from on this now arid planet?

Orbiters above Mars, landers on the surface and recent Earth-based telescopic measurements have combined to provide some partial answers. Mars is not so dry after all, in the following sense: there is a lot of water, but virtually none of it is liquid. The water is in three forms. A certain amount is permanently frozen on the ground in the white polar snowfields of ice or frost. Their depth is unknown, perhaps many meters or more. The polar temperature is below freezing even during summer, so most polar water is permanently frozen. In winter it gets so cold that the carbon dioxide freezes out of the atmosphere and makes a much broader cap of frozen CO_2 (so-called dry ice), which disappears each summer.

Facing page: drilling the Martian polar sediments. Stratified deposits in the Martian polar regions may hide layers of permafrost that could provide abundant water for explorers. Here a drilling station has been set up to probe the subsurface structure.

Right: low sun near the Martian pole. Hazes of condensing carbon dioxide and water ice crystals at high Martian latitudes may provide spectacular halo phenomena surrounding the sun. Water ice crystals create halos on Earth; Martian CO_2 clouds would create arcs at different angular radii.

A second reservoir, called water of hydration, is bound chemically, molecule by molecule, in the crystal lattices of the soil minerals, like that in carbonaceous asteroids. Viking landers found that Martian soil released 0.1 to 1 percent by weight of water during heating to about 400°C (750°F).

A third reservoir, perhaps the most important, is a planetwide layer of permafrost, an underground layer of ice mixed with soil, similar to that in our own arctic regions. It is estimated to extend from just below the surface to a depth of a kilometer or two (about a mile) near the equator and as much as 8 km (5 mi) near the poles. If this permafrost were heated locally by volcanic or artificial heat, it would yield abundant water.

Interesting evidence for the presence of permafrost can be seen in some craters shown in orbiter photos. These craters have thrown out not the pulverized dust seen around lunar craters, but rather a gloppy-textured, mudlike spatter. Studies indicate that the muddy material was ejected when the impact melted the permafrost.

All three reservoirs—polar ice, water of hydration, and permafrost—will be welcome resources to astronauts. Mars may seem lush to those who had to colonize the moon!

The permafrost reservoir, in particular, helps explain certain channels that emanate from chaotic terrain. The idea is that local sites of geothermal heating—Martian Yellowstone parks—melted the permafrost in certain areas. When the ground collapsed, forming chaotic terrain, the water flowed out and eroded the channels.

But does this explain *all* the channels? A network of fine

William K. Hartmann

A telltale wisp of steam leads to discovery of the first-known active fumarole in a volcanic caldera on Mars. Discoveries like this would hold the promise of geothermal energy sources on the otherwise mostly frozen planet. Such vents would be sought during surveys of youthful volcanic regions.

channels covers much of the equator, even away from chaotic terrain. Certain channels emanate not from chaotic terrain, but from systems of tributaries that fan out into the desert. Here the source of water seems not to have been localized, but to have come from runoff in broad desert regions. Some scientists studying the pattern have suggested that rain must have fallen on these areas. This would require a profoundly different atmospheric condition during the channel-forming period, since today's Martian atmosphere is too thin and dry to permit rain. Other analysts reject rain, suggesting that the channels grew by "headward erosion," fanning out into the deserts.

Was the ancient environment different? And if so, when? Dating the channels would help us unravel the mystery of the

Pamela Lee

Martian climate, and collection of datable rock samples will be a top scientific priority for future explorers. In the absence of such samples, our best way to estimate channel ages is to count the number of impact craters that formed since the channels, then use the estimated meteorite impact rate to figure how long it would take to accumulate the craters. The resulting answer is that the channels are much younger than the heavily cratered old features of Mars, but greater precision is difficult. Probably many channels experienced flooding in the middle third of Martian history, one to three billion years ago.

Back to the Mythic Mars?

Two lines of evidence suggest why Mars' climate might have been different that long ago. First, Viking landers' analyses of gases in the Martian air indicate that the total amount of gas emitted from the interior of Mars by volcanoes, throughout Mars' history, was much greater than the amount in Mars' atmosphere today. (The estimate comes from detection of certain heavy tracer gases like argon that have remained in Mars' air and allow calculation of the original total inventory of gases.) Much of the missing gas may have escaped, molecule by molecule, into space during geologic time. One estimate is that at least 140 mb of carbon dioxide was exhausted by Martian volcanoes, and another study calls for as much as 500 mb or more of nitrogen. Ironically, if most of this gas was in the early atmosphere at one time, the ancient Mars would have looked much like the mythic Mars postulated by Lowell! The thicker atmosphere would have held heat better, allowing Mars to be warmer and possibly to experience rain.

A volcanic outburst on Mars. The pristine appearance of Martian lava features in some Viking photos suggests that some Martian volcanoes may be active in contemporary geologic time. Eruption of a large volcano would provide a spectacular view for Martian astronauts.

Pamela Lee

The second line of evidence about ancient climate conditions is more complex. Theorists have calculated that if Mars' polar icecaps ever tipped more toward the sun, then the summer sun would have shown more directly on them and melted the ice. This would release water vapor into the atmosphere, where it would circulate. The more vapor gets into the air, the more solar heat is retained in the air, the warmer it gets, and the more melting occurs. Note the feedback: a *little* extra atmosphere may eventually lead to a *much* thicker, warmer, wetter atmosphere. Some researchers calculate that if Mars ever gained a little more water vapor, there could have been a runaway effect, causing a shift to a dramatically different climate. Martian history, in this view, could involve an intermittent "flipping" between the present dry, cold state and the other wet, warm state.

Could the polar tilt ever increase enough (in the past or

Above: Martian Arches Natural Monument. A goal from the beginning of exploration of each planet should be to identify areas of unique beauty and scientific interest. Martian low gravity, water and wind erosion may combine to create spans of great length and delicacy.

Facing page: exploring a Martian channel. Astronaut-geologists hike along an apparent ancient watercourse, looking for clues to its age and origin. How did this now arid planet sustain temporary rivers in the ancient past?

future) to cause this effect? Unfortunately, although it oscillates a little bit today due to various astronomical forces, the tilt never gets high enough to melt the polar ice and cause the transition to the wet, warm state. But now another bit of Martian science comes into the story. The tilt is influenced by the distribution of mass on the surface of Mars. Today this distribution is irregular because of the huge bulge of lava piled up on one side of the planet in the so-called Tharsis plateau, capped by four huge volcanoes that reach 22 km (72,000 ft) or more above the mean Martian surface—two and a half times the height of Mt. Everest on Earth! These volcanoes are young. They may have started building up only one or two billion years ago, in the last quarter of Martian time, and they may even still be active. Researchers asked how Mars' tilt would have behaved before they were there. The calculations indicated a much wider range of pre-volcano tilt, to values as high as 43° (almost twice the current value), which would be adequate to melt the polar ice during the intervals when the tilt was reached.

Now let's put the story together. In the early or middle part of Martian history, the atmosphere was thicker. Volcanoes added gases, but had not yet built the huge Tharsis plateau. As the polar tilt oscillated, it would reach states in which, for many thousands of years, the summer ice would melt, perhaps adding enough water vapor to the atmosphere to allow occasional rains. The periods of maximum atmospheric density, wetness and warmth may have been episodic—some occurring during eras of maximum tilt, others during eras of maximum volcanic outgassing. Even if there was never any rainfall, these periods encouraged the melting of the permafrost. The atmospheric pressure and mild temperatures allowed the released water to flow across

Ron Miller

A historic site on Mars is the remains of the first human-made object to arrive there: a Russian probe that parachuted and crashed in 1971. In the background, the passing shadow of Mars' moon Phobos temporarily darkens the surface and dusty atmosphere.

Devil's postpile on Mars. When thick flows of basaltic lava cool and solidify, they often crack into flat-sided columns, exposed by later erosion. On Earth, such explosives have been given colorful names and preserved as national monuments (Devil's Postpile in California, for example, and Devil's Tower in Wyoming, popularized as the landing site in Close Encounters of the Third Kind). Such a site could be set aside as a natural monument on Mars.

the surface for great distances, rather than evaporating and freezing rapidly, as it would under today's conditions.

Slowly the atmosphere thinned as gas leaked into space. The lavas piled up in Tharsis and reduced the maximum tilt angle, leaving more water permanently frozen at the poles. Ground water froze into permafrost. In an evolution more complex than but akin to that theorized by Lowell, the red planet became dry and desolate.

Where Are the Martians?

If this story is anywhere near the truth, it offers threefold excitement. First, it teaches us how a planet's climate may change due to long-term geologic processes. More evidence about Mars' climate evolution and its channels, steam vents and volcanoes might help us understand the history of our own

planet. After all, Earth, too, has experienced ice ages and biologically devastating climate shifts that wiped out humerous species.

Second, research on Martian climate change may teach us something about accidental, *artificially* induced climate changes, such as those that may be caused on Earth by carbon dioxide build-up from the dumping of industrial wastes into our own atmosphere.

Third, this story of climate change on Mars brings us back to the question of Martians. Where are they? It's an important philosophic question. For thousands of years, humans have wondered how plant, animal and human life started on Earth. The biblical theory in Genesis is just one of many answers handed down from early philosophers and naturalists. If we claim to understand anything about this process, we need to know why life *didn't* get a foothold on Mars. The question is especially vexing because we think life got started when organic chemicals accumulated and interacted in oceans or tidal pools on Earth. Scientists used to suspect that there was no life on Mars because Mars is too dry. If we now claim that Mars had liquid water, why no life?

Based on the Viking landing soil analyses, most scientists have concluded that Mars today is as dead as a doornail. Or even deader than a doornail. Even your random nail is likely to have some organic molecules or scum on it, but the Martian soil contains *no* organic molecules—to a measuring accuracy of a few parts per billion! There is an explanation for this. Any organic materials formed on the Martian surface would have been exposed to sunlight over the years as Martian dust blew around. During this process, the complex organic molecules would have

Left: the Martian aircraft. Experimental designs suggest that light aircraft with wide wingspans could provide enough lift to operate in Mars' thin air. Here the aircraft flies over a strange, fractured region of parallel faults, of a type photographed by the Viking orbiter.

Facing page: over a Martian valley. The Martian aircraft conducts a reconnaissance survey over an old, cratered valley, possibly part of an ancient channel system.

Ron Miller

Pamela Lee

been broken apart by energetic solar ultraviolet rays and the soil would be sterilized. On Earth we are relatively protected from this process by our dense atmosphere's layer of ozone, a gas that absorbs the solar ultraviolet light (although ultraviolet light gets through the ozone layer and damages organic material in our skin, causing sunburn). On Mars there is no ozone layer and the present-day surface is blasted by the sun's ultraviolet radiation. Thus, unless Martian lifeforms had evolved with protecting shells and were constantly producing new organic material today, we could predict that the present-day soil would be sterile, as observed.

But if Mars once had abundant liquid water and air, why didn't such ultraviolet-adapted life evolve?

Death on Mars. Exploration is never without risk: here a Martian astronaut sustained fracture of his faceplate during a freak afternoon dust storm. Lightning due to charge build-up during Martian dust storms is possible, but has not yet been confirmed.

Martian explorers will seek to support or refute several possible theoretical answers: a) We're wrong. Mars was always dry. There was never much liquid water and there was never any life. b) Our climate theory is right, but liquid water never lasted long enough in any one place to allow vigorous life to get started. If no lake on Mars lasted more than a few thousand years, any organic materials that formed there may have been broken down as the lake dried up. c) Primitive Martian life actually did evolve, but died out as Mars dried out. Only fossils are left. No organic

molecules are left today because they have all been destroyed by eons of ultraviolet exposure. Just as fossils of primitive, soft-bodied life in the first 85 percent of Earth's history are very rare, fossils of any primitive Martian life would also be hard to find. But they would be a spectacular treasure, worth seeking! d) We have been hasty in using Viking data to conclude that no life exists on Mars. Perhaps there really is life, hidden from ultraviolet rays deep in the soil or inside cracks in rocks (where microbes have been found hiding in the hostile Antarctic environment on Earth). The Viking landers, after all, scratched the surface in only two sites on Mars. Perhaps life hides in other areas, as in polar ices where liquid moisture may sometimes appear during summer meltings.

Which idea is closest to the truth? What is the real story of biochemistry and life's evolution in the solar system? We will have to conduct further Martian exploration before we find out. As we think of silent, scattered boulders, graceful arcs of wind-blown dunes, towering cliffs of eroded sediments, layers of ice seeing sunlight for the first time as they are exposed in landslides, hot lavas buried but squeezing upward toward permafrost layers where they might explode in steam-rich outbursts—as we imagine Martian winds whistling down dusty canyons or across knife-edged crystals of polar ice, the ghosts of Lowell's Martians haunt us. The ghosts, at least, will always be there.

The Mars Mission

If a rocket is launched from Earth's orbit toward Mars with the lowest possible energy and fuel expenditure, and it then coasts on an orbit that intersects Mars' orbit, the travel time to Mars is about 260 days. This could be cut by using more fuel to depart at higher speed or by using small engines to accelerate and then decelerate during the journey, but it's likely that the first Mars expedition will require travel times of six to nine months.

The journey is not beyond present technology. It merely requires reliable machines and willingness to endure long flights. As early as 1948 Wernher von Braun calculated the technical requirements and envisioned an expedition of ten spaceships, of which three would carry "landing boats" that would land on Mars, return to Martian orbit and be left behind while the remaining seven ships returned to Earth.

Today, with our better knowledge of the Martian atmosphere and surface, the travel plan might be different in detail, but the overall magnitude and time scale for an expedition to land on Mars would be much the same. While no plans for such an expedition have been announced by the United States or other countries, there are persistent rumors of Russian interest in a Martian expedition of some sort. The Russians have repeatedly compared the duration of their manned missions in the Salyut space stations (as long as seven months) to the duration of an interplanetary flight. In other words, Russian cosmonauts have already undertaken individual flights as long as a trip to Mars. Russian scientists failed in their numerous attempts to land cameras and other equipment on Mars before Viking. However, their program of unmanned Venus landers has been very successful. Lacking experience for an early, difficult and dangerous landing attempt, Russian cosmonauts might first attempt a Martian fly-by mission. An interplanetary journey passing close to or perhaps completing numerous orbits around Mars would be a dramatic first in space exploration and allow observations in a unique new setting. Rumors in 1984 suggested that instead of merely looping around Mars, Russian scientists might attempt an (unmanned?) mission to rendezvous with one of its moons.

The Martian Base

As we gaze into the future, we can discern what we might call a time horizon. Events on our side of this horizon, such as a space station or a lunar base, we can foresee moderately well even

Overleaf: building the Martian base. Construction of permanent, roomy quarters on Mars will be both a safety measure and a relief for early explorers, who will have to live for an initial period in their landing ship. Internally pressurized domes that could be later reinforced on the outside might serve as Martian surface quarters while more permanent structures are erected.

Pamela Lee

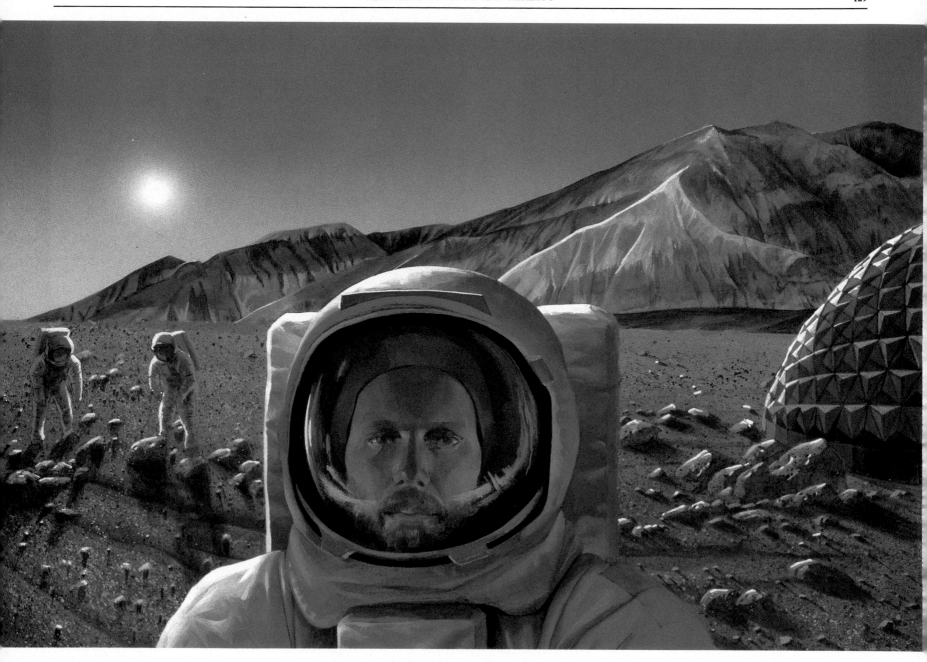

Ron Miller

*Martian explorers will develop
their own in-group humor.*

Ron Miller

*Above: solar sailing to Mars. Sunlight
exerts a slight pressure on exposed sur-
faces. Studies show that sunlight could
exert enough force on enormous low-* *mass surfaces, or "solar sails," to pro-
pel ships through the solar system. Solar
sailing would allow inexpensive resup-
ply of Martian expeditions.*

though they have not yet happened. But a Martian base is among
the events beyond the time horizon; it is too far ahead to foresee
clearly. Nonetheless, our discussion of the scientific mysteries of
Mars allows us to see the basic scientific and life-support goals on
that planet. To study the complex geology and climatology of
Mars, we would want mobile astronauts who could travel to sites
of various types and use their instruments, geologic expertise and
scientific common sense to search out drilling sites, geothermal
areas, impact craters, ancient sediments, hypothetical fossil-
bearing strata, active volcanic sites and steam vents (if any),
permaforst exposures, etc. Even on early Martian expeditions
there may be attempts to set up bases for extended stays on the
surface, since flights back and forth to Earth are expensive and
time-consuming. These would resemble the early seasonal bases
on cold, arid Antarctica. Martian material to support life in these
bases will be much more accessible than such material on the
moon. Water from permafrost, polar ice or hydrated minerals
will be especially welcome, and the first order of business may be
to locate reliable water sources.

Calspace planner David Criswell has suggested that the first
Mars expedition, unlike Apollo 11, might operate as a "Mars
University." It could be a large expedition consisting of several
ships and a collection of scholars who would not land and quickly
return, but stay *on* Mars or in orbit for a year or more, until the
second or third Martian expedition arrived to spell them.

As early Martian shelters grow into bases and colonies,
explorers will spread out into the hills and craters of Mars,
looking for relics of ancient conditions on Mars, prospecting for
additional resources that will ensure a Martian future and search-
ing for ephemeral traces of hypothetical primordial Martian
lifeforms. Yet even as they wander among the ghosts of Lowel-
lian Martians, or perhaps among subtle fossil traces of ancient
lifeforms, they will be creating the first true Martian civilization.
When will this happen? Harrison Schmidt, veteran of the last
expedition to the moon, recently predicted that today's students
will be the parents of the first Martians.

PHOBOS AND DEIMOS: DEPOTS ON THE ROAD TO MARS

Circling Mars are two small black satellites, no bigger than a mountain or a modest town. Named Phobos (Fear) and Deimos (Terror) after the mythological attendants to Mars, the god of war, they were discovered by American astronomer Asaph Hall in the summer of 1877 during a close approach of the planet Mars. For weeks, Hall used his telescope to search the sky around Mars for faint moons but found only background stars. He was about to give up when his wife, who was also his secretary, urged him to stay at the project because Mars would not be so close again for years. Hall returned and searched closer to the planet. On August 10 he found the faint outer moon, Deimos. To confirm the discovery he kept charting Deimos' position and, while surveying a region still closer to Mars' disk, on the seventeenth he found the brighter, closer moon, Phobos, almost lost in the glare of the planet.

Strange Objects

Almost nothing was known of the Martian moons until Mariner 9 photographed them at close range in 1971. Even their diameters were unknown because their tiny disks, too small to be seen in a telescope, appear like faint starlike points.

The close-up photos quickly revealed that the two moons are unusually black and irregular in shape—Phobos is 19 × 27 km (12 × 17 mi) and Deimos is 11 × 15 km (7 × 9 mi). They also revealed that both the potato-shaped moons are heavily cratered—as battered as any surfaces in the solar system. The scars mean that the surfaces are old. Probably they have been exposed to meteorite impacts since the early days of the solar system four and a half billion years ago. The largest crater on either moon is an 8-km (5-mil) bowl on Phobos. Mariner scientists named it Stickney, the maiden name of Mrs. Hall, who spurred Asaph Hall on to discovery. It lies near the equator of Phobos, somewhat on the Marsward side.

Stretching more or less radially outward from Stickney are peculiar swarms of 100-m-wide grooves and chains of small crater pits. These grooves and center chains, kilometers long, may mark fractures in the solid body of Phobos, created when the Stickney impact nearly shattered the little moon.

Studies with Mariner instruments revealed that there is dust on Phobos and Deimos, at least a few millimeters deep and quite possibly much deeper. The dust is debris blown out of the craters, similar to the dust on the moon. The grooves and crater chains stretching out from Stickney may be sites where the dust drained down into underlying cracks in the solid interior of Phobos. In this case, the dust depth may be comparable to the crater radius, perhaps, 50 m (50 yd) deep.

Though its texture may be similar to that of lunar dust, composed of rock chips and flourlike powder, the dust on Phobos and Deimos has a different history. The gravity of the moons is so low that much ejecta from their craters is blown clear off into space. Why, then, does any dust remain? The dust goes into orbit around Mars, close to the orbit of the little moon from which it was launched. After a few trips around the planet, the particles strike the moon again and reaccumulate on the surface.

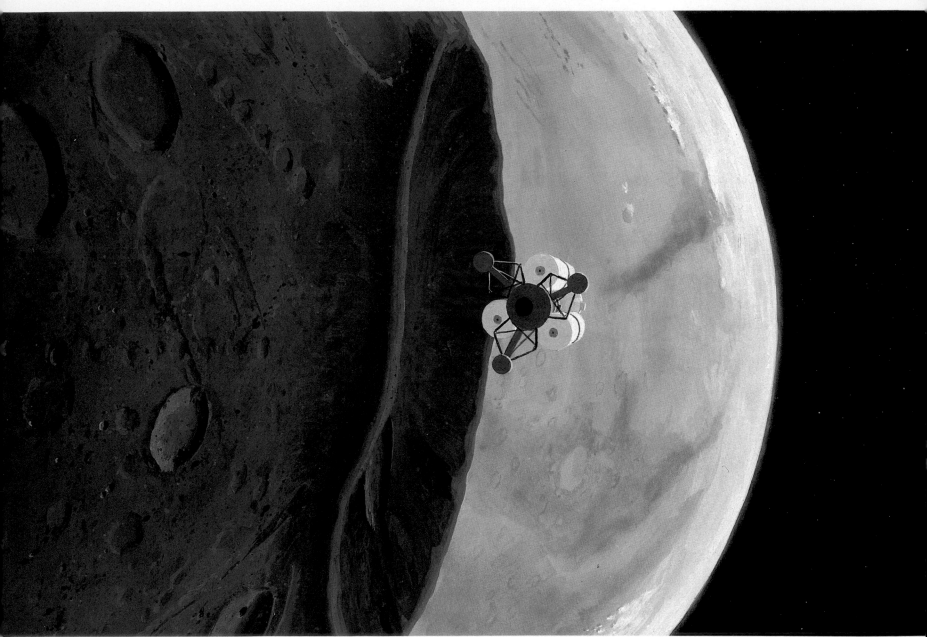

William K. Hartmann

The process works better for Phobos than for Deimos, because Phobos is closer to Mars and therefore deeper in its gravity field. Some dust blown off remote Deimos may be blown clear out of Mars' gravity field and lost forever into interplanetary space. This difference may explain a difference in surface textures between Phobos and Deimos. Phobos seems to have rolling hummocky terrain and its craters often have gently rounded rims. Deimos seems flatter, with more scattered, house-sized boulders.

Certain craters, especially on Phobos, have dark patches of material at their bottoms or layers of light material exposed in the walls. What are these deposits and strata? Only future astronauts will know.

Mariner and Viking orbiters, studying the spectra of Phobos and Deimos, revealed that their compositions seem to match those of the black, carbonaceous-type asteroids in the outer part of the asteroid belt and near Jupiter. This material is probably rocklike but laced with, and colored by, black carbon-bearing compounds.

This was a provocative discovery from the point of view of future exploration. If Mars' moons are really like carbonaceous asteroids, then they may contain large amounts of chemically bound water and organic compounds that could be used as resources on the way to Mars.

Landing on Phobos. Under the low gravity of this tiny moon, a brief burst of the engine is sufficient to brake the fall of the ship onto the dark-colored surface.

William K. Hartmann

Facing page: coming around the bend, over Phobos. A reconnaissance ship making a low orbital flight around Phobos crosses the rim of its largest crater, Stickney. About 8 km (5 mi) across, Stickney was caused by an impact explosion almost large enough to disrupt 27-km-long (17-mi) Phobos. Phobos is made of much darker material than Mars, which looms beyond Stickney's rim. The painting, with an angular width of 60°, is based on a globe of Phobos and shows actual orientation of Stickney relative to Mars.

William K. Hartmann

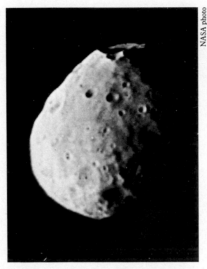

Right: Viking orbiter photographs like this one revealed Phobos to be a potato-shaped, heavily cratered body. The smallest visible craters are the size of a football stadium.

Far right: close-up photograph of Deimos. The surface from the Viking orbiter revealed subdued craters and scattered boulders on a rolling surface. The smallest visible boulders are the size of a house.

Carbonaceous moons with water content? This raises a strange and intriguing property of the Phobos crater chains radiating from Stickney. If the craters were merely pits caused purely by drainage of the dust into fractures, they should be rimless. But they aren't. Many have raised rims, probably formed by material that blew out and piled up around the vents. The crater chains can't have formed by impacts, since impactors don't fall in straight lines. Then what could have blown material out of Phobos? It couldn't be volcanism: Phobos is too small to heat up and melt rock. It *could* be gas, released from subliming ice melted inside.

Phobos may have formed with ice in its interior—consistent with our ideas of carbonaceous asteroids formed in the outer solar system. This supports the exciting possibility that Phobos and Deimos may provide a watering hole in orbit above Mars.

Strange Origins

How did Phobos and Deimos come to be moons of Mars if they are more like asteroids from the outer asteroid belt or Jupiter's region? Where did Phobos and Deimos come from, anyway? Why does Mars have two tiny moons when Earth has one large

one, Jupiter has a variety and Venus has none?

It's hard to believe that Phobos and Deimos formed in a cloud of the same material that was forming Mars. The other alternative is that the moons were captured, perhaps starting life as ordinary asteroids. The most complete scenario of this sort was worked out in 1979 by Arizona astronomer Don Hunten. In 1979 Hunten found that primordial Mars could have had a dwindling, short-lived extended atmosphere of gas around it, concentrated from the solar nebula as Mars formed. As asteroids were deflected past Mars, by gravitational forces of other planets, they might have been slowed by drag forces of the gas and captured into random orbits. In a few years the gas drag forces would alter the moons' paths into circular orbits over the equa-

Facing page: On the inner wall of a relatively fresh 1-mile impact crater on Phobos, explorers find sparkling crystals. Could they be industrial-grade diamonds produced by the high pressures of impacts in Phobos' black carbonaceous soil? The disk of Mars, with an angular diameter of 42°, dominates much of the sky as seen from many regions of Phobos.

Pamela Lee

Ron Miller

tor. Further drag would cause the moons to spiral inward, just as Skylab and other artificial satellites on the fringe of our atmosphere have done. Such moons would eventually crash on Mars, but the atmosphere dwindled so fast that Phobos and Deimos were left stranded in their orbits. Earlier asteroids might have been captured and crashed into Mars; later ones were never captured for want of gas drag.

As an alternative, perhaps Phobos and Deimos were captured as a single object and later broken by an impact or drag forces. This would explain why they have similar compositions; two randomly captured asteroids might have been of different types.

Hunten's model would be consistent with our speculations about ices in primordial Phobos. Ice is perhaps a normal internal component of many carbonaceous asteroids. When Phobos arrived near Mars, some of the ice in the outer layers was lost due to solar heating; however, its evaporation mobilized residue materials that welded loose grains together. This helped form a weak seal over ices in the core of Phobos, allowing a slight buildup of gas pressure inside the core. When the giant crater Stickney formed, radiating fractures split the solid layers and gas erupted from the core up through the cracked solid layer, then out through the dust layers of the surface, blowing out dust under Phobos's low gravity and forming chains of vent craters above the cracks. If this scenario is correct, Phobos and Deimos hold secrets of the solar system's outer realms and ancient times, and the Stickney grooves and crater chains hold secrets of unusual internal structure—clues to alien geology.

Explorers on Deimos examine the cratered, rolling surface, looking for clues to explain the somewhat different erosional texture from that found on Phobos. Astronauts in distance drift above the surface in the low-gravity environment. Mars subtends an angle of 17°; the view has a typical snapshot angular width of 42°.

Strange Orbits

The orbital spacings of the Martian moons cause some curious phenomena. Deimos is far from Mars—7 Martian radii out from the center—and takes about 30¼ hours to go around the planet. Phobos is close—only 2.8 radii out—and takes only 7½ hours to go around. These numbers compare with the 24-hour day of Mars, meaning that Deimos orbits only slightly slower than the planet itself turns, while speedy Phobos orbits considerably faster than the planet turns.

These orbits produce unusual apparent motions of Deimos and Phobos as seen in the evening skies over the equatorial regions of Mars. Like our own moon, slow Deimos rises in the east along with the stars. But it moves almost at the same rate Mars is turning, and so it takes a full 60 hours—from moonrise to moonset—to cross the sky. It would rise early one night, be eclipsed in Mars' shadow the next night and set at dawn on the third night. Because of its small size and great distance, it would look like a very bright star, somewhat brighter than brilliant Venus in our sky but not like a disk-shaped moon.

Speedy Phobos, on the other hand, overtakes our location on Mars as the planet turns and therefore rises in the west! It takes only 4½ hours to cross the sky, disappearing into Mars' shadow on its way, or on another occasion emerging from Mars' shadow as if from nowhere. Its motion among the stars would be easily visible to the eye: it would take only about 40 seconds to traverse an angle equivalent to the ½° width of the full moon in our sky. Phobos would look bigger and brighter than Deimos, about a fifth the size of our moon—a pinhead disk drifting across the sky. As it passes by, the direction to the sun would change and we would see it change phase, perhaps from crescent to nearly full.

Both moons are so small that neither can cause a total eclipse of the sun as seen from Mars' surface. But on rare occasions they would appear as small spots, crossing the solar disk. Perhaps this would be most impressive near sunset on a dusty day when the solar disk, dimmed by low dust layers, could be contemplated as a little moon passes across it. We would have to know just

Ron Miller

when to look, because Phobos crosses the sun in only about 25 seconds!

Ready-Made Space Stations

Phobos and Deimos present attractive targets for manned or even unmanned exploration. Rumors in 1984 suggest that the Russians may send a probe to rendezvous with Phobos, approaching as close as 50 m (50 yd)! Launch is contemplated as early as 1988. An eventual Soviet manned expedition is not out of the question. The cosmonauts who stayed on Salyut for seven months could as well have been on their way to the red planet, as far as their daily routine was concerned.

In any case, early Mars expeditions will enter a parking orbit around the planet after arriving. If landing on Mars is attempted, the landing ship(s) will undergo final preparation in these orbits and then depart. As in the Apollo flights some crew members will stay behind in Martian orbit, which could be selected to pass near Phobos. The mother ship or a small craft, perhaps like the Apollo landing module, could be maneuvered close to Phobos and could be oriented, landing legs down, to fall gently toward the dark moon. With a final burst of the engines, it could cut its meager 11 m/sec (25 mph) fall speed to zero as it touches down.

Astronauts could take the minute-long jump from a spacecraft cabin 15 m (50 ft) above the surface and land easily at about 1 mph. Heavy weights or hooked poles might be used to help explorers stay near the ground. In the low gravity of Phobos—where a jump that would lift you over a six-inch curb on Earth would take you some 800 feet above Phobos and about 1,500 feet over Deimos!—explorers could bounce along, peering into black craters and strange grooves, and leaping atop tall boulders in a single bound. This experience would give a curious intimacy with Newton's law of gravity. How odd, when all is said and done, that a 27-km chunk of rock actually attracts a human being and keeps one from jumping off.

An early task while waiting for the Martian surface explorers might be to erect a permanent station where supplies (perhaps labeled in many languages) could be stored as emergency rations for future expeditions. Then the explorers might begin drilling tests and chemical processing experiments to see if water could be easily obtained from Phobos or Deimos materials.

Here, as if at an orbiting Martian museum, the explorers would be studying objects that may have formed still farther away from the sun, in the outer wilderness of the solar system. These objects may have experienced weird histories of capture, fragmentation and/or outgassing. Phobos and Deimos may offer astronauts opportunities to study the properties of alien worldlets while waiting for their companions to return from the surface of Mars, thousands of kilometers below. Astronauts could thus make a single expedition to Mars and end up exploring several types of solar system objects. An expedition that carries a landing craft first to Phobos and then on to Deimos could knock off several stones with one bird!

Building the Phobos base. Such a base may provide an important waystation en route to Mars, serving not only as a scientific outpost on a mysterious worldlet but also as a source of raw materials for Mars expeditions.

INTO THE REALM OF ICE AND FIRE

Now we venture beyond the asteroid belt, into the cold realm of the outer solar system. As described in the prologue, regions far from the sun are rich in ice. The distant portion of the planet-spawning cloud of gas and dust was so cold that ice was a major constituent of all planetesimals forming there. As these planetesimals aggregated to form planets and moons, ice became a major constituent of the finished worlds. On the giant planets, the ice (along with other material) is hidden from view beneath massive, cloudy atmospheres. But on many of their moons, ice is prominent and plays the role of rock on Earth. It is ice that forms much of the solid surface, ice that melts during volcanism, water that is produced as lava. Yet there are exceptions—among them, an ice-free moon with fiery, raging volcanoes.

Different Kinds of Ice

There are several kinds of ice in the outer solar system, each with its own freezing temperatures. As shown in the table on page 143, the farther out we go, the colder the average surface and the more likely we are to encounter ices with low freezing points.

Rock is stable throughout the solar system. As we go out from the sun, the first abundant ice we encounter is frozen water. Even when exposed face-on to full sunlight, this ice is stable in solid form beyond about 3½ A.U., a point in the midst of the asteroid belt. Of course, even inside this distance, it can be found in cold spots such as the polar regions of Earth and Mars. Water ice is the most important ice in the solar system.

Next on the list are ammonia and carbon dioxide ices, which

might be expected in the region of Uranus and beyond. Carbon dioxide ice is common also on the poles of Mars because the planet's atmosphere is almost pure carbon dioxide, and on the polar winter nights this gas freezes and snows out of the air; in the outer solar system, however, carbon dioxide appears not to be very important. Last on the list is methane, a common material in the outermost solar system.

In a single world that contains several ices and is heated by sunlight or volcanism, the ices will melt in order from the bottom of the table upward. Methane ice will melt and give off methane gas; then the ammonia and carbon dioxide ices; and finally the water ice. Note that water ice heated under pressure (under the ground, for example) will turn into liquid water; if either the ice or the water is heated under very low pressure on the surface, however, or if it is exposed to space, then both the ice and the water will turn immediately into gas, or water vapor. Any rocky component will remain solid unless the temperature exceeds about 1,000°C.

Resurfacing an Icy World

Suppose we find a frigid world of rock and water ice, with pockets of trapped methane ice under the ground. If it heats up

The Jupiter expedition. Manned reconnaissance ships, traveling together to provide safety through redundancy, make the first human penetration into the Jupiter satellite system. The ships pass Io, Jupiter's sulfur-tinted satellite, as the sun goes into eclipse behind the giant planet. Angular width: 45°.

Ron Miller

to –100°C (perhaps due to internally trapped radioactive minerals, as in Earth), the rock and water ice will remain solid, but the methane will melt and perhaps create volcanic vents that spew out methane gas and methane ice crystals, producing a temporary thin methane atmosphere. If much methane erupts, the ground could sag into the underground cavity, producing fractures and collapse craters.

If the interior of such a world warmed up to, say, 30°C, the water ice would melt and the rocky soils would sink to the center of the world, or at least to the bottom of the melted zone. Liquid water driven by steam pressure could erupt onto the surface through cracks and vents. Water would gush onto the surface along with snowflakes and frost from the condensing steam. The water would refreeze into clean white ice, forming a new surface. We will encounter worlds where this has happened.

Ices, Soils and Colors

As we've seen, the inner solar system has rocky worlds with rock colors of intermediate tan, brown, red and gray. In contrast, the outer solar system has mixtures of white ices and black or reddish-black carbonaceous soils. Thus, like salt-and-pepper mixtures, the tones range from bright white to very dark.

Worlds with black carbonaceous soil show various tones of gray. Worlds with reddish-black carbonaceous soils show various tones of tans, browns and reds. Other materials, including sulfur and organic compounds, color some of the outer solar system moons, producing tones of red, yellow, orange and white.

Soaring over Valhalla. A reconnaissance ship passes near Jupiter's dirty-ice moon, Callisto. A dominant feature of this moon is a huge, multiringed impact scar named Valhalla. The ring system stretches across 2,400 km (1,500 mi) of this Mercury-size moon. Angular height: 40°.

Ron Miller

		World Building Materials			
MATERIAL	COMPOSITION	SOLID AT TEMPERATURES BELOW:*		SOLID IN FULL SUNLIGHT BEYOND APPROXIMATELY:*	EXPECTED PLANETARY REGION OF COMMON OCCURRENCE
		°C	°F		
Rock	Various silicates	1000	1832	0.08 AU	Mercury and beyond
Water ice	H_2O	0	32	3.5	Outer asteroids and beyond
Ammonia ice	NH_3	−78	−108	10	Uranus and beyond
Carbon dioxide ice	CO_2	−79	−110	12	Uranus and beyond
Methane ice	CH_4	−182	−296	35	Neptune and beyond

*The freezing temperatures vary slightly depending on the gas pressure of the environment, but the table lists representative values.

Energy Resources of the Outer Solar System

Although it is hard to predict engineering techniques that will be utilized in the outer solar system decades in the future, we already can see many scientific goals that may lead to a long-term human presence in the outer solar system. This will lead to a search for energy sources. Arthur C. Clarke, who has a good track record in predicting developments in space, sets his novel *Imperial Earth* on Titan in 2276 and foresees a thriving solar-system-wide economy including utilization of Titan's hydrogen resources. Today's technologists are trying to develop the energy source of the sun, known as fusion, wherein nuclear reactions consume hydrogen atoms, combining them into helium and releasing energy. If fusion reactors are developed, explorers in the outer solar system will have inexhaustible sources of hydrogen fuel, utilizing the ices and gases of that region. Refueling there could be easy, and Clarke foresaw shipping of hydrogen resources from low-gravity Titan to other worlds rather than lifting water-derived hydrogen "uphill" from Earth.

Conversely, solar energy is less attractive as we go into the outer solar system, since we are farther from the sun. The energy received by a solar panel in Jupiter's orbit is only 1/27 that received by the same panel near Earth; however, in the absence of other cheap energy, this drawback could be offset simply by building panels with 27 times as much area.

In addition to energy resources, the critical resource of water will be abundant on the icy surfaces of most outer solar system moons.

What about scientific goals? We will organize the rest of this chapter around questions that early explorers can attempt to

answer. These questions may provide much of our motivation for venturing into the realm of ice and fire.

How the Giant Planets Formed

Why does the solar system have a family of small, rocky inner planets and a family of four giant, hydrogen-rich outer planets? Some scientists believe each giant formed when a huge section of the primeval planet-forming gas cloud contracted due to gravity, trapping all the gas, dust and ice grains in that region into a single, giant planet.

A growing majority of scientists think this explanation is too simple; instead, they postulate a two-stage process in which the cores of the giant planets grew like the inner planets, one planetesimal at a time, during collisions. Soon they grew to Earth-size worlds of ice and rock, and then they grew even larger than Earth. When they reached some 10 or 15 times Earth's mass, their gravity became large enough to trap the surrounding nebular gas so that the massive hydrogen envelopes were added late. It is odd to think that Jupiter, Saturn, Uranus and Neptune may each contain a super-Earth, frozen beneath layers of ice, liquid hydrogen and swirling clouds!

Scientists expect to be able to test these ideas by measuring the exact composition of the gases of Jupiter, Saturn, Uranus, and Neptune. They can look for gases that would have been trapped if the giants had formed by the first process, but would be rarer in the second process.

Asking about the origin of giant planets might seem academic. Not so. Understanding how giants formed will set the

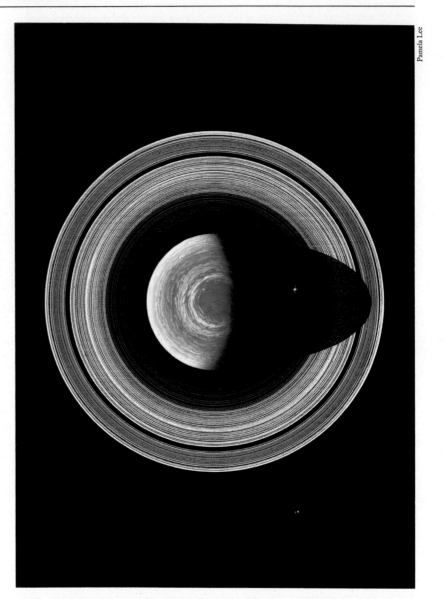

Pamela Lee

Saturn and its rings offer an endless variety of geometric and shadow patterns. Here the system is seen from above one pole. The shadow of the ball falls across the rings and varies in shape seasonally, according to the angular distance of the sun above or below the ring plane. Ring subdivisions are prominent at this unusually high lighting angle.

stage for the next great era of space exploration: the exploration of other star systems. Already satellite and ground-based telescopes have revealed evidence of dust particles and planet-like objects somewhat larger than Jupiter, orbiting around other stars! Are these systems really analogs of our solar system? If so, do they contain habitable Earth-size worlds or only gas giants? We can't answer until we know more about the processes that formed our own giant planets and their systems of world-size moons.

Outer Moons of Jupiter: Phobos and Deimos Revisited?

Let us describe the mysteries of Jupiter's 16 known satellites by approaching the Jupiter system from a distance. The outermost satellites, two groups of four each, are strange because each group is clumped in similar orbits. The outer group orbits at about 22,000,000 km (14,000,000 mi) and all four moons move around Jupiter in a "backwards" direction, compared to most other moons and planets! That is, they move clockwise as seen from the north side of the solar system. The inner group of four moons orbits at about 11,000,000 km (700,000 mi) in the usual (counterclockwise) direction. All of them are believed to have black, carbonaceous soils on their surfaces. The largest is about 170 km (106 mi) across; the others are small, about 8 to 60 km (5 to 38 mi) across. Thus, in composition, color and size, they resemble Mars' moons, Phobos and Deimos.

How did Jupiter acquire these two groups of moons? Could an initial carbonaceous outer moon have been shattered by another, similar object, with the two groups of fragments evolving into these orbits? Alternatively, some scientists have suggested that Jupiter could have captured nearby asteroids (which are the carbonaceous type) into these two groups of orbits. No theory has been widely accepted. Spectroscopic studies suggest some differences among the moons. Is this because they started out as independent asteroids or because they are fragments from inside different regions of two asteroids that collided?

Do the black surfaces hide ice interiors? Because the moons are farthest from Jupiter's gravity and have little gravity of their own, they would be the easiest places within this system to supply water to ships of a Jupiter expedition.

Small and obscure though they may be, these eight moons (and any undiscovered companions) will be high-priority stops for Jupiter explorers. They may contain clues to origins of other satellites, including Phobos and Deimos (similarly captured black asteroids?).

Callisto and Ganymede: How Did Icy Crusts Evolve?

As we move in toward Jupiter from the small outer moons, we encounter the four giant moons called Galilean satellites (after their discoverer, Galileo). Farthest out are Callisto and Ganymede, comparable in size to the planet Mercury.

Callisto is the more uniform, with a dark gray surface dotted by bright craters. The craters have punched through a dirty soil layer, exposing brighter, cleaner ice underneath. Bright splatters of ejected icy material stretch out from them. Ganymede has large regions that look like Callisto, gray and cratered. These regions are cut by swaths of bright, ridged, icy material which is much less cratered and hence younger. Apparently, the old, cratered, gray crust that formed on both worlds was split by internal forces on Ganymede. During the splitting, watery "magma" erupted, freezing to form the icy swaths.

The mean densities of these moons, together with other evidence, suggest that Callisto and Ganymede may have formed from roughly fifty-fifty mixtures of carbonaceous soil and water ice, with other minor components. The radioactive minerals in the soil, just like the radioactive minerals in Earth's rocks, heated the interior of each world, melting ice and allowing the soil to sink to the center. Thus the interior of each moon contains a rocky core overlaid by liquid or slushy water. The ice at the surface, exposed to the cold of space, radiated away its heat and avoided melting.

According to these models, then, Callisto and Ganymede probably have rigid surface layers of ice and soil floating on

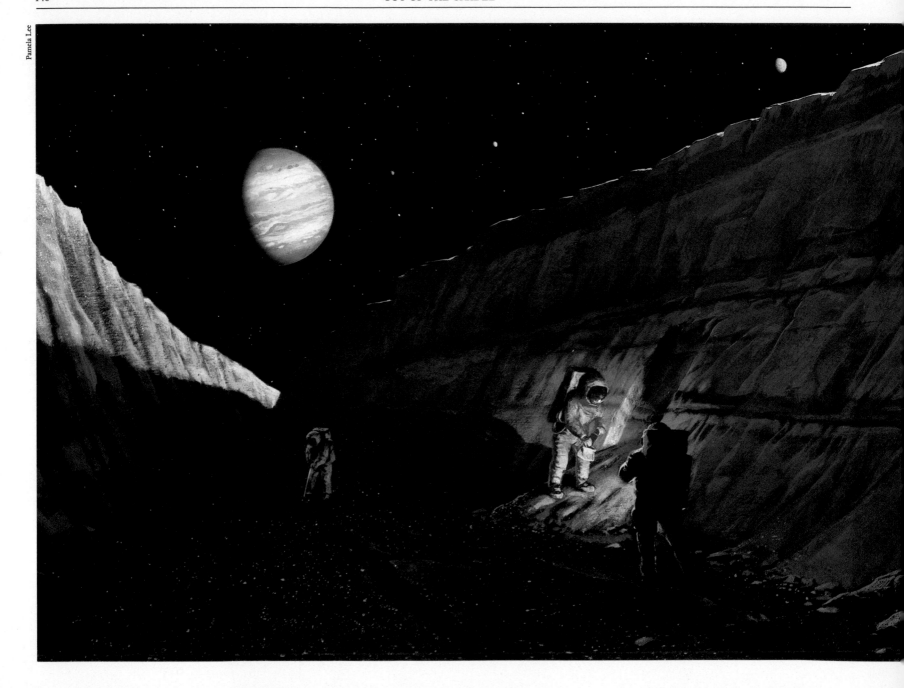

Pamela Lee

watery interiors. The situation is rather like the ice pack on the Arctic Sea, but with thicker ice.

Strangely, all of this has a bearing on our understanding of Earth. Sections of Earth's outer rigid layers, called "plates," are being pushed around by movements of more fluid material below. Understanding the origin and breakup of Ganymede's crust, and the absence of such breakup on Callisto, may lead to a better understanding of Earth's "plates." Close-up study of the structure of the fractured swaths and exposed soil layers in grooves and crater walls, drilling experiments, and examination of soil and ice samples will help clarify mysteries of the crustal structures of Callisto and Ganymede.

Why Is Europa Smooth?

The next moon in from Ganymede is Europa, about the size of our moon. Paradoxically, this moon has less geologic structure than practically any other world but is one of the most interesting of all worlds. The interest lies in its very featurelessness. It looks like a white billiard ball, crisscrossed by faint tan streaks. Just as Ganymede has more bright, fresh ice regions than Callisto, Europa has more than Ganymede; in fact, it is virtually covered by fresh ice. Moreover, there are only a few impact craters. All this must mean that Europa's surface is very young, possibly formed within the last 100 million years.

Scientists analyzing the Voyager photos of Europa found an unusual bright area, possibly projecting off the disk, on the last photo taken as the spacecraft sped away from the moon. Some of them believe this is an erupting cloud of ice crystals. Europa may even be geologically active today!

A possible source of the proposed geological activity on Europa is a mechanism called tidal heating. Among the inward large moons of the giant planets, gravitational forces from one moon may cause a neighboring moon to vary its distance from the planet by a small amount. As Europa moves closer to and farther from Jupiter because of these forces, Jupiter's strong gravitational pull stretches the moon slightly into a football shape with the long axis toward the planet. Called a tidal bulge, similar

Jupiter's moons Callisto and Ganymede are laced by systems of parallel grooves, some associated with multiple rings of impact scars. The grooves may be fractures in the icy crust. Here astronauts on Callisto cut into a groove wall to obtain a cross section of structure of the ice/soil mixtures, in hopes of clarifying the history and compostion of the region.

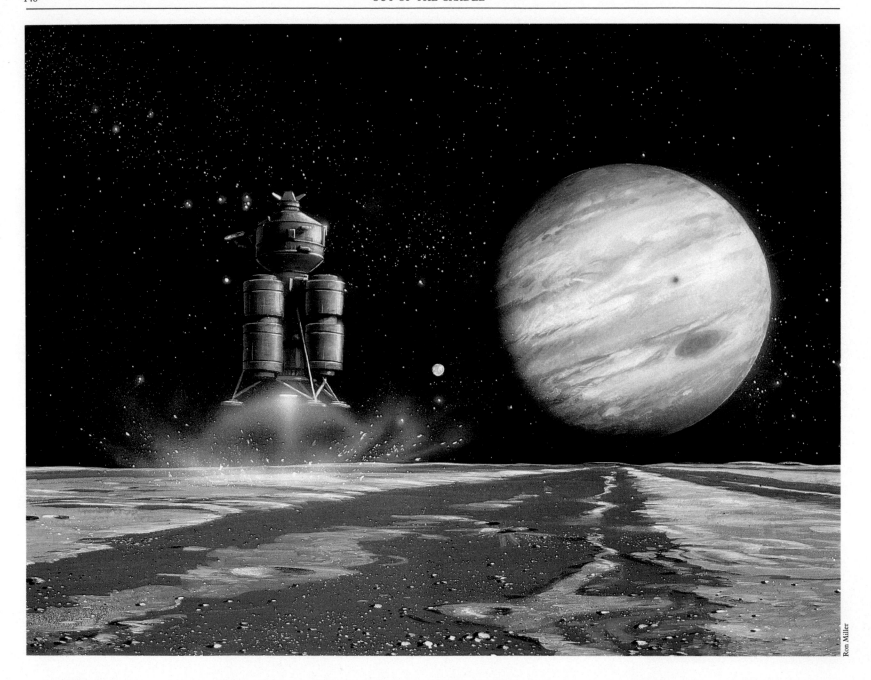

Ron Miller

to the tides raised in our oceans by Earth's moon, the stretch is first strong and then weak, depending on the distance to Jupiter. If you flex and relax a tennis ball in your hand, the ball will eventually heat up due to the friction caused within; similarly, tidal flexing heats Europa. This has probably maintained a warm temperature inside Europa, keeping most of its ice melted except for a thin crust, which is occasionally broken as water erupts. The main puzzle is that calculations indicate only a modest heating, hardly enough to do the job. It is thus doubly important to measure the crustal thickness and heat flow before we can understand what is happening inside Europa.

What Supports Io's Fires?

One of the great success stories of recent science is the development of the theory of tidal heating *before* Voyager 1 got to Jupiter. The tidal heating is much stronger on the next inward moon, Io, than on Europa. In the issue of the journal *Science* published the week Voyager got there, California scientists *predicted* that tidal heating was strong enough to melt the inside of Io and suggested that Voyager might spot volcanoes. Which, of course, it did. And what volcanoes! During just six and a half days of monitoring, Voyager 1 photographed eight volcanic plumes shooting 70 to 280 km (44 to 174 mi) above the surface and spreading to widths as great as 1,000 km (622 mi).

Tidal heating, then, supports the Io volcanoes in the energetic sense. But there is also a question of what supports them in the physical sense: are the volcanoes underlaid by rock or molten sulfur or what? Sulfur explains the surface colors, such as the black volcanic calderas, orange-red surroundings and white plains. At temperatures greater than about 600°C (1,112°F), sulfur is black, explaining the dark color of the volcanic vent regions. As it cools, sulfur turns lighter—first brown and then bright orange at temperatures around 125°C (257°F), matching

Pamela Lee

A jaunty astronaut is pleased to have collected samples of ice on Europa. Chemical analysis will shed light on the history and composition of this puzzling moon. Jupiter is reflected in the astronaut's faceplate.

The first landing on Europa. A ship from the Jupiter expedition touches down on the flat, groove-streaked surface of icy Europa. Jupiter subtends 12°, appearing twenty-four times as big as the moon in our own sky.

the colors of flows around the volcanic vents. At still lower temperatures, sulfur grows yellow at room temperature and then white at temperatures around −200°C (−328°F), explaining the colors of the cold plains between the volcanoes. Recent evidence

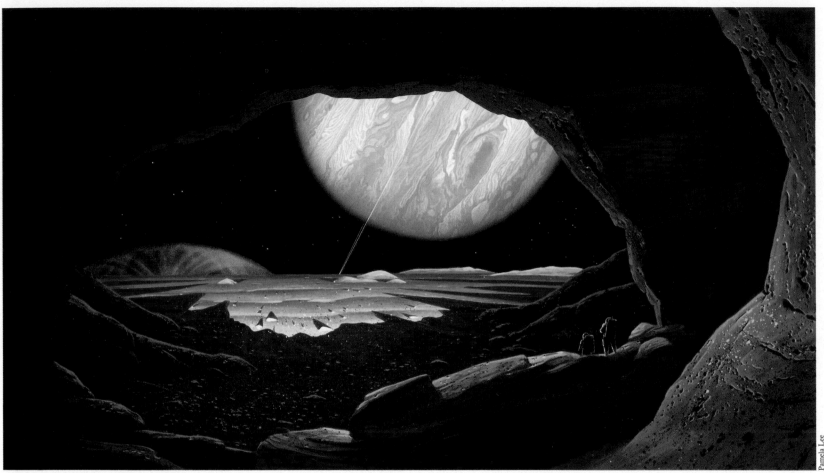

A lava cave on Io. Any future human visits to Io may be brief and rare, due to the dangers of volcanic eruptions and energetic atomic particles associated with Jupiter's enveloping magnetic field. Here heavily shielded astronauts examine the mouth of a lava tube that might offer temporary shelter from such hazards. Because of Io's constantly evolving surface, the long-term stability of the cave is questionable.

Pamela Lee

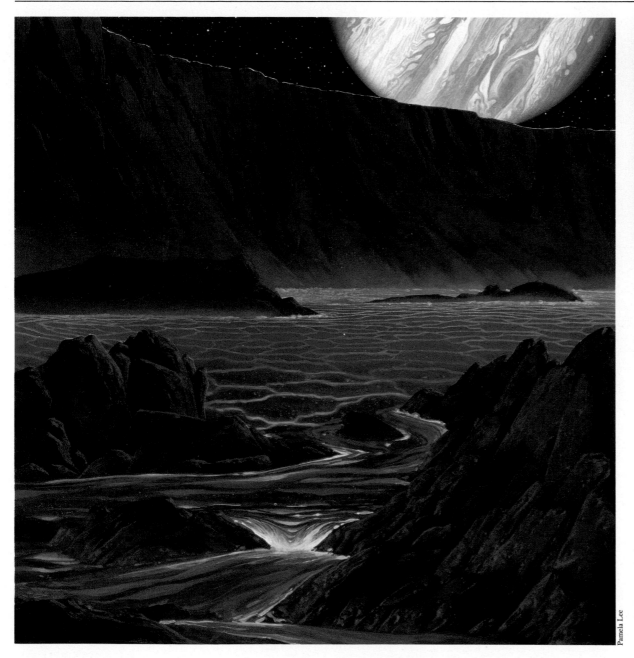

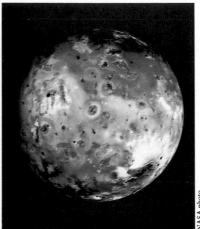

NASA photo

Jupiter's bizarre moon, Io, is the size of our moon but is extremely active volcanically. Its volcanoes have produced a surface of mottled orange, red, black, and white regions colored by various sulfur compounds at various temperatures. This photo was made by a Voyager spacecraft in 1979.

Pamela Lee

A volcanic caldera on Io. Voyager spacecraft and observers using Earth-based telescopes have detected hot spots on Io, believed to be calderas where molten or hot lavas have recently erupted. Jupiter subtends 20° as seen in Io's sky, appearing forty times bigger than the moon in our sky.

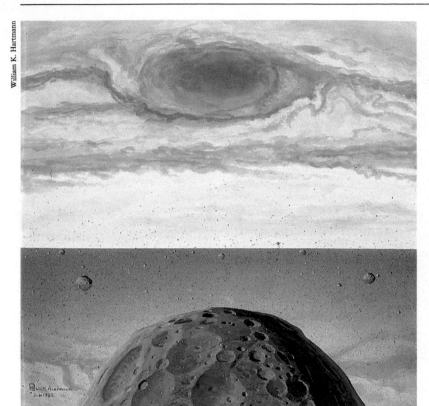

William K. Hartmann

In Jupiter's ring. We float above a small moonlet (bottom) at the outer edge of Jupiter's thin, enigmatic ring of dark, stony particles. Looking toward Jupiter, we see the surreal cloud pattern of Jupiter's Red Spot (above) and the gray ring stretching away thousands of miles into the distance (bottom half), creating its own "horizon." The ring is thin enough that we can dimly see through it.

suggests that as the volcanoes erupt, snows of white sulfur dioxide (SO_2) may fall out of the volcanic clouds and blanket some regions temporarily with additional white deposits.

The density of Io is greater than that of Callisto, Ganymede, Europa and our own moon; Io must be made of sulfurous rocky material with virtually no water ice. Researchers believe that the volcanoes have been active so long that all original ice has been melted into steam and blown into space through the volcanoes. Only sulfurous rocky materials are left.

Researchers working with these facts have puzzled over Io's internal structure. Some models call for sulfur and silicate lavas on a thin crust of silicate rocks overlying a molten interior. Other models suggest interspersed layers of solid sulfur compounds, liquid sulfur, solid rock and molten rock.

Though deeply embedded in Jupiter's magnetic field and dangerous energetic particles, and characterized by unpredictable volcanic explosions, Io presents an intriguing target to researchers trying to understand how alien planets work. Perhaps someday heavily shielded astronauts, or at least their robot probes, will wander the surface of Io, clarifying the nature of its strange volcanoes.

Is Jupiter's Ring Parented by Inner Moonlets?

Jupiter has a ring of microscopic, dark-colored particles extending inward from the region of four small moons that lie inside Io's orbit. The largest of these moons, Amalthea, is a potato-shaped lump about 155 × 200 km (97 × 125 mi). It has a reddish color, possibly derived from sulfur materials knocked off Io by meteorites or energetic atomic particles. The other moons are much smaller: 35 to 75 km (22 to 47 mi) across. Tiny particles knocked off these moons, especially the one on the very edge of the ring, would spiral in toward Jupiter and may be the source of the ring. In this view, the ring with its inward flow of particles would be like a river—always there, but containing different material at each moment. Dynamists, trying to understand the origin and evolution of ring systems, will be anxious to study the entire region close to Jupiter, from the ring's fuzzy inner edge to its sharp outer edge near the moonlets' orbits.

By blocking the sun's glare with a thumb, an astronaut in Saturn's vicinity glimpses the inner solar system. At left is Saturn's nearest neighbor, Jupiter (which is generally farther from Saturn than from Earth). Right of the sun, from left to right, are Venus, Earth (at elongation 6° from the sun) and Mars. Angular width: 35°. Asteroidal and cometary dust reflect a glowing band of zodiacal light around the sun.

Saturn's Outer Moon Phoebe: Another Captured Asteroid?

Saturn's system of at least 17 moons echoes Jupiter's system in some ways but also shows some differences. The densities are generally lower and the surfaces mostly whiter, indicating a greater proportion of ice as befits the location farther out in the solar system.

On the outermost edge of the system, however, is yet another small black moon in the tradition of Phobos, Deimos and the outer moons of Jupiter. This moon, Phoebe, is 220 km (138 mi) across and is probably carbonaceous in composition. Phoebe is another example of a moon in a backward, or "clockwise," orbit, moving in a direction opposite to that of all other Saturn moons. These properties again suggest that this moon

might have originated as a passing asteroid captured by Saturn, but the method of capture is unclear. Soil samples from Phobos, Deimos, the outer Jupiter moons, Phoebe and the "Trojan" asteroids of Jupiter's orbit would be very exciting as a means of clarifying the relationship between the mysterious, outermost, black moons of the solar system. Are they all descendants of a near-vanished breed of black carbonaceous planetesimals?

Why Is Iapetus Two-Faced?

As far as appearance is concerned, one of the strangest moons in the solar system is Iapetus, the next moon in toward Saturn. One side is carbonaceous, as black as coal; the other is icy, as white as paper. Like most moons, Iapetus keeps one side toward its planet while the other trails; therefore, one hemisphere always

Ron Miller

Astronauts on Iapetus try to find the explanation for the relatively sharp boundary between the bright icy regions and the dark, soil-covered regions of Iape- *tus. This boundary area runs around the moon between the bright, leading hemisphere and the black, trailing hemisphere.*

leads in its orbital trip around Saturn. It is the leading hemisphere that is black, the trailing hemisphere that is white.

One theory to explain this unusual situation is that meteorites blast black powder off neighboring Phoebe and that some of the powder spirals in toward Saturn (like the dust in Jupiter's ring). During the eons, much of it has been swept up by the leading side of Iapetus (just as the leading windshield of a car gets plastered by bugs, while the rear window doesn't). But the coloring of black Iapetus soil is somewhat different from the black Phoebe soil, implying that some chemical changes must occur if this is the process. Does the Phoebe dust react with the Iapetus ice as it impacts? Photos from Voyager, though of poor quality, indicate intricate structure, such as black crater rims in white backgrounds, near the boundary region. Plastering of Phoebe dust ought to produce a smooth transition from dark hemisphere to light hemisphere. Does some unknown geologic activity produce the intricate structure? Future explorers, under the baleful eye of distant Saturn and its rings, may drive across this boundary region and discover the elusive truth about this two-faced moon.

Why Is Hyperion Chunky?

As the reader is becoming aware, each moon in the solar system offers its own personality, its own special mysteries. The mystery of the next moon, Hyperion, is its shape. In the midst of a family of spherical moons, this is a potato-shaped world considerably larger than most other irregular objects. Its diameter is 220 × 410 km (138 × 256 mi), twice as big as Jupiter's potato-moon, Amalthea. Planetary scientists usually attribute such irregular shape to origin as a fragment of a larger body shattered in a collision. Hyperion would be an unusually large fragment and therefore may offer unique opportunities to see a cross section through the interior of what was once a sizable moon. Will it reveal an inner core, evidence of melting, or a primordial "plum pudding" of once-buried planetesimals? Only a closer look will tell.

A deep collapse pit exposes layers of ice and soil on Saturn's strange moon Iapetus. Moons closer than Iapetus lie nearly in the plane of Saturn's rings; from them the rings are seen nearly edge on. Iapetus offers a rare surface from which the rings can be seen tipped toward us.

What Lurks Below Titan's Clouds?

For anyone interested in the early history of Earth and the origins of its life, Titan, the giant, Mercury-size moon of Saturn, is one of the most interesting places in the solar system. Titan has by far the densest atmosphere of any moon. The atmosphere is

*The Bonestellosphere of Titan. There
may be a narrow atmospheric zone
above the orange smog where the over-
lying atmosphere is clear and thick
enough to produce a blue sky, rare in the
solar system. Ron Miller has suggested
this atmospheric layer be called the
"Bonestellosphere," after astronomical
artist Chesley Bonestell, who first visu-
alized a blue sky on Titan after discov-
ery of its atmosphere in 1944.*

William K. Hartmann

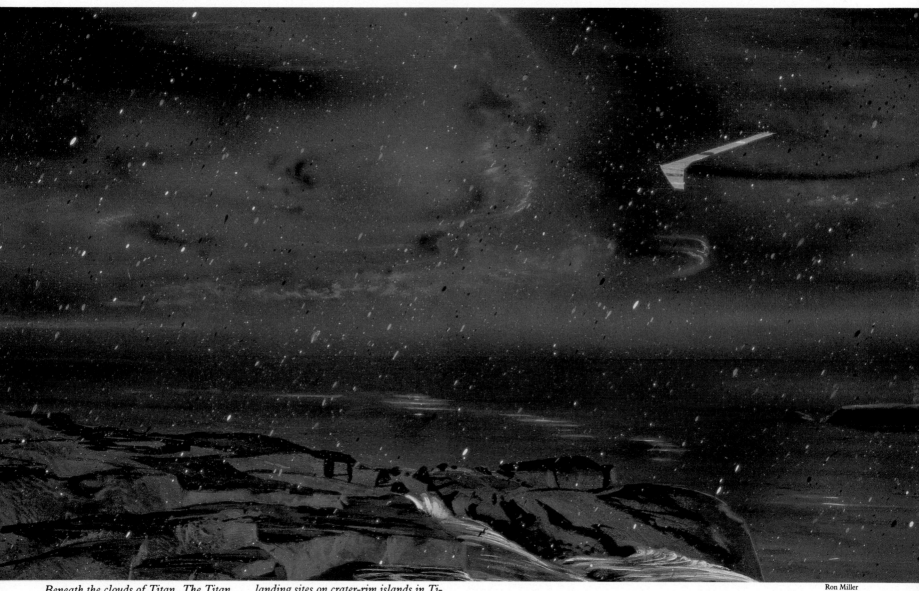

Beneath the clouds of Titan. The Titan aircraft has penetrated beneath the lowest cloud deck and flies through a methane snowstorm in search of potential *landing sites on crater-rim islands in Titan's methane-ethane seas.*

Ron Miller

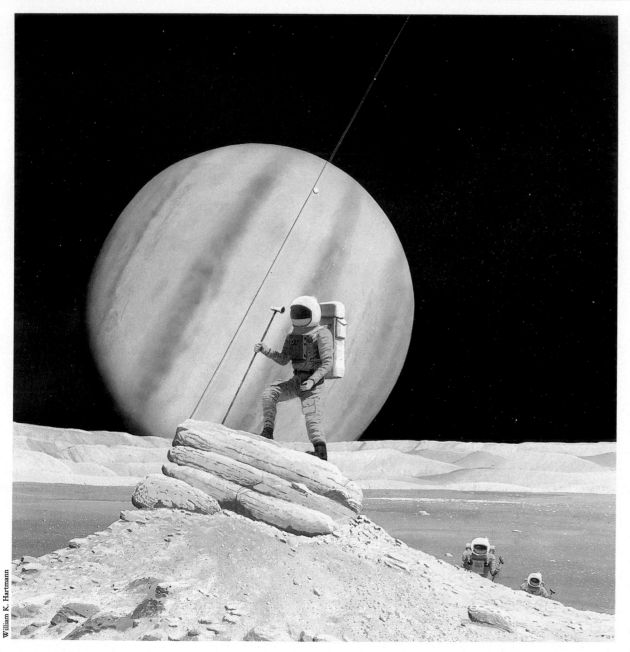

William K. Hartmann

Facing page: An ice fracture on Enceladus. Voyager photos in 1979 showed that Enceladus has more pronounced fracturing and resurfacing than other Saturn moons. Here we look along a geologically young fracture toward Saturn, which subtends 29°. Angular width: 45°.

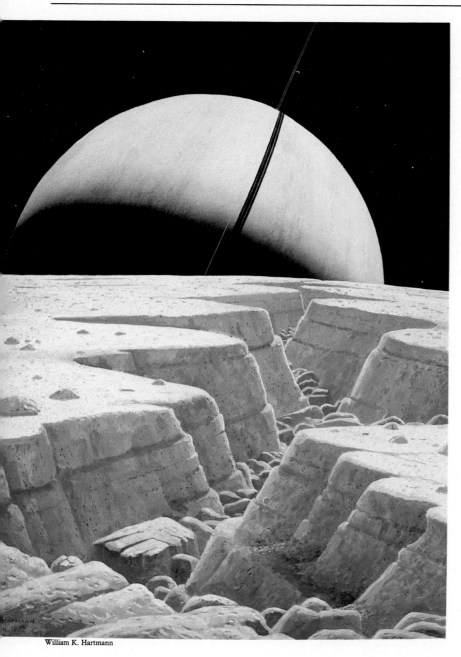

William K. Hartmann

primarily nitrogen gas, like Earth's, and the pressure at the surface is surprisingly close to that on Earth's surface, only about 60 percent greater. Minor atmospheric constituents include methane gas (CH_4) and a variety of organic compounds such as ethane (C_2H_6), propane (C_3H_8) and hydrogen cyanide (HCN). Additional organic compounds probably produce the color of the reddish smog, so thick that a visitor cannot see the surface from orbit. Conversely, no future visitor can see Saturn from Titan's surface, contrary to the hopes of early space painters who portrayed golden Saturn in clear blue skies over Titan.

The methane in Titan's lower atmosphere may exist as solid ice, liquid and gas, just as the water in Earth's atmosphere exists as ice, rain and water vapor. Therefore, snowstorms, rainstorms and fogs of methane compounds may sweep its surface. Rivers of methane or other liquids may run across the ground and collect in oceans. Researchers investigating this chemistry recently proposed that much (or all?) of Titan's surface may actually be covered with oceans of mixed liquid methane and liquid ethane.

To confirm such theories, closer measures must be made. Considering the Earth-like structure of the atmosphere, we can envision future shuttle-like aircraft prepared in orbit and sent off to collect the first direct samples and measurements from widespread areas in the twilight gloom below Titan's reddish clouds.

Have Saturn's Inner Moons Been Broken and Reassembled?

Most of Saturn's moons inward from Titan are made primarily of ice and have cratered, bright, white, icy surfaces. Voyager scientists pointed out an interesting fact concerning the cratering rate on moons at different distances from Saturn. Saturn's gravity concentrates the stream of incoming meteorites. The innermost large moon, Mimas, gets about 20 times as many hits as Iapetus. Thus Mimas and the inner moons have a much higher chance of receiving a catastrophically large hit. Starting with the known number of large craters on Iapetus, the scientists calculated that the innermost moons—Dione, Tethys, Enceladus and Mimas, in order inward—were probably all hit at least once by

objects big enough to smash them. Then why do they exist? The smash-up would have produced a cloud of fragments orbiting around Saturn. The theory is that these reaccumulated into moons after each smash-up. Since these moons range from 392 to 1,120 km (245 to 700 mi) across, we are talking about large catastrophes! In support of this idea, Tethys and Mimas each have fracture systems and giant craters more than one-third as big as the diameter of the whole moon. These craters alone were almost big enough to break them.

Future explorers will be able to land directly on these icy moons. It is strange to think that they may walk on objects that have been through several cycles of assembly, disassembly and reassembly.

What Happened on Enceladus?

As we moved in toward Jupiter, we encountered evidence of resurfacing by tidal heating. On Ganymede the ancient cratered surface was broken by swaths of grooves; on Europa the entire world was resurfaced by smooth ice. The second large moon out from Saturn, 500-km (312-mi) Enceladus, provides a missing link between Ganymede and Europa. Much of Enceladus is heavily cratered, but large regions are covered by Europa-like smooth, sparsely cratered plains, cut here and there by Ganymede-like grooves. Enceladus is the only Saturn moon that has such young regions. It is also the brightest white surface known in the solar system, suggesting very fresh, clean ice.

The theory of tidal heating helps explain these characteristics. Researchers *before* the Voyager encounter studied this activity and predicted that Enceladus was the satellite most likely to show effects of heating. Despite their success, a problem remains. As with Europa, the calculated amount of heating seems insufficient to do the job of melting and resurfacing. Measurements on Enceladus may help clear up the puzzle of the heating mechanism on such worlds.

Could Enceladus have resurfacing activity even today? Evidence comes from an unexpected source. Studies of Saturn's

An eclipse of the sun as seen from a crater rim on Tethys. Reddened by shining through Saturn's atmosphere, the sun casts a sunset glow across Tethys' icefields. The puzzling moon Enceladus, covered by the brightest ice in the solar system, is at upper left. The sun backlights the mysterious E ring, a fuzzy extension of Saturn's main ring system. The E ring consists of microscopic ice crystals, concentrated along Enceladus' orbit, which may be evidence of fresh ice-volcano eruptions blowing material off Enceladus. Angular width of wide-angle view: 70°.

William K. Hartmann

Pamela Lee

Our legacy on Mimas. Seeking clues as to whether icy Mimas was completely disrupted and reassembled one or more times by the intense cratering it has undergone due to meteorite impact, explorers have left their mark on this innermost of Saturn's sizable moons. Saturn, subtending 39°, covers much of the sky.

rings show that although the prominent part of the rings ends sharply inside Mimas' orbit, a very tenuous ring system extends out from Saturn beyond the orbit of Enceladus. *At* the orbit of Enceladus is a concentration of microscopic particles. This has led some researchers to suggest that Enceladus is the site of occasional water-volcano eruptions that blow out clouds of tiny ice crystals. Some escape into the local ring, explaining the concentration; others fall back, explaining the extremely bright, fresh color of the surface. With some sense of trepidation, future astronauts will monitor Enceladus and traverse its surface, searching for eruption sites and possible internal activity.

What Controls Saturn's Rings?

Since the 1800s astronomers have known that Saturn's rings are a swarm of particles orbiting around the planet and that the ring system is divided by a few major gaps. This structuring is something like the flat plane of a phonograph record, with its spacings between individual musical pieces. More recently, it was shown that the particles are water ice, or at least ice-covered, and that the most common particles range from marble- to house-size. The rings are incredibly thin. Although the main part of the rings stretches some 270,000 km (170,000 mi) across, they are less than 100 m (100 yd) thick from "top" to "bottom."

Unexpected was the revelation from Voyager photos that the rings are thoroughly laced with tiny gaps and ringlets, only kilometers wide, resembling the grooves on our record. What causes such detailed structure? The wider gaps have long been attributed to gravitational forces from the nearer moons, but this theory does not explain the multitude of narrow gaps. Moonlets a few kilometers across probably exist within the rings and may clear out the gaps. It would be worthwhile to locate these moonlets and learn their composition and origin.

Other weird configurations exist, including twisted and wavy ring strands and ringlets with wavy edges. These, too, might be explained by forces of moonlets within the rings, but we may not know until we get there and study the orbital

Eruption on Enceladus. The brightness of Enceladus' ice, its sparsely cratered, fractured plains and the nearby E ring of ice crystals suggest that Enceladus may be geologically active. Here an eruption of water and vapor blows a fresh supply of ice crystals off Enceladus and into the E ring.

Pamela Lee

Wide-angle view on the outskirts of Saturn's rings. In this 120°-wide view, we see the rings stretching away from us to a distant "ring-horizon." Two moonlets on the rings' outer edge pass in front of us. The distant sun (upper right) creates crescent lighting on Saturn and casts a shadow of the rings on its globe. A wavy "braided" structure can be seen on one of the outer rings, in the distance. The forces causing such structure are yet to be defined.

Riding the co-orbitals. As we enter the outskirts, we are in a region of numerous small moonlets, some sharing nearly the same orbits. By remaining still, astronauts could ride their surfaces, but slight motions would tend to launch a rider into space because of the moon's low gravity and because of tidal forces from Saturn.

William K. Hartmann

Ron Miller

dynamics at first hand. Perhaps we can perform experiments with the rings, moving some of the moonlets and watching the response of the ring structure!

A final mystery is the origin of the rings as a whole. Are they debris of inner satellites broken by collisions? Or are they a swarm of particles that never formed a moon, remaining in orbit since the days of Saturn's formation? Do they match the composition of Mimas and other nearby moons? Again, close-up sampling may be required before we can know the answer.

What Happened at Uranus?

As we move on to the outer limits of the solar system we know less detail, but we still have questions that would be interesting to answer. A question about Uranus concerns the tilt of its axes and equator. Most planets have their equators lined up nearly in the same plane as the solar system. Jupiter's tilt is nearly zero, for example, and Earth's is about 23½°. But Uranus is tipped practically 90° to the solar system, so that its north and south poles can point nearly *at* the sun during certain seasons. What's more, the five satellites orbit in the same plane as the equator, out of the plane of the solar system. It's as if the whole Uranian system were rotated. Did a giant planetesimal hit Uranus and tilt it, even before the satellites formed? We don't know.

What Happened at Neptune?

Neptune has two known moons. (A third, smaller one is suspected.) Of the two, the larger, Triton, offers an unusual feature. Besides Titan, Saturn's giant moon, Triton is the only other moon believed to have a substantial atmosphere.* Methane gas is believed to leak off methane ice on the surface as the ice is warmed slightly by the wan daytime sun. In 1983 astronomers in Hawaii reported evidence for oceans of liquid nitrogen on Triton. If this is correct, Triton would have not only an unusual surface, but also additional nitrogen gas in its atmosphere. Its

* It is a handy memory aid that the two moons with atmospheres (and oceans?) have similar names!

atmosphere may even be denser than Mars' atmosphere. What variety this adds to the solar system! If this work is correct, there are at least three oceans, each different: water on Earth, ethane/methane on Titan, and nitrogen on Triton. And these are in addition to the buried water layers beneath the ice crusts of Europa and other icy moons.

Neptune's satellite system offers a different kind of peculiarity, this one orbital. The outer, smaller moon—940-km (590-mi) Nereid—moves in a highly elliptical orbit in the usual counterclockwise direction seen from the north. But the inner moon—Triton—moves in a circular orbit in the "backward" clockwise direction! If the process of planet formation produced planets and moons generally orbiting in the "normal" direction, how did the largest satellite of Neptune end up going the "wrong" way? Why is its neighbor in an unusually elliptical orbit?

Some researchers have suggested that a large asteroid or comet passed through the Neptune system, disrupting the original orbits by means of its gravitational force and leaving this unusual pattern. But where could such a body have come from? A possible answer emerges by studying Pluto, as we will see next.

Are There Many Plutos?

After the discovery of Neptune, scientists realized that its orbital motion was being disturbed by some undiscovered body. This, in turn, led to a search that resulted in the discovery of Pluto. Unlike the other planets, Pluto has a strange orbit that crosses the orbit of its neighbor, Neptune. Right now, it is actually

Within Saturn's rings. In a moderately populated section of the rings, we are surrounded by ice chunks ranging from house-size icebergs to floating hailstones. From "top" to "bottom" the rings are less thick than the height of a skyscraper. The ring plane stretches off into the distance (lower center). Saturn's globe, covered by orangish clouds, is be- *low us (left), and the sun (right) backlights the scene.*

William K. Hartmann

William K. Hartmann

Left: Uranus as seen from a crater floor on Umbriel. As the Uranus seasons have proceeded, the sun has reach a latitude of 33°, illuminating much of the polar region; as Uranus moves on around the sun, it will reach a point where the sun fully illuminates the entire northern hemisphere of Uranus and its moons. Uranus' thin ring and an inner moon, Ariel, can be seen. Angular width of wide-angle view: 60°.

Right: Triton's liquid nitrogen ocean. The icy land surface is here visualized as heavily fractured, perhaps due to ancient disturbances among Neptune's satellites. Vents along the fractures have erupted colored organic compounds. Occasional quakes may create gentle ocean waves. Angular width is 50°.

closer to the sun than Neptune and will remain so until 1999! Pluto is also much smaller than the other planets, being comparable to the moon in size. For these reasons, its status as a true planet has been questioned.

In 1978 a moon of Pluto was discovered and named Charon. Nearly half as big as Pluto, this moon appears to support Pluto's claim to be a full-fledged planet; some asteroids have been suspected of having moons, however, and until the controversy of asteroidal moons is settled, Pluto's relation to planets and asteroids remains in doubt.

In 1977 astronomers discovered Chiron (not to be confused with Charon), an object roughly one-tenth the size of our moon and moving between Saturn and Uranus, crossing Saturn's orbit. Chiron was catalogued as an asteroid, but its existence proves that Pluto is not the only large object crossing giant planet orbits in the outer solar system.

Recently, astronomers studying the motions of Neptune and Pluto have concluded that the motions still aren't satisfactorily explained. This may mean that there are still more Pluto-size (or larger?) bodies out there. Pluto, Charon and Chiron may be just the tip of the cosmic iceberg. Perhaps these are planet-size planetesimals that were thrown into the outskirts of the solar system during step 5 of the planet-forming process described in the prologue. If so, others may await discovery, and one of them could be the body that disrupted the orbits of Neptune's satellites.

Solving the Mysteries of the Outer Solar System

We have listed many questions that will be studied during robot and human exploration of the outer solar system in coming decades. But we must not minimize the difficulties. Already, scientists sending probes to reach the outer planets work for several years on probe design and then spend as much as ten years of their career waiting for the device to get there. If a component fails, all this work may be lost. A probe like Voyager, launched on a ballistic orbit, could take decades to reach Pluto!

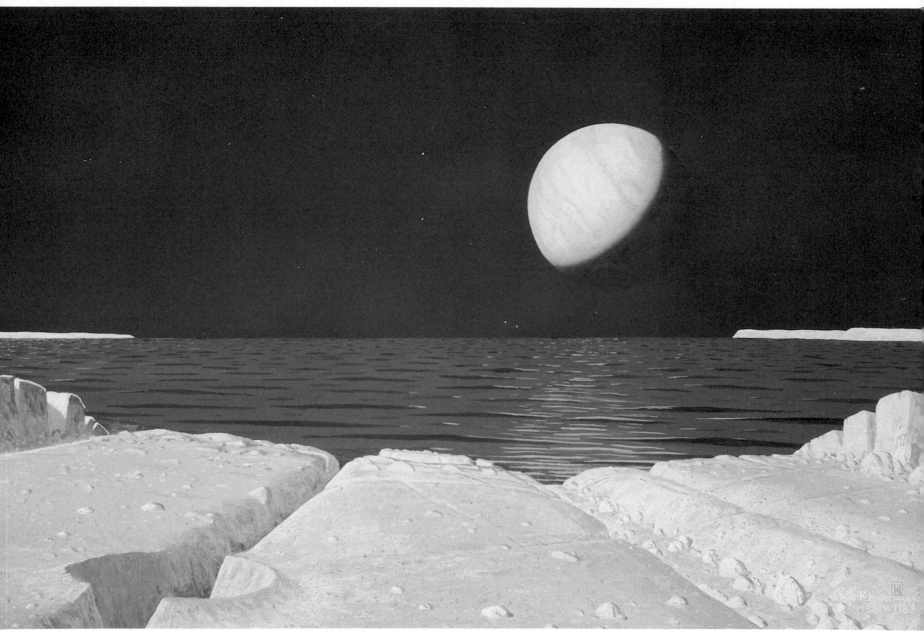

William K. Hartmann

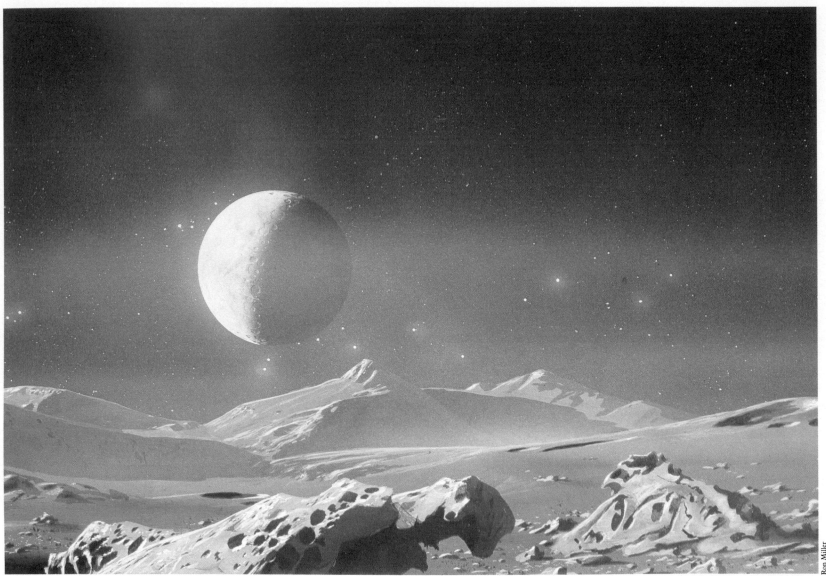

Ron Miller

Clearly, to facilitate outer solar system exploration, we need ships that do not coast ballistically on unpowered flights, like Voyager, but that are powered and can accelerate throughout the journey. So-called ion drives are one example, but feasibility studies on them have been underfunded. We must expand research on such propulsion systems today, in hopes of producing a new generation of future space vehicles capable of long interplanetary voyages in days and weeks instead of years.

Pluto as seen from its icy moon, Charon. Spectra indicate that Pluto and Charon have surfaces of methane ice, some of which sublimes into gas during a "warm" season every 248 years, as Pluto approaches its closest point to the sun just inside Neptune's orbit. The atmospheric pressure thus produced on Pluto may exceed that of Mars. Angular width: 45°.

THE SEARCH FOR LIFE

Paradoxically, as we move farther from Mother Earth, we will be pursuing the search for our own origins—for the holy grail of the origin of life. Our quest may be one of the longest-lasting adventures as we push back the frontiers of space. Already, over the decades of the twentieth century, we have seen this grail glimmering in the distance, tantalizingly just beyond our grasp.

In the 1700s we thought life's origin was an event of only six thousand years ago, fully described in ancient scriptures. Then fossils and rock dates relegated it to a much more remote past, about four billion years ago, whose records have been destroyed by a crumpling of Earth's crust more effective than an ancient scribe's crumpling of his manuscript.

By 1800 we thought life might exist on the moon. But our landings there proved that the moon is bereft not only of life and organic chemicals, but even of water.

By 1900 we thought life might cover the plains of Mars with waxing and waning fields of brown and gray-green. Then our space probes taught us that Mars is barren and that the surface soils at the two Viking sites are sterile. Only lifeless dust alters the patterns of Mars' disk. Solar ultraviolet radiation, unshielded by the thin atmosphere, has broken down any organic molecules that might have formed in the past.

The distant gleam of the holy grail brightened in the middle of our century as scientists learned more about the formation of organic molecules. Those big molecules involve carbon atoms, often in chains with oxygen, hydrogen and other atoms, and are the basic chemical building blocks of all life that we know. Biochemical theorists have long assumed that terrestrial life started when these chemicals formed and then concentrated in tidal pools, eventually aggregating first into giant self-reproducing molecules and finally into living cells. Pursuing this idea, experimental chemists showed that when gases of the ancient atmosphere (such as nitrogen, methane and water vapor) are exposed to water and energy sources (such as lightning, ultraviolet sunlight and even meteorite impacts), complex organic molecules form and accumulate in the water. These molecules include amino acids, the building blocks of the proteins that form much of our substance. Scientists have found additional processes by which the molecules aggregate into tiny cell-like spheres floating in the water, but they have never seen chemicals aggregate into true living cells. Thus scientists have never been able to *create* life. They have got only partway to that goal.

The experiments prove that nature can make life's building blocks very easily. This was verified in the 1970s when researchers discovered extraterrestrial organic molecules—including amino acids!—lodged inside carbonaceous meteorites and floating in interstellar clouds of gas and dust. Yet the carbonaceous meteorites (which also contain chemically bound water) contain no fossils or signs of life. Like the flasks of the experimental chemists, they got only partway there.

The Magic Interval for Life's Origin

How long did it take to evolve life on Earth? The oldest fossils (of very simple lifeforms) are about 3.5 to 3.7 billion years old. Many researchers think even simpler life arose within a few hundred million years of Earth's origin. After that event, another 3.5 billion years of evolution was required before lifeforms like the trilobites got sturdy enough to leave *prominent* fossils,

and a total of 4.4 billion years before we mammals evolved!

In short, a period of a few hundred million years seems to be a "magic interval" for forming life. If, on any planetary body, habitable conditions with liquid water and organic chemicals persisted this long, we should expect that primitive life would have evolved.

A Second Look at Mars

The ease with which nature can make organic molecules increases the puzzle of why none were found on Mars, the planet that until 1976 was regarded as the most likely home of alien life. Remember that the Viking landers could scoop up samples of loose surface soil no more than a few inches deep. Therefore, as explained earlier, the Vikings probably picked up primarily material that has blown around in the air and been sterilized by solar ultraviolet light. Plausibly, Viking could have missed more deeply buried organics. So it is possible that Mars' watery past lasted as long as a few hundred million years in the ancient past and that organic molecules and simple lifeforms once evolved. Once the water dried up or froze, life might have died out and most organic residues would have been destroyed. If this theory is correct, traces of primordial organics (or even fossils from three-billion-year-old Martian lifeforms?) might survive in special hidden places, such as the stratified deposits of ancient sediments exposed in canyon or crater walls. Extending the same thought, some researchers propose that deposits of ancient organic materials might interact with seasonal water in the polar icecaps, possibly providing hidden environments where primordial Martian lifeforms could survive even today.

Proponents of such ideas like to point out that in ice-free Antarctic valleys, from which soil samples tested out as sterile with Viking prototype instruments, microbial life was later found inside fractures in rocks!

Thus, while it wiped out hopes for a planet with flourishing alien life, Viking leaves open tantalizing possibilities that need further study. At the very least, we want to understand how

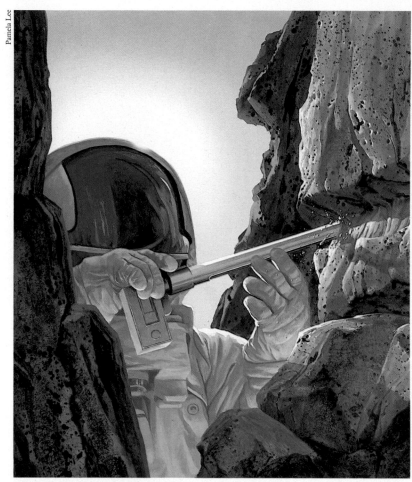

Pamela Lee

The search for Martian life. A future Martian astronaut obtains a sample from ice-rich soil buried in stratified deposits at the edges of the Martian polar icecap. Researchers hope such soil, long shielded from ultraviolet rays and occasionally exposed to melted ice water, will shed light on the early organic chemistry of Mars. Perhaps it will reveal the evolution of ancient lifeforms, now extinct.

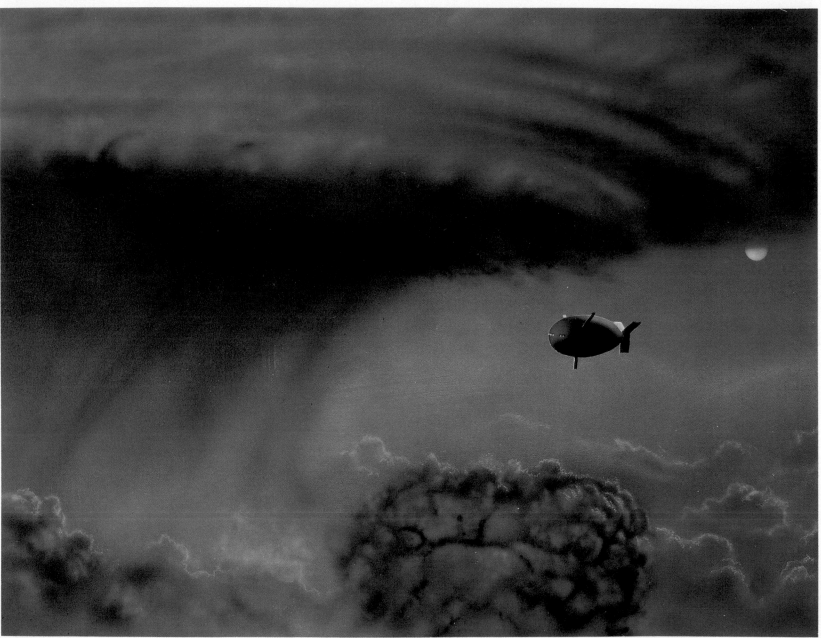

Ron Miller

far synthesis of organic materials proceeded on Mars in its ancient past.

Carbonaceous Asteroids and Comet Nuclei

A second group of sites where we can pursue secrets of early organic chemistry in the solar system are the carbonaceous asteroids and comet nuclei. These two classes of objects may be related, since some researchers believe comets evolve into carbonaceous asteroids as their ices are depleted, leaving behind a residue of carbonaceous soil. The dark tones of carbonaceous asteroids probably come from opaque carbon compounds, and the reddish tone of some of them probably from colored organic compounds. As already noted, carbonaceous meteorite samples contain abundant water, chemically bound in their minerals, amounting to as much as 20 percent by weight. Meteorite evidence suggests some of the water actually trickled through some of these bodies in liquid form. Organic chemicals abound, among them the amino acids mentioned earlier.

Lifeforms, even primitive ones, are unlikely to have evolved in such small bodies as comets or asteroids, since liquid water probably could not have persisted long enough inside them. Even if they were heated enough to melt their ice, they are so small that the heat would quickly have radiated away and they would have frozen again relatively quickly.

Thus the future explorers of carbonaceous asteroids and comet nuclei will be interested primarily in getting pristine samples from the interiors of these objects, in hopes of measuring the level of complexity in the well-preserved organic compounds.

The Jupiter aircraft probes the dense, lower atmosphere of the planet to study the organic chemistry there. Probes with near-vacuum chambers might be designed to sink slowly through the atmosphere, or drift with the wind, though the classical terrestrial dirigible design is unpromising because Jupiter's atmosphere is rich in hydrogen, the lightest gas.

Floaters on Jupiter?

Besides Earth there is at least one other environment where water droplets and warm temperatures lasted billions of years. This is the lower atmosphere of Jupiter. Although Jupiter's cloud tops are extremely cold (–225°F), the heat generated inside the giant planet warms certain layers in the lower atmosphere to room temperature. Here dense fogs of water, ammonia and organic compounds are believed to mix, and the pressure is perhaps ten times that on Earth.

Some years ago, astronomer Carl Sagan suggested that floating organisms like airborne jellyfish might have evolved in this thick, soupy air, just as organisms evolved in our seas. Other scientists, however, quickly pointed out that Jupiter's clouds are turbulent on a large scale, resembling the convecting thunderclouds that ascend on a summer afternoon. This means that a "floater" happily drifting in a temperate layer would be carried by updrafts to a very cold level, later to be caught in a massive downdraft that could carry it to a level too hot for it to survive. It seems unlikely that the hypothetical organisms could ever have begun evolving in the presence of this problem. Nonetheless, designers of the first airborne probes to fly among the lower clouds of Jupiter, and the other giant planets as well, may ponder whether their airships might encounter the floating offspring of another world.

Life on Remote Moons?

Until a few years ago, responsible astronomers would have scoffed at any suggestion of life on the icy moons of the outer solar system. These moons, known to have surfaces far too cold to permit biological activity, were thought to be frigid, barren iceballs. Then, in 1979, the Voyagers discovered the volcanoes of Io and theorists deduced the heating mechanisms that warm the interiors of Io, Europa and Enceladus.

Europa seems the most intriguing case. Its uncratered ice suggests repeated eruptions of liquid water that have re-formed the surface. Yet it is not as active as Io, which appears to have

Under Europa's ice. One of the most provocative environments in the solar system, from the point of view of the search for biochemistry, is the liquid water believed to exist under the ice crust of Europa. In the future, it may be possible to drill through thin, fractured regions and lower probes that might search for complex organic materials or even lifeforms. Perhaps it will be hard to distinguish these at first from complex masses of organic compounds.

lost all its water during volcanic outgassing. Voyager analysts suggest that Europa has a warm interior, an organic-rich core of carbonaceous soil and a watery underground "ocean" sealed under an icy crust many kilometers thick. The crust is cut in places by cracks and shallow grooves where the ice may be thinner. Recently, some scientists have speculated that life could have evolved in this underground "ocean." (This possibility was developed most dramatically in 1982 in the novel *2010* by Arthur C. Clarke, who, as usual, was a jump ahead of most everyone else.) The organic raw materials are there. Warmth is there, provided by the tidal flexing explained in the last chapter. What about sunlight? Recently, oceanologists on Earth found colonies of lifeforms clustered around geothermal, sulfurous hot-water vents on the seafloor, existing independent of sunlight. Such sun-independent life proves that organisms can draw energy from planetary rather than solar sources and supports the speculation that life might have evolved and persisted in the liquid water layer under the icy surface of Europa. What an irony it would be if, after finding Mars sterile, we find evidence of alien lifeforms (inscrutable bacteria; luminescent jelly blobs?) clustered around hot vents on the floors of buried oceans, on what was once thought to be a cold, sterile iceball in the outer solar system! Conversely, if Europa's subsurface waters are sterile, we must understand why before we can claim to understand life's whimseys of appearance and absence. Deep drilling and sub-ice probes will be on the agenda for Europa explorers. This moon, with its bland surface and buried mysteries, will beacon us for decades to come.

Titan: A Natural Laboratory for Primitive Organic Chemistry

In terms of seeking life's origin, smog-shrouded Titan is as provocative as any known world. As described in the last chapter, its ruddy smog is a haze of organic compounds formed by photochemical reactions in the atmosphere. These reactions are triggered as sunlight interacts with molecules of nitrogen, methane, and the other atmospheric gases high above Titan. Also, because its surface is reminiscent in some ways of the environment that gave birth to our microbial ancestors, it is clear that this is an environment rich in organic compounds, with conditions that might promote evolution of organic chemicals much more complex than those we have detected on this enigmatic moon.

What about life itself? Several factors may have prevented chemical evolution from going that far. First, remote Titan, at some –290°F, is much colder than Earth. Second, its surface is quite dark, perhaps no brighter than a moonlit night.

But, as remarked earlier, the discovery of sun-independent lifeforms in Earth's ocean depths around seafloor hot springs prompts speculation about frigid moons. Could hot springs, geysers or volcanoes on Titan's surface or seafloor provide temporary warm environments where biochemical evolution could begin? Do any such heat sources even exist on Titan? If so, did they persist as long as the magic interval of a few hundred million years? We know too little about the surface to answer. Probes below the clouds, samples of the surface materials, measurements of heat flow and probes of the ocean depths will be important goals for seekers of the biological holy grail on Titan.

Beyond the Solar System's Frontiers

Throughout this book we have described what humans will be doing as they explore the solar system. Most of this exploration is directed toward a better understanding of our own solar system—the resources that exist in the sky around us, the ways we might establish productive outposts on other worlds and learn to live in cities spinning through space itself.

The search for life, however, brings up an activity that will direct our gaze outward beyond the planets we know. This will

Readying the Titan aircraft. Following radar mapping from orbit, and measurements from parachuted probes, future explorers may attempt direct flights into the orange, smoggy atmosphere of Titan.

Ron Miller

Studying the organic chemistry of Titan. If land surfaces can be located amidst the probable oceans of Titan, they will offer attractive targets for exploration.

Hot-spring areas might reveal interesting chemistry, or even simple lifeforms. Spacesuit-like apparel is not to shield against near-vacuum, as on most planets

(Titan's surface air pressure is similar to Earth's), but rather to shield against intense cold.

be a search for planets and life beyond the solar system. There will be several motivations. First, from what we know so far, it seems virtually impossible that we will find any other intelligent lifeforms in our own solar system. Second, it seems questionable that we will find anything more advanced biologically than complex amino acids on nearby worlds—and as humorist Woody Allen has noted, amino acids aren't very gregarious, even at parties. If we want evidence of company in the universe, we will probably have to look across interstellar distances. A scientific debate rages over whether planets even exist near other stars. More and more suggestive evidence has been found. Dust, from which planets could form, orbits around many young stars. Unseen bodies a few times bigger than Jupiter circle other stars and affect their motion. But *proof* of Earth-like planets is still lacking. Most stars are double or triple, and formation of stable, habitable planets around them seems doubtful to theoreticians.

Yet, if even 1 percent of the stars in our galaxy have planets, this would leave at least a billion planetary systems. And if only 1 percent of *those* had a planet where liquid water persisted during the magic interval of a few hundred million years, we might expect at least ten million worlds on which life made a start. Or, if only a percent of those tenuous starts managed to survive ice ages, asteroid collisions, stellar flares, nuclear wars and other disasters of nature and intelligence, we would still have at least a hundred thousand civilizations scattered across our galaxy. And the universe contains millions of galaxies...

These numbers are so extraordinary that we can't help but turn our eyes to the sky and wonder. Are *they* really out there? If so, what are they like? Or, if they are not there, why not? Would it mean that we, too, are doomed? Does intelligence never last more than a few million years, the wink of a cosmic eye, disappearing due to catastrophe or inability to sustain itself?

To answer these basic questions, explorers of the solar system will take advantage of the space environment. Giant orbiting telescopes will allow better searches for the faint, elusive planets that may circle other suns. Arrays of radio telescopes will

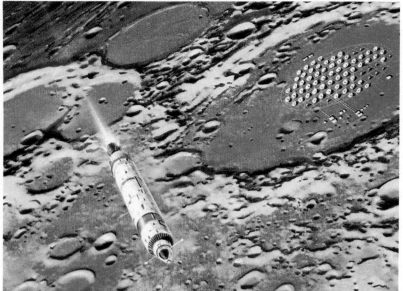

Ron Miller

SETI antennas on the moon. The search for extraterrestrial intelligence (SETI) is already being pursued by large radio telescopes listening for artificial signals from distant stars. Radio-quiet sites on the far side of the moon, shielded from Earth's radio noise, may become prime sites for vast future arrays of telescopes as part of humanity's effort to detect other intelligent lifeforms in the universe. Here we see such an array in a crater floor as a resupply ship departs for an orbiting space city.

sprout on the moon's far side, and others in radio-quiet zones, where they will scan the skies for artificial radio signals from other civilizations. Preliminary searches have already started with radio telescopes on Earth but have proved negative, only scratching the surface in terms of numbers of stars and radio frequencies.

We cannot prove that alien life does *not* exist. We can only lower our expectations as negative results accumulate. If we don't find the holy grail of alien life in our own solar system, it will always be out there, dimly glinting in the starlight of the Milky Way. Perhaps the *next* radio frequency, perhaps the *next* star we look at...

EPILOGUE: THE GOLDEN RULE OF SPACE EXPLORATION

Among large-scale human enterprises, space exploration has a unique combination of two traits.

First, it has great potential for humanity: the likelihood of yielding discoveries and technological advances that can, if used correctly, bring good to people. Among these are the large-scale harvesting of solar power, new sources of metals and other resources in nearby asteroids, processing of such materials in space instead of in our own atmosphere (thus reversing the current destructive environmental trends on Earth) and zero-gravity manufacturing techniques such as those used on the shuttle to produce new drugs.

Second, it has great appeal: given our basic nature as exploring animals, we have been enthralled by seeing our fellows undertake the sheer physical challenges of floating in space, stepping onto the moon and roaming the ghostly lunar hills. Apollo 11's first landing on the moon united humanity, if only for a day. In addition, we enjoy the intellectual challenge of formulating and answering questions: about the origin of planets, the origin of life, the violent nature of giant meteorite impacts, the causes of climate changes on Mars and Earth, the history of organic chemistry on alien worlds, and so on. Space exploration appeals as an adventure into the unknown.

The unique combination of *potential* and *public appeal* offers us a remarkable opportunity to use space exploration for human good. In view of this opportunity, the most important next step in space exploration is not a particular mission but rather the adoption of a critical golden rule of space exploration:

> SPACE EXPLORATION MUST BE CARRIED OUT IN A WAY SO AS TO REDUCE, NOT AGGRAVATE, TENSIONS IN HUMAN SOCIETY.

Each decision, each policy, must be tested against this principle.

In this book, we have seen evidence that Earthbound society will face dramatic changes; that resources and pollution are heading for catastrophic levels in the middle of the next century unless new discoveries or new ideas alter "business as usual"; that precedents in Antarctica offer both promising and threatening models for scientific cooperation and territorial partitioning during exploration; that our generation's attempt to maintain stability by erecting ever more fearsome and impregnable military walls is becoming more and more a damaging strategy that

The children of Earth. In another century, the spacecraft and space cities orbiting in Earth's equatorial plane may form a diffuse ring of starlike objects. Such vehicles are already visible from the ground and would be more prominent from space. It is summer in the northern hemisphere; Australia is at the lower left edge of Earth; the Milky Way crosses the background; the moon is at the right. We are in geostationary earth orbit (GEO) over the Pacific. Angular width of wide-angle view: 60°.

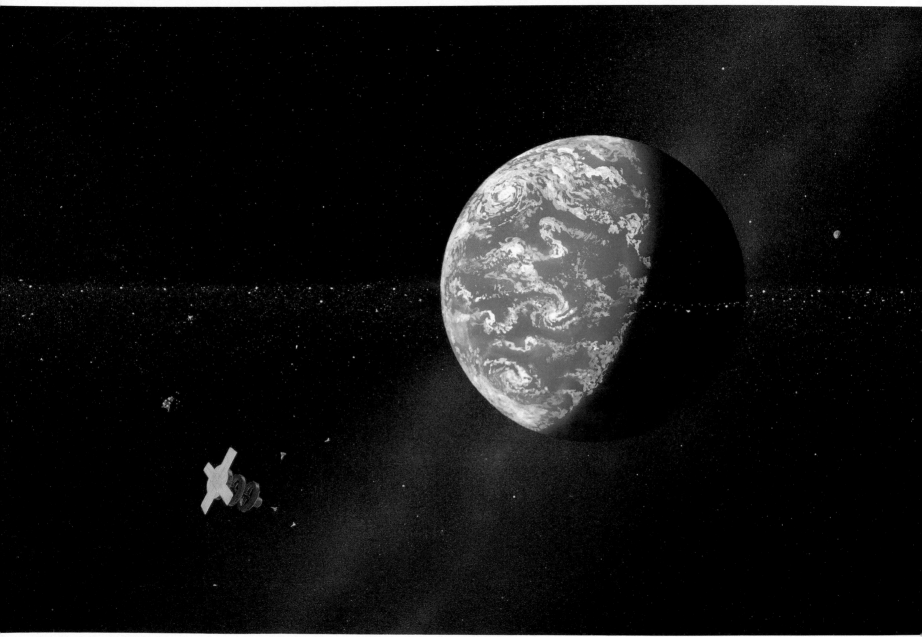

William K. Hartmann

financially inhibits more productive responses. Space exploration offers political leaders a chance to step out of this desperate situation. They can step in a different direction by challenging teams of technologists to develop exploration programs in their respective countries to inspire public imagination and pour new resources back into Earth's economy. They can fire the creativity of people everywhere and provide a new role model for international cooperation by insisting that their technologists collaborate with those of other countries (as we already did with Apollo-Soyuz) to carry out joint expeditions, to create multinational bases whose inhabitants will be motivated to show the rest of the world that "it can be done."

Deciding to follow this golden rule is easy now but will be hard to do later. If the United States, for example, proceeds in a mad dash to gain military *control* of the high ground of space and exclude others from it, or to *claim* for our exclusive pleasure as many resources as we can reach, we will only aggravate long-term tensions. But if we apply the rule, we can set easy and modest precedents. We can publish more satellite reconnaissance data to discourage the spread of militarism and to reduce the amount of waste in duplicated military systems in space. We can work to spread some of the gains from space resources throughout the world economy in order to reduce some of the tension-aggravating economic gaps. We can encourage a sense of not national but *world* participation in the venture. That costs us nothing. By skillful application of this golden rule, we may find that in taking the first steps out of the cradle, twentieth-century society will take joyful steps toward *solving* some of the problems that we and our forebears have created.

Index